CAMBRIDGE STUDIES IN NEW ART HISTORY AND CRITICISM

is series provides a forum for studies that represent new approaches
the study of the visual arts. The works cover a range of subjects, in-
ding artists, genres, periods, themes, styles, and movements. They are
inguished by their methods of inquiry, whether interdisciplinary or
ted to developments in literary theory, anthropology, or social his-
The series also aims to publish translations of a selection of Euro-
material that has heretofore been unavailable to an English-speak-
adership.

General Editor
Norman Bryson, *Harvard University*

Advisory Board
Stephen Bann, *University of Kent*
Natalie Kampen, *Barnard College*
Keith Moxey, *Barnard College*
Joseph Rykwert, *University of Pennsylvania*
Henri Zerner, *Harvard University*

Other Books in the Series

VISUALIZING BOCCACCIO

VISUALIZING BOCCACCIO

Studies on Illustrations of
The Decameron, from Giotto to Pasolini

JILL M. RICKETTS

CAMBRIDGE
UNIVERSITY PRESS

PUBLISHED BY THE PRESS SYNDICATE OF THE UNIVERSITY OF CAMBRIDGE
The Pitt Building, Trumpington Street, Cambridge CB2 1RP

CAMBRIDGE UNIVERSITY PRESS
The Edinburgh Building, Cambridge CB2 2RU, United Kingdom
40 West 20th Street, New York, NY 10011–4211, USA
10 Stamford Road, Oakleigh, Melbourne 3166, Australia

First published 1997

Printed in the United States of America

Typeset in Weiss

Library of Congress Cataloguing-in-Publication Data

Ricketts, Jill M.
 Visualizing Boccaccio / Jill M. Ricketts.
 p. cm. – (Cambridge studies in new art history and
criticism)
 Includes bibliographical references.
 ISBN 0-521-49600-4 (hardcover)
 1. Boccaccio, Giovanni, 1313-1375. Decamerone. 2. Sex
differences (Psychology) in literature. 3. Sex role in literature.
4. Boccaccio, Giovanni, 1313-1375–Film and video adaptations.
I. Title. II. Series.
PQ4287.R44 1996
853'.1—dc20 96-5233
 CIP

*A catalog record for this book is available from
the British Library*

ISBN 0 521 49600 4 hardback

CONTENTS

v

ILLUSTRATIONS

ACKNOWLEDGMENTS

IT IS MY PLEASURE to give thanks and grateful acknowledgment to all those who have helped me in this work. I owe much to my teachers at the University of Rochester: Mieke Bal, whose personal and academic generosity inspired me to undertake this study; Donatella Stocchi-Perucchio for her enthusiastic support and advice; Sharon Willis and Constance Penley for their enormously helpful conversations and classes; Norman Bryson for his encouragement and assistance in preparing the Tancredi chapter; Ann Fehn for her kind and useful advice. I would also like to acknowledge Cristelle Baskin's kindness, prompt reviews, and criticism, and to thank Philip Berk for an Italian copy of Pasolini's *Decameron* as well as his continuing interest in the project. I owe special thanks to Beverly Allen, whose exciting scholarship and friendship led me to this point. I would also like to thank Camilla Palmer, Christie Lerch, and Beatrice Rehl at Cambridge University Press, as well as Trey Ellis, Belle Yang, Jess Taylor, Marilyn Migiel, Jerry Bond, David Pollock, Asish Basu, Udo Fehn, Bob Poreda, Judy Massare, Buzz Rainer, Wally LeValley, Ray Gere, Peter Kalkavage, and Victoria Kirkham for their helpful advice.

Much of the writing and research for this book was done in Bologna, Italy, with the generous support of the Susan B. Anthony Center at the University of Rochester. I have enjoyed the resources of several libraries, including the Biblioteca del Dipartimento delle Arti Visive at the Università di Bologna, the Biblioteca Nazionale Centrale in Florence, and Stanford University's Green Library. In addition, I want to thank Laura

Betti for her help in using the extensive resources at the Associazione "Fondo Pier Paolo Pasolini" in Rome; Ugo and Ivo Palmito, who negotiated teleconferences and intricate financial transactions with great aplomb; and Dr. Francesca Allegri at the "Casa di Boccaccio" in Certaldo. I would also like to acknowledge my heartfelt thanks to Camp Shaffer and the Instituto di Pensieri Teoretici for giving me the space and quiet to compile this work.

I would like to express my love and gratitude to my family for supporting and humoring me. I want to thank Mike and Trulee Ricketts for providing the gourmet meals, time, and space necessary for me to write this book. I particularly want to thank Elaine Scarlett, the consummate storyteller and family historian whose wild tales have always piqued my curiosity about the remote past. Naomi Elena and Clare Luna provided invaluable assistance and editorial help. Finally, I would like to thank Peter Acero Rosa DeCelles for his extraordinary financial and emotional support, and for making it all worthwhile.

Author and publisher gratefully acknowledge the permission of the following to reproduce their illustrations in this book: Bibliotèque Nationale, Paris (Figures 1, 2, 3, 4); Biblioteca Apostolica (Figure 6); Museo del Prado (Figures 5, 7, 8, 25); Scrovegni Chapel (Figures 11, 13, 17, 18, 19); Uffizi Gallery (Figure 14); Museum of Santa Croce (Figure 15); Basilica di Santa Maria Novella (Figure 16); Alte Pinokothek, Munich (Figure 24).

INTRODUCTION

Giovanni boccaccio's *Decameron* is an intriguing collection of stories, concerned with the interpretation of literature. The *Decameron's* frame narrative format, with the ever-present traces of literary production and reception on all levels of the text, calls attention to its potential as a tutor in literary criticism. As many Boccaccio scholars have pointed out, one of the *Decameron's* literary lessons is that interpretation is an ongoing and open practice which always entertains new perspectives and fresh insights.[1] Even scholars who would balk at this assessment provide evidence of its truth by augmenting Boccaccio studies with additional metaliterary interpretations and analyses.

One of the goals of this book is to develop a reading of the *Decameron* which exposes the tensions generated by sexual difference that motivate privilege, in order to investigate the possibilities for changing the power relations inherent in that privilege. To this end, I will concentrate on the way Boccaccio's book functions as a mediator between the reader and the fictional world presented in the *Decameron*. The arguments I will develop posit that reading is an encounter among various subjects (internal and external to the text) who are embedded in a specifically patriarchal structure. The positions held by these subjects are, however, susceptible to reconfiguration by critical reading and rewriting. Because the field of Boccaccio studies and the literary tradition within which Boccaccio wrote his stories have been for the most part a male prerogative, it is important to examine and question the ideological adaptation evinced by the stories themselves and by the criticism.

1

As we shall see, the mediating position taken up by Boccaccio's text underlines and exploits its own erotic potential, highlighting questions of sexual difference. Of course, the notion of sexualizing the acts of reading and mediation is not novel in literary history, but in Boccaccio studies the practice has not been brought to bear on the issues of gender and subjectivity as they are constructed in the *Decameron*.

Boccaccio introduces the *Decameron* as an erotic mediator, thereby extending a metaphoric as well as literal invitation to his readers to engage in an exchange with the text. Some of the categories of exchange solicited in the book are established in the subtitle: "Here begins the book called *Decameron* whose last name is Gallehault, in which one hundred tales are inscribed, told in ten days by seven women and three men."[2] The importance of naming and sexual difference as well as the processes of identification, representation, and storytelling are all emphasized briefly in the subtitle. In particular, Boccaccio's insistence on establishing the paternity of the text (by giving it a last name) signals the sexual intent and content of his project while symptomatically expressing the erotic economy in which it takes place.

The very fact that Boccaccio bestows a patronym on the *Decameron* alludes to its literary lineage, which is patterned on the human model of the patrilinear family. The gesture of anthropomorphizing the text endows Boccaccio's book with the potential to take up the position of the child – the progeny of the writer and the literary tradition in which he was educated. Further, the subject position given to the book is animated by Boccaccio's desire to make contact with his audience. Questions regarding the relationship between reading and mediation, in particular the eroticization and sexualization of the process of mediation, that will be made explicit and dramatized later in the *Decameron* are presented *in nuce* in the subtitle.

The surname "Gallehault" derives from the Arthurian legends, in which Prince Gallehault serves as the go-between in the ill-fated love affair between Guinevere and Sir Lancelot. In Italian literary tradition, Gallehault occupies a well-known position in Dante's *Divina Commedia* as well. In the circle of the lustful in the *Inferno*, Francesca da Rimini explains to the pilgrim how her own tragic love affair with Paolo was mediated by the reading of the tale of Lancelot and Guinevere, "Galeotto fu il li-

bro e chi lo scrisse" (Gallehault was the book and its writer).[3] In Dante's famous line, the distinction between subject positions is blurred: Gallehault is both the book and the writer of the book. He occupies two places that are normally discrete. The flexibility demonstrated by Dante's Gallehault is maintained when Boccaccio appropriates the figure. The fact that Boccaccio's book begins with this allusion gives us a strong hint that subject positions in the following text will be fluid. As we shall see, the possibility of multiple and changing identificatory positions is played out again and again throughout the various levels of the *Decameron*'s narrative. The advantages of this kind of identificatory paradigm for the feminist approach taken up in this book have been discussed at length in recent feminist film criticism. In her book *The Future of an Illusion*, Constance Penley explains, "[a]s a model for understanding identification in relation to sexual difference, the feminist interest in this structure of fantasy lies in the fact that such a model does not dictate what 'masculine' or 'feminine' identification would be or how an actual spectator might take up any of the possible positions."[4]

In addition, by naming Gallehault as the father of the book, Boccaccio implies that the tales it contains are being proffered specifically as an impetus for lovesick and loveless women to engage in verbal intercourse with the text (with the possible result of following the example of Paolo and Francesca). This idea is pursued at length in the Proem, where Boccaccio explicitly addresses the collection of stories to ladies afflicted by love. He claims to desire to attend to their pleasure by helping them into and out of love relationships. This offer to make the book an erotic mediator for the reader provides an interesting opportunity to explore the possibilities available in the dynamic rapport among the positions occupied by the reader, the writer, and the text.

Boccaccio's *Decameron* has managed to remain delightfully enigmatic through centuries of critical readership. Conflicting scholarly interpretations as well as a wide array of varying visual representations of the stories attest to the rich possibilities offered by the book. In addition to the illustrations in manuscripts, innumerable visual representations of Boccaccio's tales have been made, including frescoes, *spalliere, cassoni*, tapestries, painted canvases, engravings, sculptures, birth trays, and vases. The proliferation of visual responses to the *Decameron* that has continued

throughout its history and the attention many Boccaccio scholars address to the visual cues in the *Decameron* indicate that Boccaccio's book is imbued with visuality. This may be partly because much of the humor in the *novelle*, or tales, is based on "sight gags," and partly because Boccaccio's rhetoric lingers on descriptive detail; in any case, there is ample evidence of an immanent visuality in the language of the *Decameron*.

Historically, very little scholarship has dwelt on the different visual representations as a means of shedding further light on the tales. This reluctance to use verbal and visual texts that share common themes, issues, and ideas to illuminate each other is not peculiar to Boccaccio studies; rather, it seems to reflect a particular historical bias in scholarship that regards visual representations as secondary and subordinate to verbal texts. Recently, however, scholars have demonstrated the potential for critical insight offered by the juxtaposition of works of visual and verbal art.[5] This movement toward integration of the verbal and visual fields opens up fresh and interesting perspectives in scholarship.

Although the scope of my study includes visual representations inspired by the *Decameron* as well as the book itself, I do not intend to imply thereby that the *novelle* are more important. The fact that Boccaccio's book chronologically precedes the visual pieces does not mean that the book should be given greater weight in an interpretation that compares verbal and visual representations. Nor does it imply that there is an inherent superiority in the book's ability to convey the subject matter. Consequently, this study will consider the paintings, illuminations, and a film inspired by the *Decameron* as texts in their own right, as well as resources for the interpretation of the *novelle*. A dialogue, rather than a source–imitation/illustration relationship, is the model I will adopt in considering the interaction between the *Decameron* and the visual representations.

In this analysis, I will pay special attention to the central role of women in the *Decameron*. In addition to the fact that the book is dedicated to women in the Proem, the *Decameron* abounds with female characters who exist in a wide range of social, economic, and interpersonal circumstances. Boccaccio's female characters are not exclusively relegated to the more typical medieval characterizations of women as saints, whores, subordinates, and chattel. Because many different positions are

taken up by women in the *Decameron*, my theoretical approach, which is concerned with the spectrum of subjectivity in representation, is challenged and facilitated by concentrating on the female roles. Yet, this is not to claim that Boccaccio was a protofeminist. The representation of women in the *Decameron* is frequently complex and troubled, and even though the female characters are much more interesting than those found in the standard literary fare of the time, the *Decameron* includes several arresting examples of female characters who suffer severe oppression. Dramatically divergent critical receptions of the presentation of these women attest to the importance and vitality of the female presence in the *Decameron*. I will investigate the notion asserted by some critics that certain characterizations of women in the *Decameron* are consonant with the text whereas others are disruptive (e.g., in the tale of Griselda, her extreme masochism and her husband's extreme misogyny have fueled critical controversy for six hundred years) in order to question the very definitions of "normal" and "deviant."

In this project, I will take a feminist position and use literary critical, psychoanalytic, and film theories to investigate the various versions of the *Decameron*. Taking these interpretations as a point of departure, I will examine recent critical work that explores the relations between visual and verbal arts. In this endeavor I will adopt tools from the disciplines of literary theory, film theory, and art history in an effort to expand the scope and insight of interpretation by considering perspectives and approaches not commonly brought to bear on the usually independent disciplines. By "crossing over," I intend to investigate the extent to which the narrative is perceived as serving to repress or contain the image, and the extent to which the image may elude or subvert the narrative. Questions of viewing and voyeurism, frames and boundaries, and syntax and ambiguity will be addressed. Each text will be accorded an independence from the others, rooted in its own specific historical and social context. The selections I have made in determining the shape of this book are based on my desire to reflect on the interpretative liberties and restrictions inherent in the various media under consideration.

I will begin the book with a chapter on the tale of Griselda (*Dec.* X, 10). In the past six hundred years much ink has been spilled over the interpretation of Boccaccio's "tale of misogyny," and it is this provocative

quality that makes the last *novella* in the book an auspicious beginning. The potential advantages of this organizing strategy are particularly evident for those readers who agree with Marcus's assertion that when the reader reaches this final, difficult, and contradictory story, he or she is inaugurated into the realm of independent readership (i.e., is no longer given guidelines with which to determine the meaning of the story but must instead interpret it for him- or herself). In this sense, we can see that the Griselda story is a crucial moment in the book. Additionally, by beginning a study of interpretation with a text as rich as this tale, we are given great latitude to examine the complexities of the reader–viewer–text relationship. I will approach the tale of Griselda with the tools of narratology and psychoanalysis in order to delineate the emphasis on subjectivity in my interpretative practice throughout this book.

The second chapter explores the insistent visual aspect of the *Decameron* by concentrating on the specific relationship between words and images in an obvious place: illustrated manuscripts of the *Decameron*. My approach to the illuminated manuscripts draws upon Claire Richter Sherman's notion of "codicology"[6] and what Stephanie Jed calls the "new paleography."[7] By this I mean that the material production of the text (including surface, tints, layout, script, and design as well as patronage and audience) will be considered in interpreting the aesthetic as well as historical and cultural significance.

The first manuscript editions of the *Decameron* were widely read and copied by a large segment of the Florentine population. From the prologue to Day Four and the "Author's Conclusion," it is possible to infer that the text was distributed and commented upon even as a work in progress. The narrator's rebuttals of criticism imply a diverse and eager public, and, although the narrator addresses only the negative responses to his text, it is clear from the number of copies of the *Decameron* dating from this period (the late fourteenth century) that there was a sizable and equally engaged community of *Decameron* fans. The text's audience ranged from the most wealthy and educated literati to the solidly bourgeois mercantile class and extended even to less educated segments of the population. In his "Boccaccio visualizzato," Vittore Branca emphasizes the extreme popularity of the work, characterizing the book's early readers and copyists as "impassioned" and "fanatical" mer-

chants, who "stole hours from business and sleep in order to personally transcribe the text."[8]

In the second chapter, I will rehearse the deconstructive move that questions the hierarchical relationship between word and image in manuscript illustration. The Franco-Flemish miniatures that are the visual texts for this chapter are a particularly interesting case in light of their doubly "derivative" categorization; first, they are traditionally discounted with respect to the written text, and second, they are considered a "minor" art. Otto Pächt, who argues for the consideration of miniatures in their own right, concedes that "it is probably inevitable that manuscript illumination continues to be looked upon as a stunted form of monumental art even by those who fully understand that the name 'miniature' painting originates not from *'diminuere'* (to reduce) but from *'minium'*, a frequently used red pigment."[9] The examples I will consider are illuminations for the story of Tancredi and Ghismunda (*Dec.* IV, 1). These illuminations offer intriguing possibilities for understanding an undercurrent in Boccaccio's text that is deeply concerned with, and ambivalent about, the function of vision (both licit and illicit) and concealment. In Boccaccio's *novella*, the association of vision with knowledge and of knowledge with both power and love (although not always at the same time) leads to startling consequences. The illuminations provide a gloss on the power and love relations in a father–daughter–lover triangle while overtly challenging some of the subtle endorsements the rhetoric of Boccaccio's text extends.

After considering the relationship between words and images on the same page, the third chapter turns to a series of paintings by Botticelli that was inspired by the story of Nastagio (*Dec.* V, 8). These paintings, which repeatedly depict the most violent and coercive episodes of the *novella*, were commissioned as *spalliere* (wall panels) to adorn the bedroom of a newlywed couple. The paintings were designed by Botticelli, who, with the help of his studio artists, completed the series. The segmentation of the *spalliere* (made up of a group of four separate panels) would seem to have lent itself to the serial depiction of the narrative of the entire *novella*, yet this is not the case. Instead, Botticelli chose to paint scenes in which a knight's furious pursuit and violent murder of a naked woman in a *caccia infernale* (hell hunt) appears on three of the four pan-

els, even though the *caccia* is described only once in the *novella*. (The *caccia infernale* is a literary form in which particular sins are punished in hell by the staging of a hunt and the slaughter of the sinner.)

Interesting discrepancies exist between the verbal and the visual representations of the tale of Nastagio; details from Boccaccio's *novella* are omitted or changed in the paintings, and Botticelli adds several literary references to his work that are absent from Boccaccio's text. Independently, each of these versions of Nastagio's story provides ample opportunity for us to question the motivation and logic of the *caccia*'s cruelty, and when juxtaposed they allow us to reconstruct and interrogate the premise of guilt on which the genre depends. I will argue that the text offers the possibility of a subversive reading of its overtly didactic content. The fact that Boccaccio's *novella* allows for the contradiction of its overt project, while simultaneously calling into question the integrity of the conspicuous "heroes," provides the reader with the opportunity to develop an interpretation wherein the significance of the *novella* does not rest exclusively on the male bias so strongly apparent on the surface of the story. Instead, an interpretation sensitive to the irony in the story can posit a narrative that does not make absolute claims to the Christian truth proposed by the internal narrator. Such an interpretation calls into question not only the logic of the story but the position of the reader of the text and the viewer of Botticelli's paintings as well. As a result, the reader's position becomes ambiguous (in the context of the *caccia*, does one identify with the victim, the victimizer, or the voyeur?) thus providing for shifts among gender roles and power positions.

The fourth chapter will look at the late Italian author and filmmaker Pier Paolo Pasolini's 1973 film *The Decameron* and incorporate the theoretical elements discussed in previous chapters in an interpretation of the film's version of Boccaccio's text. Pasolini's film provides a unique occasion to consolidate my investigations of the relations between the verbal and visual representations of the *Decameron*, because it incorporates elements of the written text and of painting and is itself an entirely different verbal and visual medium. Although Pasolini's film provides some remarkably literal renditions of the *novelle*, it also diverges drastically from the book Boccaccio wrote. First of all, Pasolini completely rearranges the frame narrative in Boccaccio's work. In addition, he selects

only ten of Boccaccio's one hundred tales to represent, complementing these with ten of his own invention. Also, the *novelle* Pasolini takes from Boccaccio are radically changed when he centers the action in Naples and integrates the characters from the stories into segments of his frame narrative. In a further delicious complication, Pasolini, the film's director and screenwriter, himself plays the role of the famous Florentine artist Giotto di Bondone, who, in the fiction of the film, is shown producing a fresco and presides over the transitions from one story to the next in the second half of the film.

The fourth chapter will explore how the figure of the artist and his work are represented in Pasolini's and Boccaccio's versions of the *Decameron*. Comparison between Giotto in the film and the authorial voice in the *Decameron* bring to the fore the status of fantasy, imagination, and play in the two works. In my investigation of these key issues, I will turn to the Boccaccian character Calandrino, who embodies a particular version of the artistic imagination common to Boccaccio and Pasolini. This exploration of the theme of artistic creation, and particularly of visual representation, nicely condenses many of the issues at the center of my inquiry into comparative arts strategies.

Finally, in the last chapter I will expand my analysis of the role of the artist in Pasolini's film. In the first four chapters I develop a feminist reading of the verbal and visual texts, concentrating on the meaning engendered by sexual difference. In this final chapter, I shift gears and explore the homosexual sensibilities in the text, extending my interpretation to include the first half of Pasolini's film. Here I contend that Pasolini's *Decameron* represents a fantasmatic negotiation of his homosexuality, an eroticism that is intimately informed by the homophobic and heterosexist culture in which it developed. I discuss Pasolini's use of film techniques such as the embodiment of a "cruising" gaze with the "eye" of the camera, and the infiltration of high art pastiche, in the form of tableaux vivants, in the ostensible narrative of the film. I argue that these two elements characterize the particular homosexual aesthetic in the film. Further, I discuss how this homosexual aesthetic works against the narrative impulse toward coherence in a manner that both indicates the homosexual investment in the film and sublimates its literal expression.

In this last chapter, I argue that in Pasolini's *Decameron* the representa-

tion of Giotto's artistic vision is distinctly nonnarrative. In this respect, Pasolini's negotiation of the questions surrounding the verbal–visual dichotomy in his representation of Boccaccio's *Decameron* differs in essential respects from the way these issues are addressed in the works discussed in the other chapters of this book. For example, Pasolini's active participation in the fragmentation and scattering of narrative meaning stands in sharp contrast to Griselda's husband's "transformative" gaze and its accompanying performative language. Gualtieri's attempts to fix meaning by imposing categories of behavior and address on Griselda represent an effort to generate order and coherence from a position of instability through his use of vision and language. In an effort to firmly establish his own position in a patrilinear family history, Gualtieri seeks to make Griselda over, for and through the affirming gaze of his vassals and subjects.

Somewhat differently, in both the visual (illuminations) and verbal versions of Tancredi's and Ghismunda's story, the representation of vision corresponds to an effort to impose a coherent narrative of political power and the doctrine of courtly love on unruly physical and emotional desires. Significantly, the rigid strictures of the courtly love tradition, which ultimately developed into the ideology of Romantic love, are sustained by a coherent psychological fiction. In Boccaccio's tale of Tancredi and Ghismunda, courtly love and political power are articulated in a shared verbal and visual field, and the overlap between the verbal and visual rhetoric gives rise to the dangerous transgressions that shape the movement of the tragedy. When the prince's paternal and political supervision turns into voyeurism in his invasion of Ghismunda's bedroom, where he witnesses the consummation of courtly love, the stability of the political and amorous institutions is undermined. Unlike Pasolini's tableau vivant of the Last Judgment, here in Tancredi's realm the reigning figure of optical competence is unable *not* to look and consequently, unable not to know. Significantly, although Tancredi's invasive vision and actions lead to tragedy, they also serve to reestablish his control over his dominion.

Finally, in the tale of Nastagio and Botticelli's paintings, discussed in the third chapter, visuality works to define and support narrative coherence. In contradistinction to Pasolini's use of painting, Botticelli's panels

endorse and enhance the overt didactic message of Filomena's tale by changing certain potentially subversive details in Boccaccio's text in ways that eliminate ambiguity. Similarly in Boccaccio's *novella*, although the imagery works to subvert the moral of the story, it does so only by calling upon the gemlike narrative perfection of Dante's *Divine Comedy*. Indeed, the imagery in Boccaccio's tale that questions Filomena's morals is based on Dante's particular form of punishment, known as *contrappasso*, a visually sensitive system, dictated by a Christian hierarchy, wherein the punishment for a given sin figurally fits the crime. In fact, the institution of *contrappasso* so rigorously forges the visual and the verbal elements that bodies become walking puns and metaphoric language the most excruciating physical torture.

The readings in this book demonstrate the critical insight that we can gain into how vision functions as power in the construction of gender by comparing different media representations of a particular story. In addition, these readings examine how visuality in the *Decameron* and the visual representations of the *novelle* bring up questions of privilege and power relations and thus allow a reader to investigate the possibilities for change within those structures.

BEASTLY GUALTIERI

ANOTHER AUDIENCE FOR THE TALE OF GRISELDA

THIS FIRST CHAPTER examines the story of Griselda and Gualtieri (*Dec.* X, 10) in an effort to delineate the specific means of expression and interaction among the characters in the *novella*. On the basis of this reading, I will focus a critical eye on the ideologies (political, economic, and social) carried by the language of the *novella*, concentrating on the dynamics of the relationship between Griselda and Gualtieri. Specifically, I will discuss how the notions of paternity, maternity, and conjugal bonds dominate the action in the story and give rise to the controversy that permeates the *novella*'s critical reception.

This chapter explores how Gualtieri's relentless "testing" of Griselda exhibits anxiety about the possibility of fixing meaning and determining interfamilial relations, and how this anxiety bleeds into specific critical responses to the tale on the level of interpretation. By this I mean that the critics who have chosen to allegorize the tale, and in doing so underwrite Gualtieri's behavior by likening him to God testing Job, Mary, or Jesus, suppress, to a certain extent, the anxiety regarding familial relations evident in Boccaccio's *novella* by overprinting the secular household with the Christian "mystical" family structure. It is my contention that ultimately, when examined in detail, this allegorical template proves unstable as well, rooted as it is in problematic familial and pedagogical relations.

The text under consideration is the last tale, told on the tenth and final day of storytelling in the book. As the *brigata* (the seven young women and three men who have fled Florence to escape the plague and

have passed the time by telling the stories in the *Decameron*) come to the end of their sojourn outside of Florence, "King" Panfilo has declared that the stories for the final day are to "concern those who have acted generously or magnificently in affairs of the heart or other matters."[1] The stories told on this day tend to assume the posture of *exempla* showing how various characters strive to be recognized as magnanimous.

The final story is told by Dioneo, the one member of the *brigata* who, from the beginning of the book, has claimed impunity from the dictated topic of the day. Rather than follow the themes established by the monarchs, Dioneo consistently tells bawdy stories, which draw embarrassed and titillated responses from the ladies of the *brigata*. Dioneo prefaces his last story with an obscene allusion and by proclaiming that his story is not intended to be an *exemplum*. In fact, he declares that it concerns a man who performs deeds "of insane cruelty, which, while good did result from it in the end, I would never advise anyone to follow as an example, for I consider it a great shame that he derived any benefit from it at all."[2]

The story that follows involves a man named Gualtieri, who is the marquis of Sanluzzo. As the tale begins, Gualtieri is a bachelor who enjoys his unmarried state. However, his happiness is interrupted by his subjects, who declare a need and desire for Gualtieri to get married in order to produce an heir, so that they will not be left without a master. Gualtieri reluctantly responds, saying he will select a wife on condition that they accept and honor his bride no matter whom he chooses. At this point in the *novella*, Gualtieri proceeds to make arrangements with the father of a young peasant woman who had long since caught his eye. Once preparations for the nuptials are complete, Gualtieri collects his friends and subjects and informs them that he has chosen his bride. An enormous cortege accompanies him to the woman's house, where the strange ritual that culminates in their wedding takes place. First, Gualtieri calls out her name, "Griselda," and asks her if she will always be obedient to him. Griselda simply assents. Next, Gualtieri has Griselda stripped naked in front of the entire company and has her dressed in garments he has prepared, and then Gualtieri performs the ceremony in which Griselda consents to be his wife. Griselda is then taken back to Gualtieri's home, where elaborate feasts ensue.

Dioneo describes how, over the course of time, Gualtieri's subjects overcome their initial misgivings and determine that Griselda is a wonderfully noble and obedient wife and that they are pleased to have her as their lady. Griselda gives birth to a daughter and then later to a son. Everyone is delighted with the children. However, their arrival provides the occasion for Gualtieri to test Griselda's obedience, with "a long trial and intolerable proofs."[3] Gualtieri tells Griselda that his subjects cannot stand having such lowly (i.e., peasant) blood in their rulers. He then takes her children away from her and pretends to have them put to death but secretly sends them to relatives to be raised. Gualtieri is greatly pleased with Griselda's acquiescence when she delivers the children up without a complaint. Finally Gualtieri decides that it is "time to put his wife's patience to the ultimate test"[4] and so he contrives to abandon her, pretending to take a new, more suitable wife.

Gualtieri displays Griselda to his subjects, declares their marriage dissolved, and sends her back to her father. Griselda is required to leave behind everything that Gualtieri has given her, with the exception of the shift he allows her to wear to cover her naked body on her journey to her father's house. After a time Gualtieri summons Griselda, telling her to prepare his home for the arrival of his new bride. Gualtieri sends for his children, ordering that his daughter be presented as his future bride. When the children arrive, his subjects decide that Gualtieri has made a "good exchange"[5] and judge his daughter to be very beautiful. Gualtieri then asks Griselda what she thinks of his new bride. She responds with praise for the child, but does include one bit of advice: "I beg you with all my heart not to inflict those wounds upon her which you inflicted upon that other woman who was once your wife, for I believe that she could scarcely endure them, not only because she is younger but also because she was reared in a more refined way, whereas that other woman lived in continuous hardship from the time she was a little girl."[6] Upon seeing that Griselda continues to obey him, Gualtieri decides to reveal his scheme, and so he declares that he is still married to Griselda and that he has brought his children back to stay with him. He explains his behavior by saying, "[W]hat I have done was directed toward a preestablished goal, for I wanted to teach you how to be a wife, and to show these people how to keep such a wife, and to give birth to my own lasting tran-

quillity."[7] Gualtieri's revelation is warmly received and Dioneo says, "[E]very man was very happy with the way everything had turned out."[8] In closing, Dioneo remarks that "godlike spirits do sometimes rain down from heaven into poor homes, just as those more suited to governing pigs than to ruling over men make their appearances in royal palaces"[9] and concludes with a bawdy comment to the effect that Gualtieri would have better deserved a woman who would have left him and taken another lover to clothe her. The *brigata* as a whole responds somewhat enigmatically, praising and criticizing various parts of Dioneo's story.

The plot synopsis provides some indication of why this peculiar *novella* has elicited volumes of critical responses over the centuries.[10] Gualtieri's sadistic manipulations of Griselda's circumstances, coupled with her remarkably passive behavior, strike the reader as somehow inadequate to themselves. The framing commentary by the *brigata* does not attempt to justify the cruelty Gualtieri inflicts on Griselda, and Dioneo's own evaluation demonstrates that he is not satisfied with the trajectory of the plot. The reader is left to somehow reconcile the notion that although this story does nothing to indicate that the events that transpire have any positive moral or social value, it ends with a "happily ever after" scenario.

Before I explore how other critics over the years have approached this apparent conflict, I will first examine the language of the *novella* in an effort to expose the specific relationships among the various characters. Obviously, in the frame narrative there are multiple agents of narration involved in every aspect of the story. For our present discussion, it is important to distinguish between Dioneo's direct speech to the *brigata*, his third-person narration of events in the *novella*, and the direct speech of the characters in the *novella* as reported by Dioneo. As we shall see, political, social, and economic authority and power are clearly at stake in the characters' use of speech, and the appropriation and wielding of that power is one of the central themes of the discourse in the *novella*.

It is abundantly clear from the text that Gualtieri presumes and exercises authority over the other characters in the story through linguistic as well as social and political means. An examination of his direct speech reveals the various types of manipulative language he employs. First, we see that Gualtieri only conditionally accepts the wishes of his subjects

for him to marry. He does not completely submit to their will and instead turns the situation around by demanding that they accept whomever he marries as their lady. From that point forward, Gualtieri alone determines what will transpire; he issues proclamations ("It is time to fetch the bride," "I have come to marry Griselda," etc.), he decides when to test Griselda and under which circumstances, and he uses performative language[11] (marrying Griselda, abandoning her, and reinstating her to her conjugal position).

In addition to actively determining all the action in the story, Gualtieri also acts as judge of Griselda's behavior. It is primarily his tone that dictates the reader's perception of Griselda. Gualtieri initiates his dominance when he calls Griselda by her name. His hailing[12] introduces her character into the *novella*, at which point she enters the realm of his discourse, which subsequently describes her sphere of signification. As Griselda shuttles between father and spouse, Gualtieri defines her social status, capriciously changing her from a peasant to a lady, back to a peasant, and then once again to a lady. In this series of flip-flops Griselda's father, Giannucole, acts as a passive polar opposite in the male discourse that debates her significance over the course of the *novella*. In short, the overriding message we, as readers, receive is that Gualtieri's opinions and ideas are the sole agents of action. Gualtieri emerges as the force that molds the story as well as the reader's perspectives.

Griselda on the other hand, says very little, aside from consenting and assenting to Gualtieri's various demands. She never initiates dialogue, and only twice does she exhibit any particular wishes other than to conform to Gualtieri's whims. It is interesting to note that on the two occasions when she asserts her opinion, she does so in language that alienates her from herself, first referring to herself as "this body" when she accepts his rejection of her, and next as "that other woman," when she is counseling him on his behavior toward his new wife. Her locution makes her sound as if she were absent from the scene of the discussion altogether. By referring to herself in the third person, Griselda effectively removes herself from the position of actor while valorizing and endorsing Gualtieri's treatment of her as an object. On the occasion when Gualtieri abandons her, she interjects her will, but only in order to prevent personal embarrassment for Gualtieri, because, as she explains, the

body that bore Gualtieri's children should not be exposed in public. In her plea, Griselda further objectifies herself by speaking of her virginity as a fungible good, begging to be allowed one shift in return for the only commodity she claimed in the world of conjugal commerce (her father and husband lay claim to her labor and children). Ultimately, Griselda defies a coherent description, because she conforms to whichever circumstances and rules Gualtieri imposes on her. Her acquiescence and passivity have to be read as absence of self-determination; she behaves indulgently, obediently, and patiently, because that is what she is asked to do.

The other characters in the *novella*, the vassals and subjects, present themselves as a very accepting audience for Gualtieri's show. Although they have little direct speech, Dioneo ascribes acceptance and general contentment to their assessment of Gualtieri's behavior. Their only act of assertion, although it precipitates the action of the story, consists of desiring the perpetuation of their position as feudal subjects. In this, their first act, they surrender social self-determination and thereafter do not achieve linguistic autonomy. For the rest of the *novella* their speech is indirectly reported by Dioneo. The power of their speech and opinion is marshaled by Gualtieri to orchestrate his testing of Griselda. The vassals are attributed only a very weak conscience, which at its most assertive complies with every manipulation and offense Gualtieri imposes. Although the narrative notes that the vassals occasionally grumble, ultimately they openly favor all of Gualtieri's machinations. Clearly, the function of the vassals is not that of arbiter nor of social conscience. Rather, I would suggest that they are present to witness the significant liminal phases of Griselda's trek (marriage, giving birth, loss of children, expulsion, and return), and in this capacity their gaze helps to solidify Griselda's position in Gualtieri's mind. Although the vassals might have acquired power from this situation, they immediately relinquish it to the usurping Gualtieri, who adopts it for his own purposes. In line with this passivity, the vassals play one of their most effective roles, *in absentia* and without their knowledge, when Gualtieri calls upon their opinion as the motivation and justification for his treatment of Griselda.

On another level, the vassals provide the story's listeners and readers with surrogate readers, because they exemplify one possible response to

Gualtieri's actions. However, this is not an easy identification for us to make. The vassals are portrayed in such a debilitated and compromised position that it is difficult to imagine a reader who would sympathize with them. Although the vassals witness the objectification and manipulation of Griselda and endorse her treatment as a medium of exchange between father and husband, most readers are disturbed by it and find it problematic. The vassals occupy a subordinate position that is socially framed and negative, and as such they exemplify one way of reading (uncritical and credulous), against which Dioneo proposes his (decidedly critical and incredulous) counterreading of Gualtieri's theme.

As I have mentioned, Dioneo focalizes the bulk of the narrative, attributing various characteristics, thoughts, and emotions to the different characters.[13] We, as readers, must be aware that the information we glean from the text narrated by Dioneo is subject to the qualification that what we are reading is Dioneo's perception of the matter. The first information we learn about Gualtieri from Dioneo is that he behaves with "insane cruelty" and that it is a "great shame that he [Gualtieri] derived any benefit from it [his behavior] at all."[14] It is also through Dioneo's narrative that we learn what Gualtieri means to do with his sadistic treatment of Griselda. The capricious attitude that governs Gualtieri's actions is clearly narrated by Dioneo: "a new thought entered his mind, he wished to test her with long trials and intolerable proofs,"[15] and that later, when "what he had done was not enough to satisfy him, he wounded her with a greater blow."[16] Through Dioneo's focalization we watch Gualtieri slowly learn to appreciate his (perceptions of his) wife's behavior. And through Dioneo we learn of Gualtieri's emotional attachment to Griselda: "[H]e felt closer to tears than anyone else there."[17]

The impression of Griselda the reader gets from Dioneo's solo focalization of her is that she is a very passive woman. In fact, the only activities Dioneo attributes to her are responses to Gualtieri's stimuli. Griselda does not act or speak on her own. Dioneo's insistence on her absolute passivity is emphasized by his attributing to her the acceptance of being ruled by the whims of Fortuna.[18] This is remarkable, because Fortune does not play a role in the reality of any of the other characters in the *novella*. In fact, the other characters actively choose their destiny and have no reliance on the whims of Fortune.

Some of the more startling revelations about Griselda are presented from the doubly mediated focalization of Gualtieri's impressions according to Dioneo. Through this complex focalization we are told that Griselda lets her children be murdered out of obedience. It is also through this focalization that we are told that she is wise. Somehow these appraisals lose impact as a result of their focalizors. Given Dioneo's remarks to the *brigata* regarding Gualtieri's character, why would we believe that Dioneo would agree with Gualtieri's notion of wisdom? Indeed, would anyone who agreed with Dioneo's condemnation of Gualtieri's behavior take Gualtieri's word that Griselda is wise? Would Gualtieri be considered wise? Or is it possible that Gualtieri's evaluation of Griselda merely reflects his desire for her obedience? It is evident in the text that as Gualtieri subjects Griselda to his sadistic whims he tends to concentrate on his own feelings about the situation, not hers. As a consequence, it would seem that Gualtieri is merely appraising a specular image in his evaluations of Griselda's behavior. It is arguable that the "tests" he inflicts on Griselda are for his own benefit, not her edification, and, as such, all emotion he expresses would then be the self-indulgence of solipsism rather than the loving care of a spouse.

Griselda's compliance with all of Gualtieri's manipulations is reflected on the verbal level of the text. Her mostly mediated presence, punctuated by rare assents and even rarer assertions, renders her character somewhat ephemeral. As a result of Griselda's passive behavior, the reader is left with a very shadowy idea of who Griselda is without Gualtieri. It is possible to imagine a less jarring story in which a more concrete Griselda responds differently to her circumstances (and in fact Boccaccio's book contains many other possible permutations of the story of a woman subjected to a difficult spouse),[19] but the interaction between Griselda and Gualtieri in this *novella* is decidedly disruptive. In particular, the coercive quality of Gualtieri's behavior in the face of no opposition lends an uneasy tone to the narrative. In addition, Griselda's complete submission to Gualtieri's will draws attention to his emphatic sadism. Gualtieri's relentless pursuit of ever harsher means of "testing" Griselda drives the reader to question his motivation. One wonders what, precisely, Gualtieri is looking for in his wife. As Griselda demonstrates that she is willing to yield to his every demand, Gualtieri search-

es for yet another, more difficult position for her to assume. First he makes her a wife, then a mother, then an accomplice in the murder of her own children; then he divests her of the very position for which she has made all the other adjustments; and finally he makes her act as a servant in a ritual that will definitively exclude her from her past, only to reverse the role in midexecution and make her his wife again. By driving Griselda to the extremes of his imagination, one gets the impression that Gualtieri is striving to find a "test" that will prove that Griselda has limits — one that would demonstrate that she cannot conform to all his whims — almost as though, if Gualtieri were successful in proving her limits, he would thereby effectively fix her meaning.

Gualtieri's attempts to pin Griselda down with intensifying resolve foreground her elusive and unstable significance. Griselda's utter passivity and slippery subjectivity function to elaborate a structure in the narrative that is analogous to the semiotic framework. In this sense, Griselda's character conforms to the lacanian notion of a signifier, subject to the endless play of signifiers, with no possibility of absolute anchoring.[20] Likewise, Gualtieri's testing of Griselda is an attempt to fix meaning — however provisionally or conditionally. In this analogy, definition of Griselda's value emerges as she is traded back and forth between her father and Gualtieri. Her meanings change as a consequence of her displacement along the signifying chain constructed of and by men.

The uneasiness generated by Griselda's floating status is accompanied by a significant absence in the story: Griselda has no mother.[21] The one person who could anchor Griselda's identity at the beginning of this game of patriarchal Ping-Pong is nowhere to be found. Her mother's absence is important, because although paternity and conjugal fidelity are always subject to doubt (particularly in the minds of males interested in conferring their patrimony on genetically related individuals), maternity is evidence of a fixed interpersonal tie. The absence of a mother leaves the possibility of absolute identification completely up in the air. And perhaps it is this uncertainty that motivates the extremity of Gualtieri's sadistic actions. Interpreted as a question of semiotics, the harshness of the "tests" could be construed as an attempt to place, name, assert, or establish some ultimate significance that is elusive within the normal circulation of identities.

Within this context, Gualtieri attempts to establish a final test to prove his wife's credentials and his own claim to secure paternity. His efforts to generate order without any ground is, of course, futile. Nothing he can do will absolutely establish his dominion over either Griselda or her children. In his bizarre exercise of power and authority we see that something more important to him than the fate of a woman and her children is at stake. In fact, it is his own identity that Gualtieri attempts to nail down with his cruel "tests." In effect, his efforts are directed at establishing his own identity through his violence against Griselda. For Gualtieri, Griselda figures the unfixed state he himself occupies; all the rites of passage Gualtieri subjects her to (naming, undressing, dressing, abandoning, and embracing) are only relative. Griselda as much as says this when she tells Gualtieri, "[T]he position I have held with you I have always recognized as having come from God and yourself, I never made it mine or considered it given to me – I have always kept it as if it were a loan."[22]

Among the various trials to which Gualtieri subjects Griselda, she is able to transgress one of society's most emphatic interdictions by consenting to the murder of her own children. This is not simply the cruelest test Gualtieri could devise but one that is motivated by a desire to cancel her relationship with her children. This is important, because although Griselda is willing to transgress this most taboo of barriers, Gualtieri, who occupies a very different kind of position, is not. Although he feigns infanticide and incest, Gualtieri does not actually commit either. This is because paternity is, in fact, the floating signifier, and, consequently, Gualtieri aspires to the anchoring that Griselda can do without. He attempts to anchor himself by unanchoring Griselda, but in this he cannot succeed once she is a mother.

Gualtieri's anxiety regarding paternity permeates the *novella*. When the story begins, Gualtieri is referred to as the "maggior della casa, un giovane,"[23] a young fellow who has not yet fully assumed the role of patriarch in spite of the absence of any parental figures. In this somewhat liminal state, as a footloose, free-floating bachelor, he amuses himself by hunting. At the first request of the vassals that Gualtieri start a family, he expresses skepticism regarding connections between parents and their children: "And to say that you can judge daughters by examining the

characters of their fathers and mothers . . . is ridiculous, for I do not be-
lieve that you can come to know all the secrets of the father or mother;
and even if you did, a daughter is often unlike her father and her
mother."[24]

Gualtieri's misgivings regarding filial ties is extended to a more gen-
eral anxiety about the security of family relations in his reluctance to be-
lieve that his wife could be, as she appears, perfectly suited to him. As a
result of his doubts, Griselda is put through the "tests" designed to show
her how to be a good wife in spite of the fact that she has never been
anything but exemplary. Further, when Griselda gives birth to her chil-
dren Gualtieri attempts to obliterate the ties that bind the mother and
child by pretending to have the children murdered and sending them
away from her. Gualtieri's insecurity about his ability to concretely es-
tablish familial ties (absent his parents and the ability to actually give
birth to offspring) leads him to sow chaos. It is telling that at the end of
the *novella*, after all the havoc he has wrought, Gualtieri claims to have
acted as he did in order to "give birth" to lasting tranquillity in his mar-
riage to Griselda.

As I have noted, the question of the meaning of this tale of Griselda
has been the subject of critical controversy. The fact that this *novella* is
known as "Patient Griselda," not "Beastly Gualtieri," is an indication of
the tenor of much of the scholarly criticism responding to the tale. At
this point, I would like to review some of the approaches critics have
adopted in interpreting the story and attempt to relate them to my read-
ing of the *novella*.

To begin, while Boccaccio's contemporaries provided a large quanti-
ty of critical feedback for the entire book, by far the most influential as-
sessment of this *novella* from his peers came from Petrarch, who translat-
ed the Griselda story into Latin.[25] In a letter to Boccaccio, Petrarch
mildly chastises him for wasting his talent by writing frivolous tales in a
vulgar language. However, by translating it Petrarch salvages the Grisel-
da story, because he feels that it alone is worthy of his attention. Petrarch
includes some critical notes in his translation in which he asserts that he
is unconvinced by the literal level of events of the *novella* and instead
prefers to read the fiction as a double didacticism: both secular and reli-
gious. The secular moral he attributes to the tale is articulated in the sub-

title of his translation, "De obedientia ac fide uxoria mythologia." The religious message Petrarch claims for the *novella* resides in a Christian framework he assigns to Gualtieri's and Griselda's marriage, which he claims exemplifies the intense devotion that should bind the soul to God. Petrarch's editorial efforts serve to foreground and concretize the misogynistic potential of the text through the moral and religious justifications offered to explain Gualtieri's sadism. As a consequence of reducing the complexity of the text in order to present it as yet another Christian allegory, Petrarch obscures the unsettling and subversive potential of Boccaccio's story. By tailoring the text to comfortably fit the form of Christian allegory, Petrarch narrows the range of meaning offered by Boccaccio's *novella*.

Petrarch's translation represents a political and aesthetic move that endorses Christian hierarchy and patriarchy as cultural institutions as well as holding up Latin as a superior language for literature. The advantages gained by Petrarch's revision of Boccaccio's story are considerable. The endorsements implicit in the editorial choices effected are obviously made at the expense of people who do not exercise power in these institutions (women, children, the poor, non-Christians) as well as non-Latin expression (i.e., Italian). Rather than endorse this allegorizing rewriting of Boccaccio's *novella*, I want to explore briefly the effect such a reading/writing has had on subsequent criticism. It is important to recognize that it is possible to read the tale in a way that lets us see how it exposes specific ideologies both in the text itself and the criticism associated with it. The strategy I intend to use involves locating gender relations as real, material power relations in the world. I want to argue that we can use this perspective to circumvent the Christian allegorical view and thereby allow a feminist discussion of the misogyny inherent in those ideologies.

In her discussion of mythmaking and the *Oresteia*, Froma Zeitlin provides a helpful gloss on the effect of ideological writing/rewriting:

Psychic impulses compel the creation of the myth, but once objectified and projected outward, the myth reinforces, legitimates, and even influences the formation of those impulses by the authoritative power of that projection, especially when it is embedded in a magisterial work of art. There is a continuing reciprocity between the external and the internal, between individual psyche

and collective ideology, which give myth its dynamic life far beyond the static intellectual dimension. By uncovering the apparent "logic" that informs the myth, we can both acknowledge the indispensable role of myth and myth-making for human cognition and at the same time lay bare the operations by which it organizes and manipulates reality.[26]

In my attempt to "lay bare" the ideologies in particular readings of the *Decameron*, I am trying to deconstruct the traditional meanings in order to demonstrate the possibility of a different kind of reading of the tales. I am certainly not interested in establishing yet another dominant (exclusionary) interpretation of the *novella*; rather, I want to assert a negation of that dominance, and of the political, economic, and social systems that inhere in it.

From Petrarch on down through the ages, controversy over the meaning of the tale of Griselda has continued. In her book *An Allegory of Form*, Millicent Marcus summarizes the critical debate regarding the Griselda story as follows:

[C]ritics fall into two camps: those who make their uneasiness into an interpretive tool, citing the narrator's own internal criticism of the story as the justification for their reading, and those who explain away their own uneasiness by construing the literal level as a vehicle for allegorical truths. The first group reads horizontally, seeking meaning in the tension between the narrator's commentary and the tale itself, while the second group moves vertically from the literal to the allegorical levels of meaning.[27]

Clearly, Marcus attributes divergent readings to the critics' methods for dealing with the uneasiness the text engenders. By pointing to differences in interpretation, she raises the next question: How do readers read the text? And from this point, we might ask, How does our discussion of focalization and the use of language in the tale help us to understand which position a given reader will take on this issue? To begin, it is apparent from the literary criticism that readers see the *brigata* as the group with which they are supposed to identify. That is, the critics respond to Dioneo's statements that he is going to tell a story about a cruel man not by wondering if it is true but by seeing this as a hint to view Gualtieri's actions critically. Further, the critics' evaluation of the *briga-*

24

ta's response to the story as Boccaccio delineates it "the ladies, some taking one side and some taking the other, some criticizing one thing about it and some praising another, had discussed the story at great length,"[28] is to propose varying interpretations, introducing polemical points of view and generally attempting critical readings of the *novella*.

The persistence of divergent interpretations over the *novella's* long critical history is not anomalous, given the generally shifting and contentious character of literary criticism. In fact, it is difficult to imagine any particular interpretation satisfying the critical interest of all readers over time, simply because as each reader brings his or her own particular interpretative insights to the text the number of possible readings increases. So, even if we accept the notion that a reader of the *novella* will on some level identify with the *brigata*, the question of how he or she will interpret the text is still an open one.

To further consider the practice of interpretation, we must explicitly account for the subjectivity of the agency of reading (the reader). We cannot presume an "objective" or constant subject, who unproblematically is able to assimilate and interpret the text before him or her. Rather, we must allow for an actual individual (like myself), who, at a given point in time, with a specific material background and political disposition, will attend to the text. Additionally, a relationship between reader and text is complicated by the kaleidoscope of subjectivities within the text with whom or which a reader might identify. Kaja Silverman explains in *The Subject of Semiotics* one theory of how this relationship plays itself out, namely the theory of "suture." I would like to introduce here a brief summary of her theory in order to continue with a reading of Griselda and Gualtieri's story.

Silverman's theory describes the relationship between a reader and a text in terms of a lacanian paradigm in which the reader is aware that he or she lacks absolute power (the power of the phallus). The theory of suture addresses the anxiety a subject experiences in this position of powerlessness on the level of narrative and theorizes the motivations for the reader's identification with the text. According to Lacan, a subject constitutes itself through speaking, yet, because the subject is born into preestablished conditions (the symbolic register) of social position, culture, gender, and so forth, it is also spoken (i.e., it inherits desires and

language from the symbolic register). The theory of suture attempts to account for the means by which subjects emerge within discourse. It claims that on the level of the text, a reader is aware of the limitations established by the text itself to which he or she is subject (i.e., the reader is able to know only what is in the text). As a consequence of this realization, the reader is made aware that he or she does not have access to all information and, in response, posits an absent field of signification, one that he or she is not being shown. The author, who controls the fictional world, represents a lacanian "other" for the reader, who attributes to him or her qualities of potency, knowledge, transcendental vision, self-sufficiency, and discursive power. The reader is alienated from this hypothetical "other," because as a reader of the text he or she has no influence over the author. Thus, the "speaking subject" (the author) has what the "spoken subject" (the reader) lacks and desires. The theory of suture posits that in response to this perceived lack, the reader engages in a complex signifying chain of narrative that serves to "suture" the "wound" he or she feels as a spoken subject.

According to this model of suture, it is important to remember that only the recognition of the lack by the spoken subject creates the desire in him or her for the restoration afforded by meaning and narrative. This desire is addressed when the spoken subject is interpellated by the subject of speech (e.g., by identifying with a character or some other aspect of the text). One of suture's chief aims is therefore to define a discursive position for the reader that necessitates not only a loss of being but the repudiation of alternative discourse, because only in this way does the reader misrecognize him- or herself as achieving the qualities of potency and knowledge.

To address the question of suture in the tale of Griselda, we must ask how the reader is interpellated into the *novella*. Because the story displays a strong emphasis on gender and class distinctions, does this mean that in order for the reader to achieve suture, he or she should identify with the controlling figure of Gualtieri and participate in the relay of male gazes from the reader's voyeurism to the gaze of Gualtieri that transforms Griselda? Fortunately, the text does not encourage such a simple solution, because it openly calls into question the position Gualtieri represents. However, the character of Griselda presents an equally disturb-

ing alternative. How can readers ameliorate a sense of lack by identifying with a manipulated and abused character? Griselda's very nonidentity, nonsubject is threatening on that level. Should we, as Laura Mulvey might suggest,[29] fetishize the very lack that Griselda represents, transforming her into a phallic representation? Or can we seek solace in another of Mulvey's suggestions, by privileging lack and passivity over potency and aggression? Or can we simply explain away Griselda's treatment by blaming her for having provoked it?

As we shall see, the answer to all these questions is no. These strategies would allow the reader to respond in complicity with the narrative, in other words, to experience suture. However, the representation of Griselda is too extreme to be acceptable and is instead profoundly disruptive. Readers of Griselda's story are not lulled into a feeling of power and omniscience, as suture would have us be. Rather, the disturbing aspects of the *novella* encourage the reader to refuse cultural reintegration (suture's goal) and to prefer lack or alienation to the false plenitude of a subject who mistakenly believes she or he is like the "other." The critics' uneasiness represents a form of resistance to a system that defines woman as powerless and lacking. This is not to say that Boccaccio or his readers are feminists. Rather, it suggests that Boccaccio presents us with such a disturbing story that it is difficult to accept on any grounds. As readers, we are not content with our understanding of the tale of Griselda, and we find it uncomfortable to identify with any position available in the text. Obviously, identification with Griselda would not provide the delusion of power, and although Gualtieri is perhaps to be envied for his power, he is ultimately not sympathetic because of his irrational behavior. At the same time, we cannot accept the vassals' complacency in the face of Gualtieri's behavior, because as surrogate readers they present a negative example of how to respond. And finally, the *brigata*'s response is ambiguous, its members provide no clear resolution of the significance of the story.

The critics have clearly followed the *brigata*'s example by fueling controversy without reaching a final answer. And perhaps this is the best that we can do. However, we can still address the question of how different readers are able to interpret the text differently and what it means to leave the situation unresolved. Even if suture is not successful (if we are

not able to identify with particular positions in the text and remain convinced that our identity is stable), it does not mean that the story's dynamics are inappropriate. In fact, given the lacanian framework that says that the subject is always lacking, ruptured suture is an appropriate condition for the reader.

To return to Marcus's two critical camps, now we can see that their uneasiness might be attributed to ruptured suture. As we have already considered at some length, the critics who use their uneasiness as an interpretative tool do so in response to the challenge to the authority of the text by characters within the text (in this tale, that by Dioneo and the *brigata*). They take the stance that if a text allows one of its characters to question the veracity of its content, then there is no position of truth available to the reader. This argument logically states that by adding an ironic tone to the discourse of authority, the writer makes it impossible to take the authority at face value. This position gives rise to a reading of the text neatly summarized by Marcus:

[H]e [Boccaccio] writes displacing the didactic power of the word from the printed page to the mind of the reader. Indeed, nowhere is the public's responsibility made more obvious than in the final tale, as the author denies the possibility of closure and refuses to privilege any one interpretation over all others. By now Boccaccio deems his readers expert enough to determine for themselves the meaning of a text which remains so provocatively inconclusive ... [Readers must have] [t]he ability to entertain a plurality of perspectives, the understanding that significance inheres not in the content of the work alone, but also in the various aspects of its form, the knowledge that literary discourse is unstable.[30]

But what about the critics in the other camp, the ones Marcus relegates to vertical interpretation? What is their relationship to the text? How do they resolve the problems of ambiguity? It would seem that critics who take up the position that the text is an allegory base their claim on the absolute authority of God and on Scripture as the ultimate Signified. It would appear that their uneasiness with the literal level of the text is assuaged by their belief that although they are not privy to the Truth, their faith allows them to believe that it exists.

What in the story of Griselda would induce a reader to make this kind of interpretation, given that Boccaccio's narrator clearly states in the

"Author's Preface" that his project is a secular one?[31] In a close reading of the tale, the allegorical interpretation is supported textually by the christological attitude and language exhibited by Griselda.[32] In the *novella*, when Gualtieri asks Griselda to return to his home in order to prepare it for the arrival of his new bride, she says, "My lord, I am ready and prepared,"[33] a statement that echoes Jesus' words of submission in the Garden of Gethsemane. Since Dioneo has just explained that to Griselda the idea of preparing his house for the wedding "was like a dagger in Griselda's heart,"[34] we know that she is undergoing a difficult trial. Furthermore, there is a textual reference to Dante's *Vita nuova*, a book that develops the persona of Beatrice as Dante's path to salvation. In the *Vita nuova*, Beatrice dramatically affects young Dante with her greeting. He calls her "la donna de la salute" (punning on the multiple meanings of *salute* as "health," "salvation," and "greeting"). In Boccaccio's story, Griselda performs a similar function when Gualtieri makes her act as mediator between himself and his guests. In one of her few spoken passages, she greets her own daughter with "Welcome, my lady."[35] Through this association with the Christ-like Beatrice, Griselda can be read as a spiritual mediator, her presence and example allowing for the salvation of others.

Historically, the allegorizing critics have variously attributed to Griselda the character of Job, the Virgin Mary, and Christ, characterizations that the more recent critics (e.g., Marcus) have viewed as fundamentally different from their own. Although I do not want to claim that the two "camps" are exactly alike, I intend to argue that in fact both the horizontal and the vertical interpretations are engaged in basically the same process: that of trying to establish meaning in a text that has no explicit, final answer. Although there is no doubt that this is the position of the critics in the horizontal camp, to which Marcus counts herself as belonging, if we look a little more closely at the nature of Christian didacticism we can see that it is also true for the allegorizing critics in the vertical camp as well.

The tale of Griselda cannot lay claim to the complexity of meaning in the Christian allegory, that of having four levels of meaning: literal, anagogical, allegorical, and moral. Therefore, it seems more appropriate to call it a much simpler form of allegory called "parable." Accepting the

premise that the story of Griselda is a parable, one would think that all that was necessary would be to look to the New Testament in order to determine how the good Christian is supposed to read this story. However, in Matthew when the disciples ask Jesus why he teaches the people in parables, he replies that it is necessary "since for all their looking they do not see, and for all their listening they neither listen nor understand" (Matt. 12:13). Then, in Luke, when the disciples ask the same question, Jesus says of the people that "they look and see nothing, they listen and fail to understand" (Luke 8:10). Clearly a conflict exists. In Matthew, Christ says he speaks in parables because the people do not understand, the implication being that he does it to clarify the issues. In Luke, he says he speaks in parables so that they will not understand, the implication here being that he does it to be obscure. Perhaps we can elaborate on this conflict if we recall that in Matthew 11:6 Jesus says, "[B]lessed is he who is not scandalized [offended] by me." The word Jesus uses in reference to himself is *skandalon*, and in using this word it becomes a little more apparent that his intentions are not necessarily to be clear. According to *Vine's Expository Dictionary of New Testament Words*, the term *skandalon* was "originally the name of a trap to which bait is attached, hence, the trap or snare itself. *Skandalon* in the *New Testament* is always used metaphorically, and ordinarily of anything that arouses prejudice or becomes a hindrance to others, or causes them to fall by the way." In the New Testament, when Jesus gives opposing reasons for teaching in parables, he sets up the problematic relationship between teacher and student (and, for our purposes, text and reader). Salvation through Jesus is not a logical or rationally directed process; it is conflicting and difficult. The allegorization of Griselda is no less so. Even if critics choose to read Griselda as a parable, they are not any closer to a definitive reading than are the critics of Marcus's camp.

In the end, a reader, whether he or she engages in a secular or allegorical reading of Griselda, will end up with the same problem. Both approaches lead to a provisional understanding of the text, not to any absolute truth. And this perhaps is the conclusion we can draw here. Although we acknowledge that it is not possible to give a definitive reading of a text, it is still possible to give a reading; that is, we as readers must accept our position and proceed, continuing to examine and dis-

cuss the arcane as well as apparent associations that exist in the texts we read.

In the following chapters, we will see how ambiguity in the *Decameron* exhibits itself on the narrative level, and how ambiguity lends itself to subversive and emancipatory readings on the visual level, in the imagery in the stories, in the function of vision in narrative, and in the visual interpretations of the *novelle*.

CHAPTER TWO

ILLUMINATING METAPHORS
THE TALE OF TANCREDI, GHISMUNDA, AND GUISCARDO

IN THIS CHAPTER, I will discuss the relationship between vision and language in the tale of Tancredi, Ghismunda, and Guiscardo (*Dec.* IV, 1). My analysis is framed by an interest in the overdetermined role that vision plays in the realms of epistemology, imagination, and erotic pleasure in this tragic tale of illicit love. As I will demonstrate, conflict between verbal representation of the seen and visual representation of the spoken underlies the dramatic action of the story. I will begin by examining the role of vision in the political, erotic, and familial economies of the story. Language in the *novella* foregrounds the function of vision in courtly behavior, illicit love affairs, and family relations; concomitantly, the debate over imaginative and literal viewing within the *novella* itself mirrors the reader's own interpretative work. In order to bring this argument into sharper relief, I will examine several Franco-Flemish illuminated miniatures that accompany the tale of Ghismunda in several early manuscripts of the *Decameron* and extend the discussion of vision and language to encompass actual viewership as well. As we shall see, including ourselves as viewers of manuscripts brings up issues of voyeurism, pleasure, and imagination in circumstances different from those that accompany a simple reading of the *novella*. The miniatures depicting the tale exhibit a marked tendency to efface the transgressive and voyeuristic aspects of vision in the story and instead emphasize the containing and regulatory functions of viewership. Central to the discernment of these differences is the portrayal of the character of Tancredi. Boccac-

cio's *novella* sketches a potentially transgressive and humiliated figure of the prince which is not one that the reader is likely to admire or condone. The miniatures, on the other hand, provide a more sympathetic representation of Tancredi, one that is not as threatening to the viewer in his or her capacity as observer.

The tale under consideration here is the first recounted on the day "King" Filostrato orders stories told "about those individuals whose loves come to unhappy ends."[1] Fiammetta, the narrator, begins the tale: "Tancredi, Prince of Salerno, was a most humane lord with a kindly spirit, except that in his old age he stained his hands with lovers' blood. In all his life he had but one daughter, and he would have been more fortunate if he had not had her."[2] Fiammetta continues to elaborate on the intimate and loving relationship between Tancredi and his daughter, explaining that the intimacy between father and daughter postponed Ghismunda's marriage in the first place, and, when she was soon widowed and returned home, prevented Tancredi from seeking another husband for her. As a result of her father's reluctance to marry her off again, Ghismunda surveys the court for a lover in order to satisfy her amorous desires. Once she determines that Guiscardo is a proper recipient of her attentions, she establishes a relationship with him by sending him a cryptic, secret message. The lovers' many meetings are conducted in the most elaborate secrecy, with Guiscardo slipping into and out of special leather clothing, secret caves, forgotten passageways, and doors sealed through lack of use. The lovers' routine is interrupted when Tancredi, who had the habit of visiting his daughter in her bedroom unannounced, stopped by one day "without being observed or heard by anyone and entered her bedroom. Finding the windows closed and the bed curtains drawn back . . . Tancredi sat down on a small stool at the foot of the bed and drew the bed curtain around him – almost as if he were trying to hide himself on purpose – and there he fell asleep."[3]

While Tancredi is napping, Ghismunda and Guiscardo meet and make love in her bed. Tancredi wakes up, watches them, and, when they leave, sneaks out the window. Tancredi has Guiscardo seized and confronts Ghismunda with the inappropriate behavior she exhibits in her affair. Ghismunda refutes his charges with great rhetorical flourish and tells him to kill them both, if that is his plan. Tancredi does not believe

that she will do violence to herself, so he has Guiscardo killed and his heart sent to Ghismunda in a goblet, with the sarcastic message that (your father sends you) "the heart to console you for the loss of that which you loved most, just as you have consoled him for the loss of what he loved the most."[4] Ghismunda pours poison over the heart and drenches it in her tears, then drinks the bloody draught. Tancredi arrives on the scene just in time for her to chastise him and beseech him to bury her with Guiscardo in a public ceremony. Tancredi buries them together with much fanfare.

As we shall see, this *novella* is deeply concerned with both literal and figurative modes of vision. In the story, vision leads to love, knowledge, and death. The narrative repeatedly foregrounds acts of discovery and concealment: knowledge, feelings, power, desires, and trysts are alternately hidden and revealed. The act of surveillance dominates the tale's structure and precipitates the dramatic events that occur. In this *novella*, the court is defined and confined by particular agents of vision, and power is assumed and subverted by alternating scopic drives.

Literary criticism about this tale commonly bears witness to the importance of vision in the text both directly (by discussing the effect of concealment and secrecy in the tale) and indirectly (by the choice of metaphors the critics use). For example, in his book on the *Decameron*, Guido Almansi claims that in approaching the text "one could start by dividing the *novella* up into two distinct narrative zones. The first of these is bathed in light; it is open and self-explanatory . . . at its very center . . . Ghismunda . . . The second is a zone of darker and circuitous effects . . . dominated by . . . Tancredi."[5] Giuseppe Mazzotta, who inverts Almansi's light–dark metaphor to describe the tale of Tancredi, asserts that the court has a "visible structure of hierarchy and order with the prince the supreme feudal lord of family and city, surrounded by courtiers and faithful vassals . . . [The prince enjoys] omniscient perspective . . . in court."[6] The fact that Almansi and Mazzotta use visual metaphors to categorize the narrative is not surprising when we note that on the lexical level of the text the concern with vision is readily apparent. The verbs *vedere* (to see) and *guardare* (to look) riddle the text, and many of the figures of speech used in the tale portray vision as the medium of love and knowledge, as well as of madness and violence. Mazzotta goes so far as

to assert that it is the *invidiosa* ("jealousy," etymologically linked to blind-ness) character of Fortuna that "shapes the story's tragic movement."[7]

Clearly, vision is a dominating and ambivalent force in the *novella*. Over the course of the tale, vision is presented from divergent perspectives as it oscillates between licit and illicit activities. The fact that the narrative repeatedly shifts from positive to negative in the wink of an eye (e.g., the inaugural sentence of the tale swerves from praise to tragedy) demonstrates how quickly perspective can change.

In this tale where the court is an optical arena in which bodies are narrativized by the signs of courtly behavior, protocol, and dress, Ghismunda exhibits her grasp of the system in her astute reading of her visual surroundings. We first notice the importance of vision in the description of Ghismunda's selection of a lover. In her search, Ghismunda uses her central and privileged position in court to observe the people who surround her. She watches them carefully and, on the basis of her observations, selects the one who appears to be the most noble. Ghismunda's reliance on her scopic acumen in selecting a lover reveals one of the epistemological routes presented in the *novella*. Her acts demonstrate that vision leads to both abstract knowledge (discernment of qualities such as "nobility") and carnal knowledge. In its dependence on vision, her behavior conforms to Andreas Capellanus's rules of courtly love, which define love as "a certain inborn suffering derived from . . . sight."[8] Ghismunda's surveillance does not pass unnoticed by the object of her gaze; Guiscardo sees that she finds him attractive and reciprocally falls in love with her. Up to this point their only means of communication is visual; stolen glances, averted eyes, and so forth. As a result of their visual intercourse, Ghismunda writes Guiscardo a note that contains circuitous directions to her bedroom and puts it in a hollow reed, which she gives to him, saying, "Make a bellows of this tonight for your serving girl to keep the fire burning."[9] This cryptic message leads to their first rendezvous. Having watched one another closely before this, each already knows what their verbal communication is about, and, as a result, the semantic value of Ghismunda's language is accorded little importance in the story. This point is noteworthy, especially in relation to the verbal virtuosity Ghismunda later demonstrates. Although at first it may seem peculiar that her verbal communication at this critical junc-

ture in their romance is so unclear, later we shall see how in the discourse of courtly love, eloquence stems from certain elements that are initially irrelevant to her affair with Guiscardo. For the time being it is enough to emphasize that the language is not entirely clear and thus not the operative code in their arrangement.

In order for Guiscardo and Ghismunda to pursue a properly discreet affair, they must circumvent the surveillance of the court. To this end, the lovers resort to the bizarre ritual that comprises Guiscardo's journey to Ghismunda's bed. Every aspect of the trip is designed to conceal their arrangement. Unfortunately for the lovers, Guiscardo's convoluted gymnastics are not the only means of entering Ghismunda's inner sanctum unobserved. Tancredi also manages the feat, by arriving when no one is watching. Once he gains access to Ghismunda's bedroom, Tancredi proceeds to conceal himself in such a way as to remain undetected by the lovers cavorting in bed. This particular scene distills the voyeuristic resonance of the scopic economy of the court by literally putting the prince in the position of observing the most intimate physical communication between Ghismunda and Guiscardo without being seen.

However, whereas in the arena of the court legibility of narrativized bodies is neither illicit nor transgressive – and is, in fact, the very code of the regime – Ghismunda and Guiscardo's naked bodies making love are not part of the courtly discourse and therefore send a message that not only challenges the authority of the court but shakes Tancredi's power and position to the very core. The implication that voyeurism infiltrates and undermines the princely prerogative of supervision is conveyed in the *novella* by the subsequent humiliation and transformation Tancredi undergoes. The theme of visual transgression is further developed in the *novella* as the realms of private and public interpenetrate each other in a manner that threatens the lives of characters as well as the power structure of the court. For example, as the father watches his daughter and "adoptive son"[10] making love, his paternal role conflicts with his public position as prince. The inverted primal scene figured in the bedroom sequence takes the prince from his station of presumed ultimate power and authority and puts him in the position of a child. The reversal of roles is later made explicit in the text during Ghismunda's chastisement of Tancredi for his "womanly" tears when the narrator says

36

he cries like a child "ben battuto."[11] Peeking out from behind the curtains, Tancredi's heretofore central and legible body is invisible and insignificant. The control over events he presumed to have is impugned by his daughter's independent acquisition of a lover, by the fact that he did not know about their relationship and, moreover, by the fact that he does not dare to interfere with their lovemaking and instead sits impotently by, grieving.[12]

The transgressions foisted upon Ghismunda by Tancredi once again signal his deviant behavior with respect to Capellanus's courtly code. In making the case for Tancredi's voyeurism, it is helpful to note that Capellanus shares with Freud the belief in a causal relationship between sexual looking and sexual action.[13] In the courtly code, imagination's creative vision of possible pleasures generates desire, which links perception to action. Contrary to this progression, Tancredi seems stuck in the perception mode. If it is possible to ascribe pleasure (incestuous, sexual) to his voyeurism in Ghismunda's bedroom, then it is arguable that he is once again subverting the prescribed order of things. Although I have previously asserted that secret vision, and specifically surveillance, is included in the visual register of the court, clearly this is not what is at stake in Ghismunda's bedroom. Bodies at court are "legible" in very specific ways, according to generally accepted codes.[14] In the scopic economy of the court, vision is concentrated and centralized in the public domain, and "legible" bodies are subordinated to words. However, in the privacy of the bedchamber the power of the gaze falters; outside of the court, "rhetorical" bodies become private and are no longer subject to the grammar of the court. It is precisely this distinction that allows for greater freedom of imagination and fantasy practiced by the lovers than is admissible in courtly exchange. The lovers practice this corporeal communication in their relationship, to the exclusion of language. Under these circumstances, the hidden body of Tancredi does not exercise its supreme right as sovereign but is reduced instead to a private act of voyeurism.

As is apparent from Mazzotta's and Almansi's work on the tale, the relationship of Tancredi and Ghismunda to the light and dark realms of the story is not at all fixed. Almansi claims that on the one hand "light" is a metaphor that characterizes the "openness" and "coherence" of

Ghismunda's narrative presence, whereas on the other hand "darkness" is a metaphor that characterizes the "ill-defined" and "essentially incoherent" narrative effect of Tancredi. Conversely, Mazzotta argues that the two narrative realms are "on the one hand a 'Gothic' world of covert passions . . . deceptions, and private revenges, of which the night is the epitome and Ghismunda the heroine" and, on the other, a "daylight world" commanded by Tancredi. Presented with two such convincing and apparently conflicting interpretations, I would like to explore the shades of difference and overlap between the two claims by investigating the nuances and subtleties of the light–dark dichotomy. To this end, one of the issues that needs to be addressed is the way the black and white categorization of dark and light lumps together all types of concealment into one group and all types of exposure into another. I find both Almansi's and Mazzotta's arguments compelling, and I believe the text allows for the diversity of their readings, so I want to examine the manner in which the two categories intermingle and blur the salient distinctions in such a fashion as to allow for them both, because, on the one hand, the "dark" world is extremely complex and not at all fixed or stable and, on the other hand, the transparency attributed to the court's visual legibility and omniscience is questionable. This discussion concentrates on how the ambiguity of the tale (e.g., Is Tancredi a tyrant or a humane lord?) undermines the possibility of an absolute opposition of moral poles and, at the same time, on how the narrative exhibits considerable exchange, interplay, and flexibility.

The first category, that of darkness and concealment, actually harbors both the access to power and pleasure and the challenging of that power, along with its concomitant unpleasure. We can see this complexity in the various ways covert surveillance figures in the *novella*. Although covert surveillance uniformly leads to discovery (Ghismunda discovers a lover, and Tancredi discovers the lovers), it is an ambiguous practice that does not necessarily give rise to visual mastery and obviously leads to multiple outcomes. When Ghismunda surveys the court in order to find a lover, her activity leads to (sexual) pleasure and filial independence (behaviors that are positively valued in the *Decameron*), whereas Tancredi's covert surveillance of the lovers cavorting in bed leads to extreme displeasure in the form of the undermining of his presumed power and

also leads to his own anguish and the violent deaths of Ghismunda and Guiscardo. In this sense, covert surveillance, one of the most obviously secret or "dark" practices, cannot be deemed simple or unproblematic. The polyvalence of secretive vision's affective charge renders it unpredictable and ambivalent.

To elaborate on the difficulty of fixing poles of dark and light, we need only look more closely at the complexity of the two moments of covert surveillance. Here we can see that the split between pleasure and unpleasure is not as tidy as it might seem, because both notions are further complicated in the *novella* by the incestuous undertones in Tancredi's affection for Ghismunda.[15] The text initiates the theme of incest in the opening sentence, which identifies Ghismunda as a lover with respect to her father ("he stained his hands with lovers' blood"). From this angle, Tancredi's intrusion into Ghismunda's bed and the voyeurism he practices when he wakes up from his nap provide him access (perhaps unconscious) to sexual gratification by observing the couple's lovemaking. This erotic component to Tancredi's watching is supported textually by the narrative's insistence on Ghismunda's pulchritude and on her carnal desires, which she pointedly claims to have inherited from Tancredi. At the beginning of the *novella* we are told by Fiammetta that Ghismunda was as "beautiful in body and face as any woman ever was,"[16] and later, in Ghismunda's rebuttal of Tancredi's charges, she accuses him of understanding her carnal desire because "he is made of flesh and blood, and therefore fathered a daughter of flesh and blood."[17] The emphasis on the physical, carnal commonality between Ghismunda and Tancredi, the extended insistence on his deep affection for her, and the disclosure of her beauty heighten the tension in the catastrophic bedroom scene. The possibility that Tancredi might derive some pleasure from watching Guiscardo and Ghismunda is not openly addressed in the text. In fact, the tale does not elaborate on his response to the scene, beyond saying that what he saw grieved him. Yet, given the incestuous resonances in the text, coupled with Tancredi's decision to remain silent while he watches and listens to the lovers "for a long time,"[18] it is certainly possible to conclude that the prince may have experienced sensations other than grief. Further evidence for a reading of Tancredi's incestuous attachment to this daughter can be found in the message which smacks of

erotic jealousy that he sends to her along with her lover's heart. After he confronted Ghismunda with his having seen them making love and she refuted his claims, Tancredi decides to punish Ghismunda in order to "cool her burning love."[19] The dictated message Tancredi sends with the heart justifies his brutal murder of Guiscardo by referring to his own grief over "the loss of what he loved the most."[20] When we consider the fact that Tancredi does not intend Ghismunda to die or believe that she will, one possible reading of his reproach is that her sexuality, her amorous passion (or his fantasies and illusions of the same) are what he has lost as a result of her affair with Guiscardo.[21]

Just as Ghismunda's covert surveillance leads to a secret affair, Tancredi's voyeurism leads to more secret events in the "dark" realm of the narrative. Tancredi's discovery of the couple's relationship sets off a series of secret actions. At night, when the castle is asleep, Guiscardo is secretly kidnapped and hauled off to Tancredi's room in the castle, where he is confronted by Tancredi and then sent off to be "guarded secretly in a nearby room."[22] Tancredi then confronts Ghismunda, who successfully conceals her feelings during the discussion while refuting Tancredi's claims. Following the interview, Tancredi has the "two men who were guarding Guiscardo go in secret and strangle him"[23] and cut out his heart. The next day Tancredi sends the heart to Ghismunda by his "segretissimo serve" (ultra-secret servant). Upon receiving the heart, Ghismunda understands that Guiscardo has been killed and proceeds to commit suicide right in front of her ladies-in-waiting but in such a way as to conceal from them what she is doing.

At the same time, and on as many different narrative levels of the text, secrets are revealed; things concealed are disclosed and discoveries are made. First, Ghismunda reveals to Guiscardo her love for him. Subsequently, Tancredi discovers the lovers *in flagrante* and, in response, exposes Guiscardo's heart to Ghismunda's eyes. Finally, Tancredi displays the lovers in a public funeral. These acts all involve the transition from the realm of secrecy/darkness to revelation/light. These revelations are expressed through the semantic encoding and decoding of bodies in the visual/narrative economy of the story. The interplay between secrecy and revelation weaves in and out of all levels of the text. Some secrets are available to the reader only through Fiammetta's narration, remain-

ing inaccessible to the characters within the *novella*, whereas other se-crets are manipulated by characters within the *novella* in order to reveal desires, messages, and intentions. It would be difficult to categorize any single instance as strictly secret without some caveat about how it ulti-mately comes into play as a revelation (even if the "secret" itself remains obscure). It is my contention that it is precisely this fluidity that allows for the multiple categorization of specific elements in the narrative.

The variegated layers of contested concealment and revelation in the visual register of the *novella* mold the verbal debate over imaginative and real vision that takes place between Ghismunda and Tancredi. By this I mean that their destructive dispute over literal and figurative meaning develops out of their conflicting and competing visual strategies. The first example of this contrast appears in Ghismunda's rhetorical tour de force. As I argued earlier, Ghismunda's affair with Guiscardo functioned primarily on visual and tactile codes; however, when Tancredi confronts Ghismunda about her affair with Guiscardo she responds at great length with a precise, well-argued rebuttal of his claim to injury. This is the first time in the *novella* that her rhetorical ability emerges, and it does so in a remarkably long five paragraphs. Ghismunda's change of medium signals a change in the erotic economy of the story as well, which opposes ver-bal to visual and desire to pleasure. To pursue this argument I will once again call upon Capellanus's *De amore* as a text that in some ways scripts the erotic relationships in the *novella*.

Initially, Ghismunda's sexual desire is awakened by her sexual rela-tions with her husband, and when she is widowed her desire remains and motivates her to acquire a lover. With previous sexual pleasure in mind (her "imagination") she contemplates the court's population until she perceives in Guiscardo the lover she has been seeking. She then acts in such a way as to initiate the affair that will satisfy her desire. In this man-ner, Ghismunda's behavior corresponds to the "love psychology" in Capellanus's doctrine. Mary Wack concisely summarizes the process: "For . . . Andreas . . . the imagination's creative representation of possi-ble pleasures generates the desire that links perception and action."[24] Ghismunda's affair with Guiscardo is an example of the simplest case of courtly love possible – simple, because much of *De amore* concentrates on the courtier's methods of getting from the point of perception into the

realm of action. Action (i.e., lovemaking) is anticipated to be a chal-
lenge, because of the illicit or forbidden character of the love itself.
(Love, for Capellanus, must be adulterous, because it cannot be entan-
gled with conjugal duty.) Thus, seduction for Capellanus transfers from
a visual field ("love is a certain inborn suffering derived from . . . sight")
to the verbal field. The nature of this transition is addressed by Wack:

[S]triving for the "forbidden" or at least the unattainable, initiates some of the
copious rhetoric of the dialogues, just as it intensifies the imaginative fixation
of sexual desire. The *platea ymaginacionis* . . . is the place where multiple aspects
of imagination dwell and interact; it is both the storehouse of images and the
space where images are clothed in speech. In *De amore,* imagination first gener-
ates erotic desire, and then . . . becomes the locus of invention for rhetorical
strategems designed to fulfill that desire . . . Eloquence . . . has its birth in imag-
ination's unsatisfied desire.[25]

As we noticed, for Ghismunda and Guiscardo only the slightest ver-
bal exchange occurred between them because Guiscardo was already a
willing participant, and, as a result, there was no need for the seduction
by rhetoric that a reluctant partner demands. The notion that Ghis-
munda and Guiscardo's affair satisfied their desires is further validated by
the fact that there is no subsequent reported speech between the two
lovers. The dearth of verbal communication in the presence of love-
making is extended to Fiammetta's narrative as well, which declines to
discuss openly the fact of their consummation. The actual, physical in-
tercourse they have is all but elided in the text when it is referred to var-
iously as "meravigliosa festa" (wonderful party), "grandissimo piacere"
(enormous pleasure), and "scherzando e sollazando" (playing and lolling
about). Rather than spend time detailing their sexual behavior, the nar-
rative lingers on Guiscardo's journey, a construction that effectively dis-
places their foreplay and pleasure onto Guiscardo's strenuous gymnas-
tics. Fiammetta's storytelling technique does not repress the sexual
pleasure of her protagonists; to the contrary, her somewhat demure dis-
closure of the lovers' encounters clearly indicates that they spent a great
amount of time giving each other pleasure. As a result, Fiammetta's
metaphors serve to expand the range of possible pleasure to the limits of
the reader's imagination.

However, this all changes once Tancredi makes it clear to Ghismunda that Guiscardo is as good as dead. At this point, the impossibility of satisfying her desires leads her imagination to expend all the energy previously occupied with making love on an eloquent defense of her actions, praise of Guiscardo's nobility, and the rebuke of her father. Although her effort does not lead to the release of her lover, it could be viewed as an attempt to do so. Ghismunda's rebuttal of Tancredi is strong enough to undermine his arguments, and, had he chosen to believe her, the tale might have ended differently.[26] Tragically, Tancredi does not believe her. Ghismunda recognizes that her speech has not convinced Tancredi when she receives Guiscardo's heart. Her violent response to the bloody gift is in keeping with Capellanus, who posits that thwarted desire is followed by destruction, because unrelieved, excessive imagination accelerates into a destructive, enclosed cycle of desire and frustration that leads to physical collapse.[27]

As we see, Tancredi's attempt to redress his verbal defeat by Ghismunda takes a grisly turn. His gift to Ghismunda of the bloody lump of muscle can be seen as an attempt to deflate and discredit her rhetoric by asserting deeds over words. In sending his daughter her lover's heart, Tancredi disregards her speech and ventures into her earlier field of expertise (visual communication and action) with a force that cannot be ignored. In addition, Tancredi's use of Guiscardo's heart demonstrates the father's desire to disfigure their love. By focusing on the viscera, Tancredi is attempting to divorce the object of love from the imagination. His practice demonstrates a canny understanding of the literary character of a love that so closely follows the patterns set forth in the *De amore*. Although neither the ultimate "meaning" of the cardiac muscle nor the literary notion of "courtly love" is truly plumbed to its depths, Tancredi's play on the exchange between the two points reveals the low value he places on her words. The view that Tancredi's act is an attempt to destroy the value of Ghismunda's language is supported by the ironic message he sends along with the heart. On one level, the simple fact that he addresses this message to her through a mediator removes his meaning to a physically distant location from its source and foregrounds its status as coded message while denying Ghismunda access to the expressive address available had he delivered the message personally. On another

level, his foregrounding of the arbitrary status of code is amplified by the fact that the words he sends do not mean what they say. His use of irony is another way in which he discredits her rebuttal by undermining the credibility of language.

Of course, Tancredi's attempt to dismantle the power of Ghismunda's rhetoric is met with opposition. As many scholars have noted, her verbal address to the bloody heart can be interpreted as an attempt to "metaphorize" it, to turn it into a representation of love.[28] This gesture defies Tancredi's intent to cancel her language and, as a result, removes Guiscardo from the picture by bringing into play a figure of Guiscardo/love that overwhelms and outstrips the dead, corporeal man and replaces him with an abstract symbol. Her eulogized Guiscardo counters Tancredi's move and accompanies Ghismunda in her last moments before she commits suicide, to the noteworthy exclusion of her father, who is neither physically nor rhetorically present at the scene. Her suicide throws back into her father's face the use of bodies as words that he practiced on Guiscardo's heart. In taking her own life she is forcing him to "read" her dead body.[29] In turn, Tancredi demonstrates his fluency in this bodily language when he performs the final act of "[re]writing" the lovers' history with a public funeral.

In her soliloquy to the heart, Ghismunda curses the one "that forced me to look at you with the eyes of my body! It was already too much to gaze upon you constantly with the eyes of my mind."[30] In this lament she addresses a thorny issue regarding imaginative and real vision in *De amore*. In her statement, Ghismunda appears to be claiming that her love for Guiscardo had been concentrated in the imaginative realm, even though, paradoxically, it had unquestionably taken place on a physical level as well. This begs the question of where "real" vision and "imaginative" vision overlap, and further (to touch upon one of the academic points of contention regarding the *De amore*) begs the question of where "imagined" sex overlaps with "real" sex. In Guiscardo and Ghismunda's case, it would appear that the two kinds of vision and sex coincide comfortably in their relationship without contradiction.[31]

So, what then is meant when Ghismunda laments the use of "the eyes of her body?" She had used them all along in her search for a lover and in her affair with Guiscardo. Furthermore, it does not seem plausible that

her horror would stem from disgust at the gruesome object, since she calmly proceeds to imbibe part of it. Obviously, her flesh-and-blood organs of vision are not the problem; rather the breach lies in the fact of the object they are forced to look upon. This transgression: being forced to see exposed what naturally remains hidden inside, takes her abruptly from the previously commingled imaginative/real state of love to her abject suicide. As we shall see later in the discussion of the miniatures, a similar deflation of fantasy (and, as a consequence, pleasure) takes place in the reader/viewer when our imagination is confronted with the visual depiction of the object upon which our fantasies are propped. I will argue that the visual representation of the lovers' rendezvous sharply curtails the viewer/reader's erotic imaginings of Ghismunda and Guiscardo's pleasure, just as Ghismunda's exposure to Guiscardo's heart drastically reduces and reforms the character of their love.

The difficulty in clarifying the questions the *novella* raises regarding voyeurism and transgression can be more compellingly discussed if we enlarge the frame of reference. Up to this point, I have been discussing visuality and vision in the *novella*. Now, in order to address the issues of voyeurism and trespass, I will expand the subjects at hand to include a few Franco-Flemish miniatures in four manuscripts of the *Decameron* and in this way include myself and others reading this chapter on the visual level. Opening up the frame, so to speak, as a strategy to implicate external viewership (our own and the illuminators') in the processes that the verbal text sets up can perhaps most convincingly demonstrate the ambiguities and intricate relationships that need to be acknowledged in this analysis.

My discussion of the miniatures will center on the problems of voyeurism, because as a visual medium manuscript illumination necessarily addresses issues of viewing and pleasure. The personal manner in which attribution of voyeurism will occur in this discussion is particularly apt, because these illustrations are of an extremely private and privileged nature. The manuscripts under discussion here were commissioned by certain wealthy individuals who could read, peruse, and otherwise enjoy them at their leisure in the privacy of their own homes and libraries. The idea that the miniatures are illustrations of a notoriously erotic book, coupled with the (private, intimate, privileged, tac-

tile, visual) circumstances of their consumption personalizes the relationship between the reader and the text. This applies to current use of the manuscripts as well, because knowledge of and access to them is subject to various levels of privilege and desire. The mundane procedures involved in arriving at the geographic location of the manuscript, being granted the privilege of holding it in your hands, and looking at it in a rare book room (under surveillance) require a certain amount of desire and certainly afford great pleasure.

Many of the earliest manuscripts of the *Decameron* in circulation included illustrations. In fact, one of Boccaccio's own personal manuscripts of the work (Doc. Hamilton 90 in Berlin) bears his sometimes humorous, sometimes whimsical ink portraits of various characters from the *novelle*.[32] Several similar contemporary examples of manuscripts embellished with small sketches and portraits in which characters from the *novelle* are labeled in cartoon fashion are in existence. In these early manuscripts, visual renditions of the stories are commonly monochromatic, schematic ink drawings or woodcuts that occupy a relatively small portion of the page. A tradition of simple illustration was practiced during the text's first century of circulation in manuscript form and continued with the advent of printing, in the incunables, as the *Decameron* remained a "best seller" in Italy.[33]

With the growth of humanism and the rise of the Renaissance, Boccaccio's decidedly secular text witnessed a change in status; as the personal libraries of monarchs and other wealthy individuals expanded to include new versions of Roman, Greek, and Arab secular texts as well as of contemporary European courtly literature, the *Decameron* became a standard addition to the libraries that housed the canonical "high art" books. As a consequence of this elevation in circumstances, the very materiality of the text changed; costly editions of the book were commissioned from copyists and professional illuminators to meet the demands of the wealthy patrons. Branca comments, "[O]ne has the impression that in the Quattrocento the presence of a richly illustrated copy of the *Decameron* was obligatory, almost a status symbol, in every ruling class library."[34] As the book accrued status it was disseminated throughout Europe, and by the end of the Quattrocento there were more than eight thousand illustrations of Boccaccio's texts in three hundred different

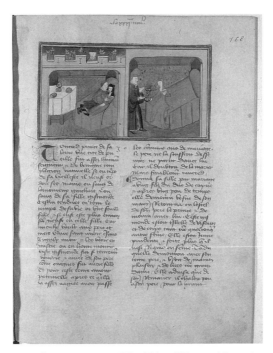

Figure 1. Manuscript illuminations to "The Tale of Tancredi" attributed to Maitre de Sir John Fastoff, c. 1447. (Ms. 12421 c 168 r, Bibliothèque Nationale, Paris. Photo courtesy of the Bibliothèque Nationale, Paris.)

codices and printed editions. In its first century of circulation, copies of the *Decameron* traveled throughout Europe, to France, Flanders, Holland, Austria, Germany, Spain, and England.[35] According to Branca, even during the late Trecento, prior to the advent of its ruling class appeal, the *Decameron* had arrived in southern France via the "fanatical" traveling Tuscan merchants and the French-Italian milieu at Avignon. Later, during the mid to late Quattrocento, in southern France as elsewhere in Europe, the prestigious high art versions were embraced by the ruling classes as well. These later, elaborately illuminated versions of the *Decameron* eschewed the simpler *fumetto* style illustrations in favor of copious and extravagant miniatures characteristic of the high art canon. Four of these French editions of the *Decameron* (all from the Premierfait translation) provide the visual texts for this chapter: Parisian Fr. 12421, attributed to

the Maitre de Sir John Fastoff, c. 1447 (Figure 1); Viennese Cod. 2561 (Eug 144) (Figure 2); Parisian ms. 5070 (263 B.F.) (Figure 3); Parisian Fr. 240, attributed to Filiberto de la Mare (Figure 4), all in the Bibliothèque Nationale in Paris.[36]

The expensive, Renaissance copies of the *Decameron* made for wealthy patrons changed the emphasis in the relationship between the word and the image in Boccaccio's book. Rather than concentrate the semantic value into a small, plain space, as the early ink drawings did, these later texts augment the space allotted to the image, allowing for extremely complicated narrative sequences, which are further foregrounded by the use of bright colors. As a result, when confronted with one of the sumptuously illuminated manuscripts the reader is immediately struck by the images. This contrasts with the reader's perception of the regular and monochromatic verbal code of the text in which the repetitive character of the calligraphy undercuts the prominence of its central position on the page. In discussions of illustrated manuscripts it is a commonplace to explain away the notion of a "relationship" between illustrations and verbal text by relegating the image to the status of ornament, assigning it a less important place both semantically and structurally, because of its "derivative" character. Historically, the strategy of diminishing the value of such works has been levied against many forms of visual art inspired by verbal texts. Often, however, the bias that favors chronological precedence is somewhat mitigated in physically independent works (e.g., sculpture, paintings, and furniture), a response perhaps attributable to their being perceived as having a "compensatory" autonomy based on aesthetics and genre. It is also possible that this kind of independence may in part be due to the fact that a viewer is able to enjoy this kind of artwork entirely separately from, and possibly even in ignorance of, the verbal text. Obviously, there is no such mitigating circumstance in the case of manuscripts, where the chronology of the production of words and images is assumed to be clear-cut. One presumes that first a writer writes the words, next the page is laid out in order to accommodate the words, and finally an artist is brought in to accompany the text with images.[37] The causality attributed to the sequence "Words cause pictures" tends to create the impression that the image is subordinated to the text.

By examining illuminations from four separate manuscripts of the *De-*

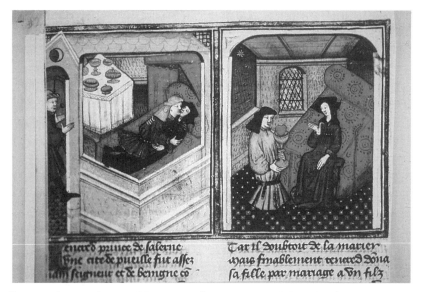

Figure 2. Artist unknown. Manuscript illuminations to "The Tale of Tancredi." (Viennese Cod 2561 [Eug 144], Bibliothèque Nationale, Paris. Photo courtesy of the Bibliothèque Nationale, Paris.)

cameron rather than focusing on a single manuscript, I hope to be able to discern emphases and tendencies in the visual representation of the story of Ghismunda, Tancredi, and Guiscardo. The miniatures under discussion here vary quite a bit in the amount of detail included, the skill of the illuminator, and the quality of preservation. It is possible that some of the illuminations may have influenced the others or had a common model upon which they were based, in particular, Figures 1, 2, and 3 share some striking resemblances. In the following discussion I will be referring to similarities as well as differences among the illuminations, in an effort to bring out the specific way each one addresses questions of vital interest to the interpretation of the narrative. I have no interest in establishing or conferring upon any of the miniatures aesthetic superiority or chronological precedence; rather, I wish to focus on the particular way each set of illuminations represents the events that transpire among Tancredi, Guiscardo, and Ghismunda.

Each of the miniatures in Figures 1 through 4 makes use of the archi-

tecture of the castle to divide up the narrative segments they represent.[38] The buildings depicted frame the narratives in a way that echoes the framing structure in the *Decameron* itself. The sense of nested narrative imparted by this architectural framing is augmented in Figures 3 and 4 by the vines and offshooting tendrils that occupy the borders. These various frames mark boundaries between narrative levels and chronology while at the same time supplying the connection among the parts delineated, thus providing continuity for the narrative as a whole. Each frame structures the space it encapsulates and, in this sense, influences the content of the space outlined. In addition to demarcating temporally discrete episodes in the narrative, the representation of architecture signals the distinction between interior and exterior as well. I want to insist on the central importance of the frames in the significance of the miniatures and I want to explicitly link my treatment of these frames to my discussion of the adjunct or ornamental status of the miniatures and visual representation in general. By valorizing these "ornaments" or "details," I am deliberately tapping into the deconstructive potential inherent in the miniatures in order to explore how the illuminations transmit the narrative.[39]

Inside the frames, each of the series of illuminations includes some representation of a world outside of the castle rooms where the drama unfolds. It is important to consider the inclusion of the outside world as an essential element of the narrative represented by the miniatures. The usefulness of this strategy is manifest; subtle indications about narrative themes and interpretative possibilities are amplified and reflected in the castle's surroundings. This is most evident in Figure 4, where the first narrative frame of the miniature is dedicated to the outside world. Here, the upper left-hand block in the illumination shows an external view of the castle compound, observed from outside of the gate/fence. This frame provides us with an introductory pan of the premises granting us explicit access to the private drama that will soon unfold. As we enter the narrative from this external position we are confronted with a gate/fence adorned with red and white roses, which separates us from the dark castle and the closed window beyond. In the second frame (lower left-hand) the window behind Ghismunda has been flung open out onto the garden, where we can see red roses in abundance. The lush garden and the

red roses provide a visual cue that anticipates the passionate love Guiscardo and Ghismunda are about to share in the bedroom and foreshadows the violent death Guiscardo will suffer. In the third frame (upper right-hand) the windows are all closed on the scene of Guiscardo's murder and mutilation. The garden is now shown completely blocked off from the interior of the castle by a thick wall and is just barely visible on the right-hand margin in the cut-away cross-section of the castle room. In this small slice of garden that is being edged out of the picture, only white flowers are visible. In the final frame of the miniature (lower right-hand) there is no garden visible at all; the windows are shut, and the frame does not exceed the confines of the room where Ghismunda is presented with Guiscardo's heart. This constriction of space (from outside world to enclosed interior) mimics the spatial contraction in the *novella*, where the world of the lovers diminishes progressively from the arena of the court to the privacy of Ghismunda's bedchamber, to Guiscardo's prison, to the chalice enshrining his heart, and finally to the common grave Ghismunda and Guiscardo share.[40] This same theme is also echoed in an abbreviated form in Figure 3, where the first edifice/frame housing the lovers includes a door but the second edifice/frame, where Ghismunda prepares to die holding Guiscardo's heart, omits any conventional venue of access or escape. In a more general sense, the external world portrayed in Figures 3 and 4 lends continuity to the progression of the narrative by referring to a larger spatial context that engulfs all the disparate elements depicted.

In addition to the architectural motif and the inclusion of a world outside of the court, narrative coherence is also guaranteed in the illuminations by the repetitive representation of the figure of Ghismunda.[41] In each series, Ghismunda's figure is the only clearly identifiable one that appears repeatedly. Because her identifying features (clothes and face) remain unchanging and unmistakable in all of the illuminations, we know that time has elapsed between scenes in which she appears. Logic dictates that she is the same character represented at two different points in time. The figures of Tancredi and Guiscardo do not supply equivalent visual cues to the viewer, nor do the architecture or the room furnishings, all of which change significantly from one frame to the next in the illuminations. However, with Ghismunda's consistent character-

istics, the manner in which the surroundings change from one frame to the next helps to convey the idea that time has passed. For example, Ghismunda is represented in both frames of Figures 1 through 3 in exactly the same central position in the picture, looking as if the only alteration she makes is to sit up in bed when Guiscardo's heart arrives. But the fact that the color of the bed changes from passionate red in the scene of their lovemaking to a cool green in the scene with the heart intimates that Guiscardo has left her long ago.

The two scenes that are repeated in all the miniatures from these different manuscripts are Guiscardo and Ghismunda in bed, and Ghismunda with Guiscardo's heart. In viewing the different series of illuminations together, the consistency in subject matter focuses our attention on what the illustrations emphasize as the critical moments in the narrative. Figures 1 through 3 begin the narrative with the scene of Tancredi's voyeurism and display Ghismunda and Guiscardo as the object of our gaze, thereby initiating us into the story with an overt reference to erotic viewing. In these illuminations, Tancredi is not represented in the bed (as the *novella* stipulates), but outside of the bedroom altogether, surveying the lovers from a superior position. Tancredi's removal from the center of the spectacle in these illuminations changes his function as an internal focalizor from one what we, as viewers, look at as an object of our gaze to one that becomes a much more accessible stand-in with whom we look at the lovers. Figure 4 does not begin with the bedroom scene, but it does initiate the series with a frame that foregrounds our viewership by presenting a point of view that only spectators can occupy. Thus, Figure 4 also confronts us with our own viewership and the concomitant questions of propriety.

Figure 1, the least elaborate of the illuminations, is the most straightforward in its depiction of Tancredi's marginalized and alienated position. Of all the miniatures, it conforms most closely to the scenario described in the *novella*, which posits that Tancredi concealed himself "almost as if on purpose." In the first frame of this miniature, Tancredi is portrayed outside of the building looking into the castle through the space in the crenelation. Because only his head and shoulders appear in the picture, our gaze is concentrated on his gaze. We see him looking down upon the lovers, who are displayed centrally for his (and our)

viewing pleasure. He occupies the aggressive place of an attacking warrior, penetrating the protective walls of the castle in order to peer at the lovers; an attitude that strongly foreshadows the antagonism and violence that will result from his activity. This illustration also hints at the incestuous undertones in Tancredi's affection for Ghismunda by rendering the face of Tancredi virtually identical to that of the person making love with Ghismunda.

Somewhat differently, in Figure 2 Tancredi is represented at the extreme left-hand edge of the miniature, gesturing at the oblivious lovers. This illumination downplays the voyeurism represented in Figure 1 by showing Tancredi in a less conspicuously sneaky position. It is possible to interpret this picture as a scene in which the prince is simply walking about in his own castle when he comes across the secretive lovers, much to his surprise and manifest agitation. However, the tortured rendition of perspective in the frame allows for another possible interpretation. If we look closely, the right foot and left hand of the prince appear to be on opposite sides of the column in front of him. If it is the case that he is hiding behind the column at the foot of the bed, then, in spite of his apparent forward motion, he would be conforming to the verbal text's description of his hiding place. This interpretation is bolstered by the oblivious behavior of the lovers and the marginalization of the prince, which is effected by cutting off Tancredi's backside and rendering him only partly visible (i.e., partly concealed). The white structure that encases the lovers and excludes Tancredi creates the impression of extreme separation between the two realms it outlines. The lovers are completely absorbed in themselves and their lovemaking, apparently unaware of anything beyond the little cubicle described by the white frame. In their self-containment they almost look like a diorama or a framed picture in a gallery, a construction that would put Tancredi in the position of a patron and a surrogate for our own looking. In another oblique reference to patronage, Tancredi's gesture looks very much as if he were holding and reading a shocking book (perhaps the *Decameron*?). We can identify with Tancredi's position as external viewer of the couple making love because, indeed, we are in that position, and as a consequence, we are able to insert ourselves into the scenario.

Figure 3 is still less explicit about Tancredi's voyeurism. In the first

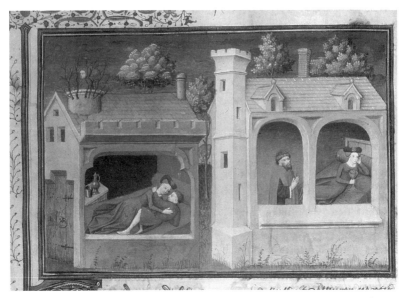

Figure 3. Artist unknown. Manuscript illuminations to "The Tale of Tancredi." (Parisian ms. 5070 [263 B.F.], Bibliothèque Nationale, Paris. Photo courtesy of the Bibliothèque Nationale, Paris.)

frame the prince is not directly represented at all and, instead, is displaced onto the figure of the watchman in the tower. The watchman's perch has peculiar branches poking out all around it, obscuring both his view and our view of him. This person is not shown watching the couple. It is rather the fact of his being shown performing the function of a "lookout" on top of the lovers that allows us to see a reference to Tancredi in his depiction. In addition, this picture displays the lovers to us in an entirely unconvincing architectural frame; the opening on the side of the building does not look nearly so much like a window as it looks like a picture of the lovers set into a building. For us to see the activity of looking, abstracted (i.e., not directly related to the narrative) in a picture that most overtly frames the lovers in bed calls attention to our watching the lovers (i.e., our own voyeurism) in a way that the *novella* does not encourage. To the contrary, according to the scene in Fiammetta's story, we focus on the spectacle Tancredi presents; we imag-

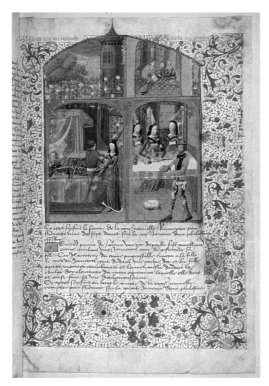

Figure 4. Manuscript illuminations to "The Tale of Tancredi" attributed to Filiberto de la Mare. (Parisian fr. 240, Bibliothèque Nationale, Paris. Photo courtesy of Bibliothèque Nationale, Paris.)

ine an agitated old man peeping out from behind the curtains at the lovers, not the lovers themselves.

In Figure 4, Tancredi's voyeurism is once again diffused, because the illumination represents the period preceding the couple's lovemaking and Tancredi's awakening. The illuminator's decision to show Tancredi in full view, laid out on Ghismunda's bed, not only contradicts the scenario described in the *novella* but also presents a narratively difficult scene. The soundly sleeping figure occupies half of the bed instead of hiding himself somewhere at the edge of it, yet he is completely ignored by the lovers, who apparently do not notice him. The attenuation of narrative credibility (How on earth could Ghismunda and Guiscardo pos-

sibly not see him, and even if they managed not to see him, how could they get onto the bed without feeling him?) is problematic. Tancredi's dormant body blocks the lovers' access to the bed, and if they went around to the other side to climb in, he would still present a considerable obstacle. Tancredi's obstruction and occupation of Ghismunda's bed conveys some of the ambivalences hinted at in the *novella*. If we take the difficulty arising from the arrangement of the characters in this scene as a cue to reconsider the ramifications of the scenario, Tancredi's behavior is cast in a new light. Tancredi's blithe occupation of his daughter's bed hints at incestuous desires on his part, especially when juxtaposed to the lovers' foreplay. Here, if we choose to interpret the disjunctive scene as two separate moments in time, we would have a scene of lovers' foreplay followed by a fanciful postcoital scene where Tancredi is sleeping off the exertion of sex. This interpretation is supported by an alternative reading of the sequences of the frames. In my discussion of inside versus outside in this illumination, I allowed the *novella* to dictate the order of looking at the miniatures (starting with the garden scene, moving down to the bedroom scene, moving up and right to the excision scene, and finally down again to Ghismunda and the heart). However, another entirely possible sequence involves following the standard path of viewing and reading that proceeds from top left to right, then down to the left and across to the right again. Although this sequence does not correspond to the story told in the verbal narrative, it does follow the established practice of Western viewing and reading. If we follow this alternative path, then Guiscardo is killed and his heart removed before we get to the scene of Tancredi in bed. And, if as I have suggested earlier, we divide this scene up temporally, then we could interpret this as Tancredi's incest fantasy.

All the miniatures show us Guiscardo and Ghismunda in amorous embraces, and we look. However, the illuminations' insistence on our complicity with the figure of Tancredi varies. For the purposes of further discussing voyeurism, I will ignore the possibility of our identifying with either or both of the lovers. Instead, I want to consider how our awareness of the possibility of overtly identifying with the kind of Tancredi presented in the *novella* (i.e., peeping out at the lovers from behind a curtain, watching and listening for a long time) diminishes with each illus-

tration in the order in which I have arranged them. That is to say, Figure 1 is the only one that actually depicts an internal focalizor (Tancredi peeking through the crenelation) with whom we can identify, who is also spying on the lovers. Figure 2, as I have argued, is at least ambiguous, and although in this illumination Tancredi is still the internal focalizor who relays our own gaze, he is not as clearly engaged in voyeurism. In Figure 3 the curious watchman is so abstract a representation of looking, in addition to not being Tancredi, that we are able to identify with a much more comfortable/removed position as viewers. In this frame, we are not obliged to associate ourselves directly with the pathetic picture of Tancredi painted in the *novella*. The man in the tower is obscured from our view by the sprouting branches; consequently, if we identify with his viewing position, we still have the consolation that not only is he not caught in the act, but he is also camouflaged or hidden from accusing eyes. Figure 4, as I have argued, does not depict the activity of voyeurism, even though Ghismunda and Guiscardo are shown in an embrace. Our own looking, as it is implied by this illustration, is disembodied and much more autonomous than in the other three. We are not made aware of our spectatorship by overt framing (as in Figure 3), nor are we presented with an internal focalizor who draws attention to voyeurism.

The illuminations efface the *novella*'s indictment of Tancredi's voyeurism and consequently diminish the imaginative potential of the story by changing the circumstances under which his viewing is portrayed. None of the illuminations represents Tancredi peeking from close range behind a curtain at the couple making love. Instead, he is entirely removed from the intimacy of their bed in the first three illustrations and is not shown looking at all in Figure 4. In addition, the illuminations dissipate the scene's erotic charge by depicting the lovers fully clothed. Whereas the *novella* leaves the lovers' behavior entirely up to the reader's imagination, the illuminations show a fairly mundane couple lying on the bed. The absence of titillation in the visual rendition of the scene also lessens the viewer's sense of participating in an illicit or sexually resonant activity. The miniatures lack the suggestive character of the polymorphously perverse marginalia of manuscripts in which sodomy between monks and bestiality, as well as other more standard sexual practices and erotic jokes, enliven the pages of otherwise sexually neutral texts.[42] These

miniatures also decline to present a scene of directly erotic content that contains a surrogate voyeur whom the viewer can "blame" (i.e., excuse our own voyeurism by transferring it onto an internal focalizor), as, for instance, Fragonard does in *The Swing*.[43] Although the illuminations insist on the bedroom scene, and in this sense tap into its potential for erotic resonance, they do not insist on titillating the viewers.

One of the effects of the changes wrought in the miniatures is that those of us who look at the pictures are less likely to feel tainted by the ignominy of voyeurism, because we are not induced to identify with the humiliated figure of Fiammetta's Tancredi. The miniatures furnish us with a subject whom we may perhaps find more sympathetic than worthy of our scorn, and consequently they diffuse the negative portrait of viewing painted in the *novella*. However, by transforming the transgressive (voyeuristic) potential of vision in the *novella* into the less problematic princely/parental supervision, the miniatures restrict the range of vision. In addition, as a consequence of the miniatures' quashing the erotic aspects of viewership in the tale, much of the dramatic tension and conflict in the story are erased. In this sense, the verbal representation of vision in the *novella* is more interesting and suggestive than the visual representation of vision in the miniatures. This apparently paradoxical evaluation concludes with the *novella*'s ambiguity regarding imagination and physical vision to support the notion that imaginative vision, rather than actual vision, is the operative locus of desire and pleasure.

BOCCACCIO, BOTTICELLI,
AND THE TALE OF NASTAGIO
THE SUBVERSION OF VISUALITY
BY PAINTING

PICTURE IN YOUR MIND a naked woman screaming for mercy as she tries to outrun hunting dogs and a knight on horseback. The dogs pin her down; the knight dismounts, stabs her with his sword, eviscerates her, and throws the entrails to the dogs. In this chapter I will consider two different responses to this scene.

The murder scene, an example of the genre traditionally called *caccia infernale* (hell hunt), was very familiar in Western literature in the early Italian Renaissance.[1] The brutal scenario was inspired by Nordic myths and over the decades took on the meaning of punishment for specific crimes as a topos of the most educated and proper oratorical tradition.[2] Although *caccia* narratives imply and often presume guilt to be the cause of the cruel predicament, our concern here will be to examine two texts (one verbal and one visual) that depict a *caccia* scene in order to see just how the logic of that guilt is played out. The texts under consideration are Boccaccio's story of Nastagio degli Onesti (*Dec.* V, 8) and Botticelli's rendering of his own response to that story.

In Boccaccio's narrative the *caccia* is presented as a supernatural vision experienced by Nastagio in which the woman's crime (cruelty in love) is described by the knight who slaughters her. We do not learn the woman's name, and she never speaks. When Nastagio hears the knight's justification for the impending slaughter, he steps back and watches the knight murder the woman. Nastagio decides to present the *caccia* (which

takes place at regular intervals) at a dinner party he is giving in honor of a woman who has spurned his amorous advances.

Botticelli depicts the *caccia* scenes on a *spalliera* (wall panel) series commissioned as a wedding gift to a Renaissance couple whose marriage Lorenzo Magnifico helped to arrange (Figures 5, 7, and 8).[3] There is some disagreement over who exactly commissioned the *spalliere*. Ronald Lightbown claims that the father-in-law of the bride paid for the series, but most other scholars claim that Lorenzo did. Other than this scholarly dispute, the wedding present was not extraordinary in any way, except for the beauty of its execution. Most weddings during the Quattrocento between families of means included the presentation to the bride of the painted *cassoni* (wedding chests) and/or *spalliere*. These pieces of furniture, destined for the *camera nuziale* (bridal chamber), provided ample space for the depiction of stories by the artist. Commonly, in the paintings on *cassoni* and *spalliere* inspired by the *Decameron*, an entire *novella* is represented sequentially, scene by scene on the separate panels in a comic strip or filmic style,[4] yet this is not the case in the paintings we will look at here. Instead, three of the four panels Botticelli painted show only scenes in which the *caccia* appears. Botticelli's insistence on repeating this violent scene is especially remarkable in light of the fact that the *caccia* is described only once in Boccaccio's tale.

As we examine the two texts more attentively, we find additional interesting discrepancies between them; details from Boccaccio's *novella* are omitted or changed in Botticelli's paintings, while at the same time Botticelli alludes to several literary references that are absent from the *novella*. Independently, each of these works provides ample opportunity to question the motivation and logic of the *caccia's* cruelty, and, when we juxtapose them to each other, we can reconstruct and interrogate the premise of guilt on which the genre depends.

In Boccaccio's *novella*, the self-conscious, sometimes ironic tenor of the text encourages a critical reading of the *caccia*. Furthermore, the text's effective suppression of focalization by the women regarding their alleged guilt (they are both nameless and voiceless) calls out for investigation. When we look closely, we see that due to the extreme brutality of both the vision and Nastagio's staging of the scene, the suppression of focalization by the women in the story is necessary in order to engender sym-

pathy in the reader for the male protagonists. Once we recognize the text's masculine bias, we, as readers, can choose to question the sympathy requested of us.

In order to recuperate elements in the tale suppressed by the masculine bias and to uncover sympathy for the women's perspectives in the texts, we can look at the texts for hints of displaced evidence of the women's experiences, their feelings, and their voices. This strategy concentrates on the images and detail rather than the plot. In her article "Myth à la lettre," Mieke Bal describes this approach as "imaginative, identifying the visual . . . [cutting] across the traditional word–image opposition in order to fill in images where words predominate, and words where images repress words. Such a poetics . . . is based on shifting and displacing back: hence, it involves a rhetorical reading of the visual." The story of Nastagio is particularly receptive to this approach, because it is one of the most remarkably visual texts in the *Decameron*. Boccaccio's readers consistently respond to the description of the *caccia* by imagining the scene. In addition, the *novella's* insistent visuality is discussed at length by critics who frequently comment on the concrete quality of the vision. In fact, the effect on the critics is often so strong that they tend to describe the entire *novella* in anomalously visual terms. For example, in *Boccaccio medioevale*, Branca uses the words "chiaroscuro," "colorizing," "tangible," "mirroring," "reflecting," "sketching," "pure visibility and life" in his discussion of the *novella*.[5] In order to draw out sympathy in the story for the silent women, we can pay special attention to the details that most conspicuously address their plight, concentrating on the text's self-conscious presentation, its relationship to the Italian literary tradition, and its visual imagery. These elements in the text, which are present on many different levels, support a critical reading that questions the means and goals the *novella* appears to endorse.

Because the tale itself is embedded in an ambiguous and ironic framework that calls into question the very possibility of reading the *novella* in a simple, straightforward manner, it is important to examine the context that the narrative's fiction outlines for us. In the first place, the theme for storytelling on the day Nastagio's tale is related is "stories about lovers who, after unhappy or misfortunate happenings, attained happiness."[6] The story is told by Filomena, who introduces it as an *exemplum* which

she addresses to the women of the *brigata* by saying, "Amiable ladies, just as our compassion is praised, so, too, is our cruelty avenged severely by divine justice. In order to prove this to you, and to give you reason to drive all such cruelty [*cacciarla*] completely from your hearts, I would like to tell you a story."[7]

Although this introduction to the tale appears to be fairly clear-cut, I would like to point out that Filomena's punning address to the ladies is somewhat ambiguous. The verb *cacciare* can mean both "to throw out" (the denotation preferred in English translations of the tale) and "to hunt." On the one hand, the hunting denotation ironically foreshadows the literal hunting down of the woman accused of cruelty in love. At the same time, however, *cacciare* hints at an active, assertive role as well by calling upon the women to be the hunters, to *cacciare* the cruelty themselves. This subtle nod to the women to actively confront their circumstances does not by itself counter the overwhelmingly silent role the text assigns them; when we bring it to bear on the rest of the subversive messages embedded in the text, however, it provides the first clue that Filomena's narrative might exhibit some ambivalences about the stated moral.

In the context of the many contradictory stories in the *Decameron*, the appeal here to the authority of the genre of *exemplum* is suspect. Although the didactic strategy Filomena adopts in her tale has existed throughout literature and, in fact, during Boccaccio's time was employed frequently by the clergy,[8] it is arguable that Boccaccio's book questions the possibility of the uncomplicated use of *exempla*.[9] Of course, it is no surprise to hear that prior to Boccaccio prose narrative affirmed the operation of divine providence in human affairs.[10] In fact, in the literary tradition preceding Boccaccio, fictions commonly were used in the dissemination of Church dogma, and the narrative word was seen as a vehicle for the divine order it exemplified. This medieval use of narrative was based on a faith in "the Word" and it is articulated in a Christian paradigm that posits that *logos* gives sense to words and sustains them. This Christian system implies that the linking among self, history, and God through literal typology exists only if there is faith in *logos*.[11] Yet, in spite of the medieval literary context, it is clear after examining the *Decameron* that Filomena's address is not to be taken at face value by the reader. In fact, as we saw earlier in the tale of Griselda, the *Decameron's* project appears

to be contrary to the premise of the *exemplum*, which is to pose itself as the literal truth continuous with the divine order it manifests. Whereas Boccaccio's text cannot be called agnostic or antireligious, it is explicitly offered as a secular narrative. The book's narrator claims neither to be able to understand the mystery of the divine order nor to be able to express such an order truthfully and, instead, he repeatedly gives us stories that show the futility and deception of any text which might make the claim that it could convey the "Truth."

Readers of the *Decameron* are encouraged to explore skepticism in the text regarding literary authority on various levels, starting with the structure of Boccaccio's book. As a book with a frame narrative, the *Decameron* provides its audience with copious opportunities to witness literary criticism in action and, as a consequence, to learn to be critical readers themselves. By having ten different people tell ten separate tales based on a common theme each day, the *Decameron*'s narrator demonstrates the wide latitude of subjectivity that comprises any given story. And, in addition to the varying opinions and strategies contained in the fiction of the *novelle*, the frame narrative includes the *brigata*'s own internal criticism regarding interpretation of the stories. After each *novella* is told, we read how members of the *brigata* interpreted the story. This commentary (which is rarely homogeneous) frequently conflicts with the moral of the story it discusses. As if this were not enough internal criticism, the *brigata* often tells stories about the deceptive and manipulative potential of narrative. Marcus elaborates on this idea:

Boccaccio makes a break from the exemplary tradition, freeing his stories from any absolute interpretive systems . . . He does this by severing the conventional bonds between concrete experience and transcendent truth implicit in the *exemplum*, forcing his readers to examine the expectations they bring to the text, and to revise them in light of the dissonant and jarring narrations. The author must disabuse his public of the tendency to interpret stories in exemplary terms by making the *exemplum* discredit itself.[12]

Significantly, the very first story told in the *Decameron* is an anti-*exemplum*. It is the story of Ser Ciappelletto, a rapacious sinner who bluffs his way into sainthood by giving a false confession on his deathbed. Although Panfilo, the member of the *brigata* who tells the story, explicitly

claims that the case of Ser Ciappelletto should serve as an *exemplum*, this is certainly not true. It is impossible to reconcile the transcendent "Truth" intended by the genre of *exemplum* with the notion that the most despicable sinner in the world can be canonized by deliberately dissimulating in his last confession. Not only does Panfilo's story impugn the genre of *exemplum*, it is also a tour de force example of the expedience of lies. Thus, by making the threshold story a clear example of the potential for deception in narrative, the *Decameron*'s narrator openly criticizes the genre of *exemplum* and gives his audience their first lesson in critical reading.

By the forty-eighth story of the *Decameron*, the tale of Nastagio, the internal readers (the *brigata*) as well as the external readers have had many opportunities to sharpen their critical skills. So, when Filomena begins the tale of Nastagio by overtly stating her didactic intention, we are wary. We wonder about Filomena's motivation for presenting an "exemplary" story, in view of her conclusion, after the tale is told, that "all the ladies of Ravenna became so frightened that from then on they became much more amenable to men's pleasure than they ever had been in the past."[13]

The question comes to mind: What brand of divine justice is served by having the ladies from Ravenna become extremely *arrendevoli* to men's pleasure? The notion of sexual surrender is particularly disturbing when we consider the other connotations of *arrendevole*, which include yielding to fate, the suggestion of physical manipulation, and the implication that what is being "given up" or rendered is, in fact, being properly restored to the men. Indeed, the notion of women's sexual capitulation to men without divine or social sanction certainly is not in accordance with the social and religious codes regarding modesty at the time. So, taking all these factors into consideration, Filomena's story would seem to be yet another situation that calls attention to the unreliability of a narrative form that invokes divine justice to justify personal desires. This notion is reinforced by the striking fact that Filomena's *"exemplum"* exhibits an additional symptom of bias and distortion by having a woman tell the story of presumed female guilt. In light of these discordant factors, we need to look more closely at the story itself to understand the logic that motivates Filomena's claim of a didactic intent.

In the interest of reading for the visual images in the *novella*, it is in-

structive to explore an interesting literary association between the tale of Nastagio and a tale in Ovid's *Metamorphoses*. Ovid's story about Philomena is a comparably visual text that is wonderfully appropriate, since it concerns the namesake of the *novella*'s storyteller, Filomena. The ironic effect of Filomena telling a story of male desire is biting, as we shall see.

Ovid tells the story of Philomena, a woman who is abducted, raped, and mutilated by Tereus, her brother-in-law. After the rape, Philomena is held captive in a cabin and guarded by an old woman. She is unable to tell the woman her story because Tereus cut out her tongue during the rape. However, Philomena manages to circumvent her mute condition by weaving a tapestry that depicts her situation in graphic images. She sends the tapestry to her sister, who rescues Philomena. Once reunited, the women take revenge on Tereus by killing his son and then feeding Tereus his own son's flesh. Ovid's passage describing the rape scene is horribly graphic:

The double drive of fear and anger drove him to draw the sword, to catch her by the hair, to pull back the head, tie the arms behind her . . . But Tereus did not kill her; he seized her tongue with pincers, though it cried against the outrage, babbled made a sound something like "Father" till the sword cut it off. The mangled root quivered, the severed tongue along the ground lay quivering, making a little murmur, jerking and twitching, the way a serpent does when run over by a wheel, and with its dying movement came to its mistress' feet. And even then – it seems too much to believe – even then, Tereus took her, and took her again, the injured body still giving satisfaction to his lust.[14]

The detailed description in Ovid's tale increases our horror at the act perpetrated by Tereus. The text's insistence on the state of the severed tongue repulses us to the extent that it would seem difficult to extract sexual titillation or gratification from the assault described. The revulsion readers feel toward Tereus renders Philomena the sympathetic character, and therefore the reader is discouraged from identifying with Tereus's lust or his action. Consequently, instead of imagining dominance and control, as one might if one identified with Tereus, the reader experiences a sense of terror and helplessness by identifying with Philomena's predicament. The valence of reader identification in Ovid's story is particularly relevant to the tale of Nastagio, because the graphic description of the slaughter in the *novella* has a similar effect to the one

inspired by the rape of Philomena. The *novella's* detail of Guido degli Anastagi plunging his sword into his victim's chest while she screams for mercy engenders in the reader pity for the victim and disgust for the knight.

In light of Ovid's tale, the *Decameron's* choice of Filomena to tell Nastagio's story is disturbing. Filomena's literary heritage gives us cause to wonder at Boccaccio's decision to have her narrate a story that admonishes women to comply with men's desires. The reader's discomfort at the role Filomena is called upon to play is especially acute because there are other members of the *brigata* who would probably have been less distressing choices (e.g., Dioneo persists throughout the *Decameron* with commentary and stories that celebrate the triumph of the libido). The circumstances under which Filomena tells a story that is arguably more characteristic of Dioneo symptomatically indexes a problem. This conflict further encourages readers to question the "exemplary" status that the story pretends. The particular discordances I have pointed out support the interpretation that the book presents the *novella* in ironic, if not contradictory, circumstances, ones that we might not question if it were just another tale of ribaldry told by Dioneo.

As we shall see, visual imagination and literary references are the manifestations of sites of repression and displacement in the tale of Nastagio. The process we have adopted in order to read sympathetically for the victims rather than the hero is intimated to us in Ovid's story of Philomena. Like the woman in Boccaccio's *novella*, Philomena's means of communication in the world of discourse was removed when Tereus's sword rendered her speechless. Yet, in spite of his action, Philomena was able to communicate by visually representing her abuse on the tapestry. Therefore, because the language of Filomena's story explicitly maligns the women, we turn to the imagery of the narrative to read what has been obscured by the effort to present a sympathetic portrayal of Nastagio and Guido's behavior.

Close examination of Boccaccio's text reveals obvious allusions to, and direct quotations (both verbal and visual) from, Dante's *Divine Comedy*. These references to a decidedly moralizing and religious work highlight the fact that didactic stories can be used in a manner different from Filomena's stated purpose. If we examine the way the references to the

Divine Comedy influence our reading of the *novella*, we begin to see evidence of the subversion of Filomena's moral.

The primary form of punishment in the *Divine Comedy* is *contrappasso*, a visually sensitive system that is dictated by a Christian hierarchy wherein the punishment of a sin figurally fits the crime. The institution of *contrappasso* is clearly referred to in the tale of Nastagio by the *caccia infernale*. However, in Nastagio's tale, the logic of *contrappasso* is distorted by the absence of a divine hierarchy. There is no evidence in Filomena's story of an absolute referent. Without this anchoring, which in Dante's system is the *logos*, it is impossible to administer the absolute justice of *contrappasso*.

Significantly, although Filomena's narrative suppresses the victims' stories and sympathetically addresses Nastagio's situation, references to the *Divine Comedy* in the fabric of the tale point to the guilt of Nastagio and Guido (the knight) rather than that of the women. In fact, the conditions and circumstances transferred from the *Inferno* to Nastagio's tale work against the "heroes" of the *novella* by reminding us of the punishment of souls condemned to hell for behavior that is manifestly like that of Nastagio and Guido.

There are several specific allusions to the *Divine Comedy* in Boccaccio's tale that bear out the subversive subtext of the *novella*. The most literal reference is the choice of the pine forest of Chiassi as the setting for the *caccia*. This single reference ties into several parts of the *Divine Comedy*. First, it calls up the language used in *Purgatory* to describe the Earthly Paradise as "the pine forest on Chiassi's shore."[15] Obviously, the Earthly Paradise, as the scene of the fall from grace, bears on Nastagio and Guido's amorous preoccupation with the women, because some of the factors leading to Adam and Eve's expulsion are temptation to sin and the sexual awareness that follows the sinning. Strikingly, the women in the *novella* are not portrayed as temptresses and, in fact, actively discourage the men's attention. In addition to this direct reference to the scene of perhaps the most famous sexual transgression in Western literature, Nastagio's story takes place in Ravenna, which is very near to Rimini, the city of the unfortunate Paolo and Francesca (*Inferno* V). Paolo and Francesca are the ill-fated lovers who (through Dante's portrayal of them) are renowned in Italian literature because they could not restrain

their passion and consummated an extramarital affair, for which they were murdered. Dante places Paolo and Francesca in the second circle in hell, the area of the lustful. The issue that condemns them to suffer eternal damnation is precisely their inability to regulate their sexual passion. In Filomena's tale, only the men, Guido and Nastagio, suffer from an inability to control their sexual passion. Therefore, it makes sense that the damning allusions to the Earthy Paradise and Paolo and Francesca must be directed at Guido and Nastagio.

Another reference to Dante's poem can be found in Filomena's description of Nastagio's arrival in the woods. The aimless, oblivious wandering she describes recalls the beginning of the Pilgrim's journey through hell. The very first lines of the *Divine Comedy* are "nel mezzo del cammin di nostra vita mi ritrovai per una selva oscura che la dritta via era smarrita" (Midway in the journey of our life I found myself in a dark wood, for the straight way was lost).[16] This quotation characterizes the confused and erring way of the Pilgrim as he strayed far from salvation. Likewise, Nastagio wanders off unknowingly into a forest, where he witnesses *la caccia infernale*, a scene that gets it name and inspiration from hell. Boccaccio, in his commentary on Dante's *Inferno*, discusses the metaphoric function of the pathless wood when he discusses the forest of the suicides (*Inf.* VIII): "From this we can understand that the wood must have been wild, and therefore horrible."[17] Of course, the scene in the *novella* does not take place in hell, but the clear implication is that Nastagio is in a place of danger and his salvation is in jeopardy.

Yet another allusion to the *commedia's contrappasso* appears in Filomena's description of the *pineta di Chiassi* as "a wood thick with bushes and briars."[18] This account of the forest calls to mind Dante's forest of suicides, which is described in the *Inferno* as "a wood which was not marked by any path. No green leaves, but of a dusky hue; no smooth boughs, but gnarled and warped; no forest there were, but thorns and poison."[19] Dante's forest of the suicides is the place where the souls of those who died by their own hand are condemned to spend eternity. *Contrappasso* dictates that the souls of suicides assume the form of the forest's gnarled and twisted vegetation. It is my contention that the briars and thorns of the place where Nastagio strays allude to the hellish quality of that forest. Even more significantly, in referring to the forest of suicides, the nar-

rative brings a new moral element to the *novella*. Whereas the *novella* purports to discuss the sin of cruelty in love, the physical characteristics of the forest bring up the issue of suicide.[20] Although punishment for Guido's suicide is not discussed in Filomena's story, it sneaks in through the visual imagery of the story's setting, where acknowledgment of Guido's transgressions has been displaced onto his physical surroundings. In a figural move similar to Dante's scheme of *contrappasso*, both Guido and Nastagio (who contemplated suicide) appear in the environment that in Dante's poem they would have helped to comprise.

There is another strong connection between Dante's hell and the *caccia*. In the *Inferno*, the Pilgrim passes through the forest of suicides, where he catches sight of two naked men, torn by the thorns, running from a pack of black bitches, which catch up with the men and rip them apart: "naked and torn, fleeing so hard that they were breaking every tangle of the wood . . . Behind them the wood was full of black bitches, eager and fleet, like greyhounds loosed from the leash. On him who was squatted they set their teeth and tore him piecemeal, and carried off those woeful limbs."[21] The naked men are being punished for squandering their wealth. In life, the men were spendthrifts who had once been wealthy but, through deliberate and ostentatious extravagance, ruined themselves. In Dante's *Inferno*, this weakness of the will is considered a kind of suicide. In the analogous spectacle in Filomena's narrative, the men are replaced by Guido's victim. Ironically, Guido's victim is given the punishment of the spendthrift "suicides," whereas Guido (who drove himself to financial ruin pursuing the woman) takes the part of the hunter and Nastagio, who had thrown away almost all his fortune in his own futile seduction attempts, stands by and watches. Nastagio's presence as spectator is yet another of the *novella*'s significant displacements. The anonymous female victim stands in for both Guido and Nastagio, who, according to the logic of *contrappasso*, should be the ones hunted and slaughtered.

In contrast, if we compare the *novella*'s visual setting to Botticelli's paintings it is clear that the *spalliere* do not make visual reference to the treacherous potential of the woods (Figure 5). The peaceful background contradicts the impression of chaos, confusion, and danger that is depicted in the *novella*. Witness the calm water that melts into the sky har-

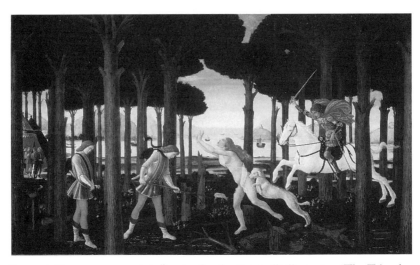

Figure 5. Tempera on panel *spalliera* by Sandro Botticelli illustrating "The Tale of Nastagio," panel 1, 1482–3. (Museo del Prado, Madrid. Photo courtesy of Museo del Prado, copyright © Museo del Prado, Madrid.)

moniously and the small vessel that floats tranquilly on the placid bay. Also note the presence of the lambs and deer, which are significantly unperturbed by the hunting; these animals, which are commonly skittish as well as the object of hunts, graze and take water unconcernedly in panels 1 and 2. In addition, the persistent detail of the quaint village off to the left in the background of the first three panels repeats the gesture of harmony and emphasizes by its proximity that this forest, unlike the *novella*'s, is not *"salvatica."*

The order and peace of the painted environment contrast with the *novella*'s references to Dante's Hell. Whereas every physical aspect of the *Inferno* is molded to reflect the anguish of the sinners being punished, Botticelli's forest has been crafted to reflect peace and harmony. What are we to make of this transformation? If we remember that what is being enacted in the painting's forest is a condemnation and punishment of woman's cruelty in love, we might be able to see the painting as an indication that the *caccia* and its presumption of guilt are not at all disruptive but correct. The civilized environment that coexists easily in the same frame with the murder indicates one level of cooperation with the

literal moral of the story. The peaceful coexistence seems to imply that the social and familial structures that create community and civilization are in concert with the moral of Filomena's story. Indeed, the paintings show a forest of orderly pine trees, which do more to subdivide and organize the space of the *caccia* than to indicate the confusion and terror experienced in the *novella*. Botticelli has replaced the Dantesque forest of the suicides in the *novella* with another in which the trees reflect Guido and Nastagio's power and stature while reinforcing the negative portrayal of the victim as vanquished and decrepit. Rather than pose a threat to Nastagio and Guido, Botticelli's trees reflect approval and support for them. We can see evidence for the identification between the men and the forest in the first painting (Figure 5), which conveys the idea that Guido and Nastagio are heroes by surrounding them with all the strong, tall, healthy pine trees, whereas the area surrounding the woman is made up of only dead, rotted, broken trees lying on the ground. It is interesting to compare Botticelli's depiction of the forest of Chiassi here with the drawing he made to illustrate Dante's forest of the suicides (Figure 6). It is clear when we consider the *spalliere* and the drawing for *Inferno* XIII, that Botticelli was not interested in placing Nastagio or Guido in circumstances that might allude to the issues of profligacy or suicide.

Similarly, except for one, all the trees in Botticelli's second painting (Figure 7) are strong and tall. These tall, straight trees divide the panel into sections that conveniently frame the separate actions depicted. The resulting segmentation of the panel reflects the temporal divisions in the narrative and makes room for the *caccia* scene to be represented three separate times in this one panel. The *caccia* scene we notice first is the foregrounded evisceration scene. Next, our eye travels to an analeptic episode of the *caccia* behind the evisceration scene.[22] Logically, this scene must be temporally discrete, because the chase had to occur before the evisceration. The third scene is represented proleptically in the lower right-hand corner of the painting; there the hounds consume the heart, which, in the central scene, Guido has yet to remove from the body.

The one exception to the straight, tall trees in this panel is the severed branch that lies in the foreground near the prone woman. Although the branch is not erect, it is still associated with the power of Guido. This branch has one sprig of leaves, which abruptly turns upward at the

Figure 6. Preliminary drawing in silverpoint on parchment completed in pen and ink by Sandro Botticelli illustrating Dante, *The Divine Comedy, Inferno* XIII, 1480–90). (Biblioteca Apostolica Vaticana, Vatican City. Photo courtesy of Biblioteca Apostolica, Vaticana).

woman's genitals. This detail in an already sexualized scene of violence metaphorically emphasizes the rapish quality of the knight's attack on the woman. The figural penetration of the woman by the branch is anticipated in the analeptic chase scene, where Guido pursues the woman with an upraised, phallic sword. In the foreground scene, although the woman lies defenseless and vulnerable, the penetration figured by the branch is displaced upward to the actual wounding and penetration of the woman in the area of her kidneys by Guido's sword and fingers. The shape of the wound, combined with the woman's posture, which conveys sleep/surrender/death, and Guido's active penetration, collectively serve to draw attention to the sexuality in the violent act. I deliberately use the words "displaced upward" as a reference to the Freudian concept of sublimation,[23] because here, as in many other parts of the paintings, Botticelli's masterful rendition of Boccaccio's famous story insinuates it-

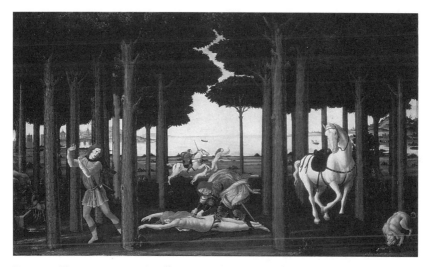

Figure 7. Tempera on panel *spalliera* by Sandro Botticelli illustrating "The Tale of Nastagio," panel 2, 1482–3. (Museo del Prado, Madrid. Photo courtesy of Museo del Prado, Madrid, copyright © Museo del Prado, Madrid.)

self into a position of presenting, as beautiful, scenes of horrifying sexual violence by virtue of the fact that the object produced is high art.

The sublimation of the violence portrayed in the *novella* is aided by the peaceful representation of the environment in all four paintings. Other details in the *spalliere* series reinforce the idea that Filomena's moral is in harmony with the social order. In the third painting (Figure 8) there are obvious stumps in the foreground; the trees, which have not been painted as unruly in the preceding panels, have been cut down. This act seems superfluous in view of the orderliness of the trees and, more importantly, because they were not in the way of the party. On one level, the fact that Nastagio has cut down the trees indexes his willful control over the "wild" forest. On another level, the cutting of the trees allows for our viewing. We are allowed to see because the trees that would have obscured our view have been truncated, a gesture that foregrounds the deliberate construction of the spectacle. In addition to cutting down trees, the scene has been further delimited by the erection of a barrier behind Nastagio's guests. The barrier helps to define the small arena in

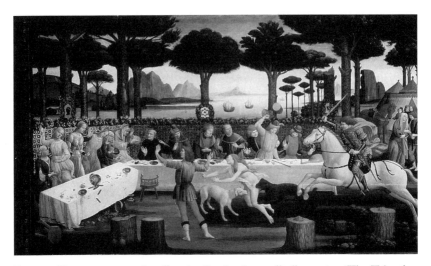

Figure 8. Tempera on panel *spalliera* by Sandro Botticelli illustrating "The Tale of Nastagio," panel 3, 1482–3. (Museo del Prado, Madrid. Photo courtesy of Museo del Prado, copyright © Museo del Prado, Madrid.)

which the spectacle will occur. This gesture of framing and containing the action invites us in to observe, indicating that the scene is to be watched. Not only does the painting stage the presentation of the vision, showing us a scene where people are positioned so as to see the *caccia*, it also frames the situation in terms of a scene being put on for *our* benefit. The trees that are cut down would not have interfered with Nastagio's guests' view; they could only obstruct the view of someone looking at the banquet from our vantage point. This particular organization, combined with the way the barrier encloses Nastagio's guests whereas our own viewing space is undefined, gives the impression that the guests as well as the *caccia* are on display. The manner in which we are invited in to view the staging of the *caccia* is unobtrusive, and the very subtlety of it informs us that it is safe to watch. As a result, we are led to believe that we will not be in any danger of being caught or hurt during the event. We are invited to view the brutal slaughter of the naked woman and the reactions of the guests to the murder in safety.

As we continue to examine Botticelli's paintings, we see more evi-

dence of sympathy for Nastagio and Guido, and, as we shall see, this sympathy necessarily condemns the women. In the first painting, Guido is seated atop a white horse in a posture reminiscent of paintings of Saint George slaying the dragon. Ironically, "Saint Guido" is not saving a virgin from destruction but destroying a woman who would not yield to his sexual advances. However, placing Guido in the position of Saint George implies that Guido is behaving nobly and heroically. A further implication of this posturing is that the woman is an evil and vile serpent. The aggressive Saint George pose is excessive in Botticelli's picture, because the adversary hardly seems to warrant such zealousness, let alone all the equipment. In fact, the spectacle of a man in full knightly regalia astride a horse, preceded by two hounds, does not make much sense when it is aimed at subduing a naked woman who appears so vulnerable and terrified. However, because the horse is white and the handsome knight reminds us of Saint George, the viewer is asked to read the woman as a dangerous threat.

Furthermore, the color of the horse in Botticelli's painting represents a significant departure from Filomena's tale. Rather than mount Guido on a black horse (as the *novella* does), Botticelli puts him on a white horse, which symbolizes virtue, purity, and strength. Whereas the *novella* describes Guido as "dark looking . . . threatening her with death in horrible and abusive language,"[24] the painting portrays Guido as a light-colored, handsome figure. Guido is placed in a central position in the painting and is represented in a position above the woman. Her impending doom is prefigured by his superior position and his red cape and sheath, which iconically foreshadow the gruesome nature of her death.

Unfortunately, this interpretation of Botticelli's painting does not help uncover sympathy for the women's perspectives, so, in an effort to enhance our reading of the story suppressed by Guido and Nastagio's perspective, let us return to Boccaccio's text. The allusions in the *novella* that damn Guido and Nastagio, combined with the lack of credibility of the genre of *exemplum*, provide the reader with ample incentive to question the logic of the story Filomena tells. This skepticism is facilitated by the fact that the narrative provides us with two opportunities to question the condemnation of the women in the parallel stories of Guido and

Nastagio. The *mise-en-abyme* structure of Guido degli Anastagi's story within Nastagio's story supplies us with two discrete outcomes to the scenario of the spurned suitor. The fact that the story has two versions in the *novella* encourages the activity of questioning the didactic tale that claims a single theme.

Although the similarities between the two stories are very clear, the differences are equally important. Investigation of the manner in which each story is focalized will help us understand whose interests are being served by the stories told. In the *novella*, the *caccia* scene is focalized by Nastagio, and, as a result, the narrative describing it is not palpably mediated by Filomena. This presentation provides us with what seems to be minimally mediated detail, a type of focalization that deemphasizes our position as external readers and places us directly in the action. Under these conditions, we tend to respond to this structure by imagining ourselves seeing the scene rather than imagining Nastagio seeing it. An important distinction to draw here is that although Guido is the exclusive narrator of his story within the *caccia* scene, Nastagio is the agent of vision. The scene is described to us through Nastagio's eyes. In the *novella*, his (and our) first impression is of injustice, and his initial impulse is to protect the hounded woman. However, when Guido narrates his version of the story with direct speech, Nastagio changes his mind and turns from protector into spectator. This transition is not necessarily repeated by the reader, who, at this point, may choose not to endorse the slaughter of the victim. The reader's potential reluctance is heightened by the fact that Guido's justification of his behavior is somewhat suspect. To the reader it seems odd that in spite of the fact that Guido's death came by his own hand because he could not control his passion for the woman, he clearly has the less painful of the two punishments. This discordant feature allows the reader to question Nastagio's motivations. We wonder how Nastagio can allow Guido to kill the woman without any further investigation or inquiry into her half of the story. As a result of our direct access to Guido's story, a gap can develop between us and Nastagio. Because we hear Guido's story verbatim, we can judge for ourselves whether or not we agree with him. In this way, we are able to see that the action Nastagio chooses is only one of several possibilities available to him, and we are provided with the latitude to agree or disagree

with his actions. Conversely, with respect to Guido's story we are told everything after the fact; it is presented as a fait accompli, and we discern no choice on his part or ours.

Nastagio's story is primarily focalized by Filomena and Nastagio himself. It is clear that the narrator, Filomena, is overtly sympathetic to Nastagio's condition of suffering from unrequited love. Throughout the *novella* Filomena presents Nastagio's behavior and motivations in a positive light, with the adjectives "magnificent," "splendid," "praiseworthy," "finest," "most elegant," and "compassionate," whereas the woman is referred to as "cruel," "harsh" (*dura*), "unfriendly" (*salvatica*), "haughty," and "disdainful." Yet in spite of Filomena's rhetorical bias, it is not clear to the reader that Nastagio is not just a parvenu buffoon who is pestering a modest noblewoman, who finds him unappealing at best. In fact, Nastagio's own friends seem to think his courtship behavior is less than circumspect. After Nastagio's friends encourage him to leave the city before he woos himself into financial as well as social ruin, his obstinate behavior (not going far enough away, and not leaving the woman alone) betray his lack of good sense and respect for others' wishes. Given Nastagio's profligacy and his subsequent terrorization of the girl at the dinner, it is possible for the reader to identify and question the prejudice in the narrative presented. As a consequence, we have yet another reason to become suspicious of the story's moral.

Within the narrative's structure, all signs point to identification between Nastagio degli Onesti and Guido degli Anastagi. In the *novella* this is borne out by the similarity between their names, their common birthplace, and their identical obsession with an uninterested woman, which leads each of them to squander his wealth and to consider suicide (and, in Guido's case, carry it out). Both Guido and Nastagio appear to share a propensity for engaging in masochistic behavior, insisting on pursuing women in the face of persistent rejection and humiliation, which is converted into sadistic behavior toward the "beloved": slaughter, by Guido; coercion, by Nastagio.

In Botticelli's paintings, identification between Guido and Nastagio is suggested differently. In the *spalliere*, the most obvious similarity between the two men is physical. In the first three paintings they have similar physiques, and their faces are almost identical. In addition, Guido and

Nastagio are indexically related to each other through their dress. Both men wear bright red clothes; Nastagio wears red pants, and Guido sports a flowing red cape. If we imagine their red separates combined into a single scarlet ensemble, we see that they complement each other and form a unified red shape.

As we shall see in the interpretation of Botticelli's paintings, focalization is also an agent of identification in visual art. To begin, we will examine one possible interpretation of the second panel. Here, the viewer's eye enters the painting at the center, where the corridor of trees, which allows light to enter from the background of the sea and sky, draws our eye to the middle of the panel, where our attention is focused on the prone white body of the woman and Guido's flowing red cape. Thus, the evisceration scene is the first part of the narrative we comprehend. Guido's figure bending over the naked, horizontal woman is menacing, his face looks cruel and hard. The many trees that frame Guido and the woman draw our eyes upward to the analeptic chase scene. Here we see the hunt in progress just as the white horse is about to overtake the naked woman and her legs are disappearing into Guido's red cape in the foreground. The cape's flowing folds appear almost liquid and create the impression that the woman is fleeing into a river of blood. Whereas in the first painting it was difficult to discern where the woman was headed, in this painting we are able to see that her destination is the combination of an empty field and a fantastic river of blood. To continue the syntax of the painting, the left-to-right motion of the chase takes our attention to the right-hand side of the panel, where the bright white horse stands set apart from his rider by the trees. The direction of the horse's gaze and his nervous motion turn our eyes back to the evisceration scene. If we resist reentering the cycle of vision just described, our eyes scan right to left in the direction of the halted motion of the prone body and Guido. The body's hands reach out empty, almost touching Nastagio's feet, but the tree prevents her from reaching his boots. Her gesture indexically brings our vision to Nastagio, who is represented in a state of motion. His torso turns away from the felled woman, although he still manages to keep his eyes on her. His hands are thrown up in a gesture that resembles the woman's hands in the chase scenes.

The syntax of our reading of the painting is dictated by light, motion,

and internal focalization in the painting. The cyclical pattern of the reading cleverly echoes Guido's claim in the tale that this scene occurs again and again through time. As we follow the circular motion described by the visual narrative (Guido, to analeptic chase, to the horse, to the evisceration, to Nastagio), we see that although compositionally the evisceration scene is the main subject of this painting, the internal motion indexically points to Nastagio as the end point, the receiver of the motion and explicit interpreter of the scene. The painting represents the actions in the panel as viewed by Nastagio, and, consequently, Nastagio is the internal focalizor with whom we identify in order to read events. The horror expressed by Nastagio's gestures reflects the gruesome aspect of the evisceration, yet his (and our) fascination with the slaughter of the beautiful naked woman is too strong to entirely turn away. He (and we) continue to watch. Our morbid curiosity is sanctioned visually because in spite of the fact that the painting elides Guido's justification sequence it nonetheless manages to represent an equivalent justification of the slaughter by having the internal focalizor we identify with look just like the man killing the woman.

The third panel depicts Nastagio's dramatization of the vision for his supper party. Not surprisingly, at this dinner dedicated to frightening women into sexual submission, the seating arrangement is governed by gender. The women's table runs perpendicular to the men's table as a subtle allusion to the fact that masculine and feminine interests are at cross-purposes here. As a result of this configuration, the women are positioned so as to cut off the trajectory of the fleeing victim, whose flight is directed straight at the table full of women. As the young ladies attempt to escape the oncoming stampede, the table is upset and the food is dumped off. The men, who occupy a grandstand position, facing us, look on with much less fear, more curiosity, and a lot less activity. Nastagio, who stands between the viewers and the banquet scene, gestures ambiguously in a manner that could be interpreted as an attempt to calm the guests down or perhaps to prevent them from intervening in the *caccia*. Our position across from and facing the men aligns us with their perspective. We look at the men, who in turn look at Nastagio, a mirroring identification in which we are included. We (along with the men) witness the hunt, but we are not directly threatened by it as the women are.

It is interesting to note that each of the men (except the old gentleman nearest to the women) is wearing a red article of clothing, identifying each of them with Guido and Nastagio and the bloody violence that they witness.

The four young women nearest to us share common facial features and hair color with each other and Guido's victim; however, they can be distinguished from one another by their dress and gestures. In fact, these four young women exhibit four very different responses to the scene of the *caccia*: one questions it, another runs away from it, another accepts it, and the fourth appears to be transfixed by it. The woman at the left end of the banquet table, dressed in green, looks upward with her palms turned up in a gesture of appeal or questioning, as if she were asking the heavens what is happening. The woman dressed in yellow turns away from the murder scene as if to escape. She appears not to want to confront the specter, and her abrupt move knocks over the table. The woman next to her has a completely different demeanor: she stands rather calmly, looking straight at the oncoming victim with a subdued gesture. This woman's blue gown recalls icons of the Virgin Mary, and her ability to look directly at the infernal scene echoes Mary's ability to look upon the devil with impunity. The woman in blue appears to be the least perturbed and most accepting of the spectacle to which Nastagio subjects them. We learn from the final *spalliera* that the woman in blue is Nastagio's intended victim; she is the one for whom Nastagio stages the scene, and she is the woman who will surrender her body to Nastagio as a result of being forced to witness this murder. The woman fourth from the left end of the table seems to resist her predicament the most. Her gesture is more animated than that of the woman next to her, and she appears to cast her eyes down to the ground in horror, as if in an effort to avoid looking directly at the scene. Her position at the table restricts her movements and prevents her from running away, so she is forced to regard the murder and evisceration of the victim. This woman's red dress links her iconically with the men at the banquet, but because of her vulnerable position, it is more evidence of her contamination by the bloody spectacle than an indication of her allegiance with the men.

Clearly, this *spalliera* represents a critical moment in the narrative of

the *novella*. The panel records both Nastagio's and his victim's social transformation. This is the point at which the formerly humiliated and exiled Nastagio is finally gaining control over his situation, recuperating his station and esteem just at the moment when the woman relinquishes control over her own life and delivers it up to Nastagio.

As I mentioned earlier, the progressive reintegration of Nastagio into society is reflected in Botticelli's painted environment. The series begins with civilization represented in the remote background of the paintings, but once Nastagio appropriates the *caccia* scene for his own uses, he imposes more urban features on the landscape. Nastagio's complete reintegration into society is represented in the last *spalliera* (not shown here), where the forest has been supplanted by an open colonnade of rather imposing weight under which the wedding festivities in honor of Nastagio and the Traversaro daughter are taking place. The pine forest appears to have been completely obliterated and is only obliquely referenced in diminutive laurel saplings that grace the three front columns. Whether the forest was destroyed or the wedding party simply takes place elsewhere, the point remains that Nastagio is no longer in exile in a forest. The remarkably balanced and symmetrical composition of the painting delivers the distinct message that order has been restored. It is noteworthy that the compositional bilateral symmetry is not perfect, because the two tables that the guests occupy are segregated by gender. The fact that the women sit on the left (sinister) side and the men on the right (dexter) side not only alludes to the fact that the social order questions the women's moral and intellectual fiber but, as we shall soon see, also mimics the proper configuration of the partners in a marriage according to the language of heraldry.

The organization of this wedding scene is dictated by a methodical Albertian perspective, with the columns, tables, and arches directing the viewer's eyes through the center of the panel to the vanishing point, a distant view of the bay framed by the two arches at the end of the portico. This panel exhibits the most rigorous attention to Albertian perspective of the set, a fact that bears upon the social message of the panel's resolution. (This notion is further underlined when we consider the extreme rigidity of Leon Battista Alberti's prescriptions for family life in

his treatise *Della famiglia*.) Wendy Steiner discusses the implications of the Albertian perspective in her book *Pictures of Romance*:

A model of communication is implied by the Albertian system that involves a mutual creativity of meaning on the part of the viewer and painting. The painting does so by modeling an ideal observer who reacts to the scene he or she observes. This ideal viewer is part of the painting that real viewers interpret, so that the act of interpretation is part of the matter to be interpreted . . . [T]he Renaissance model suggests an educative role for the painting and a training in response for viewers, who should come to match the response or responses they witness.[25]

When we consider the dominating colonnade in the last panel, the lesson that the viewer is intended to learn according to the Albertian system seems to be that the threat of violence and instability figured in the preceding panels have been entirely overcome. Instead of the earlier, colluding positions we occupied as external viewers, we have now been formally distanced and introduced to an ideal viewer who is a remote and controllable student of the painting. The predominance of the architecture in this panel conveys a literal reading of Filomena's moral by lining up all the women to receive the men and by encasing all of them in an overarching, civic context represented by the ornate portico.

In order to elaborate on the significance of the segregated wedding party, I will return to the third panel (Figure 8). This third panel is the first place where we see the coats of arms of the families of the couple for whom the *spalliere* were made. The juxtaposition of these *scudi* here and in the fourth panel refers symbolically to a marriage. Significantly, in this third panel, the *scudo* that represents the groom's house is hung on a tree beyond the barrier, directly behind the woman in blue at precisely the moment when she is corralled by the barrier, Guido's charging entourage, and Nastagio. As Guido bears down on the woman, his upraised sword cuts across another shield, and, interestingly, it is the one that emblematizes the matrimonial union of the couple for whom the panels were commissioned. Thus, the Renaissance couple whose marriage the panels celebrate is introduced at the point in the story when Nastagio scares his bride to be into submission.

It is helpful to review the nuptial traditions surrounding this gift in order to see how the fictional and real couples fit together. An investigation

of the way the actual Renaissance couple and Nastagio and the Traversaro daughter are placed together in Botticelli's *spalliere* is instructive in our interpretation. The *spalliere* were part of the elaborate ritual and exchange of goods between the families of the betrothed and were intended to be displayed in the *camera nuziale*.[26] In general, the stories depicted on *spalliere* were specifically chosen for the occasion of the union of a man and a woman and were intended to reflect the particular donor's ideology regarding the institution of marriage and the relations between men and women. Most commonly the *cassoni* or *spalliere* were commissioned by a man, either the father of the bride, the groom, or another male involved in the contract, and as a result most are concerned with specifically male perceptions and fantasies about marriage. Consequently, the furniture paintings often depicted stories intended to edify or compliment the bride (the tale of Patient Griselda appears on several such nuptual gifts).[27]

The symbolism of the *scudi* in the third and fourth panels is as follows: on the left side of the painting is the Pucci coat of arms (a Moor's head), hung on a tree directly behind the young woman in blue. The fact that these arms are alone on the shield indicates that they belong to the bridegroom's family. In the center of the painting hangs the celebrated Medici *scudo*, with the fleur-de-lys and the six *palle*, or balls. The central position of this *scudo* underlines the importance of the Medici family, as well as the fact that it was Lorenzo Il Magnifico who arranged the marriage. On the right, the shield that is obscured by Guido's raised sword shows the arms of the Pucci impaling those of the Bini, a configuration that in the language of heraldry indicates that the bride was a Bini. Historically there has been some confusion as to the exact identity of the happy couple; however, this was cleared up earlier in this century. As Lightbown explains, "in Italian heraldry when arms were impaled, the arms of the husband are shown on the dexter side and those of the wife on the sinister. Hence the bridegroom of the marriage must have been a Pucci . . . [T]he series was painted to commemorate the marriage of Gianozzo di Antonio Pucci with Lucrezia di Piero di Giovanni Bini."[28]

Certainly, the languages of art history and heraldry collude with Botticelli's paintings to praise the "able" (dexter) men (Nastagio, Guido, and Pucci) and condemn the "evil" (sinister) women (Nastagio's and Guido's

victims and Lucrezia di Piero di Giovanni Bini). In addition, Lucrezia, who already bears the names of two men, is obliquely referred to as the Traversaro daughter in the painting. Thus, the painting extends the reach of Filomena's moral outside the fictional realm of the women of Ravenna and the *brigata* to the actual Renaissance bride, who is otherwise rather obscure; in fact, most of what we know about Lucrezia is derived from the panels that decorated her bedroom. In this respect, she shares a certain interchangeable anonymity with the women in Filomena's tale. We know her last names and the name of the man she married; hers is just another woman's story that eludes us in our interpretation of Botticelli's paintings.

In Filomena's narrative in the *Decameron*, the women are virtually interchangeable; neither gets to tell her story directly, and each one's behavior is focalized through hostile agencies that describe them as cruel and wicked without providing any clear examples. I would argue that the narrative constructs the women not as agents of action but as objects. The women's passivity is emphasized in the story by the fact that the *caccia*'s victim has no choice or expression of desire. She exists exclusively as the object of the hunt, and her only action is a vain attempt to escape. In the same way, the actions of the woman that Nastagio pursues result from his manipulation. Nastagio pursues her affection, and she rebuffs him. He has her come to the forest, where he stages the sadistic spectacle, and she responds by offering him her body. He rejects this offer, choosing instead to take both her body and her dowry. She consents. The status of the woman Nastagio pursues is clearly delimited by the penultimate sentence of the *novella*: "e la domenica seguente Nastagio sposatala e fatte le sue nozze, con lei più tempo lietamente visse" (and the next Sunday Nastagio married her, and having celebrated the nuptials, he lived happily with her for a long time).[29] *Sposatala* relegates the woman's participation and identity to a direct object pronoun tacked onto the end of the past participle. The iconicity of this grammatical construction emphasizes her passive, anonymous, and rather arbitrary character (she could be any singular, feminine noun). Nastagio, on the other hand, has quite a different grammatical role as the sentence's subject, and, as such, maintains his independent identity and influence. Nastagio's centrality is further demonstrated by the language "con lei più

tempo lietamente visse." The final word of the sentence, *visse*, is the third-person *singular* conjugation of the verb "to live." The action of this verb, which is described as being "happily," only refers to one person: Nastagio. The sentence does not in any way indicate how the woman lived. The use of the third-person singular is a conspicuous omission, which in Italian makes it clear that Nastagio is the focus and the woman is excluded.

In the Botticelli painting, the distinction between the women Nastagio and Guido pursue is obvious. The woman Guido hunts is naked and separate from the others; however, notwithstanding the distinctions I have made earlier among the young women at the table, there is a certain physical resemblance between them and Guido's victim. The ambiguity of this resemblance cleverly echoes the didactic conclusion of Filomena's tale. By endowing the women with certain similarities, the painting implies that all the women were collectively affected by the *caccia* and that all were potential victims. It also implies that as potential victims, they all responded to the vision by deferring to the men's desires, which is exactly Filomena's claim in the *novella*.

As we have seen, Botticelli's paintings of the story seem to justify the repression of the women rather than indicate a problem. In response, we will turn back to Boccaccio's text and take another look at the *caccia* scene, because it is the most strikingly visual part of the narrative. The scene begins with Nastagio deep in "sweet thought" as he wanders into the forest of Chiassi. The Italian word *chiasso* means "din," "uproar," and "racket" and has connotations of confusion and disorder, so that, along with the visual allusions to the *Divine Comedy* discussed earlier, this place also has a chaotic acoustic resonance. The *novella* tells us that as Nastagio haphazardly enters this chaotic area he is thinking, he is so absorbed in his thoughts that he is oblivious to his surroundings. It is interesting to speculate on his meditation. We know that he has been rejected and shamed out of town. In the country he takes a walk in the woods, where he is lost in thought about the girl. Suddenly, in the infernal forest he experiences a supernatural vision. This vision plays out what might be considered an elaborate revenge fantasy of a spurned suitor. Nastagio, who has stopped short of taking his own life, sees what it might be like if he had, in a very sadistic "wouldn't she be sorry if . . . " scenario. Ini-

85

tially, Nastagio feels compassion for the condition of the girl but only until he learns that she has been "cruel" to the man on the horse. The knight, by invoking divine justice as the sponsor of his behavior, exonerates himself from any blame. Nastagio quickly accepts the story and steps back to watch the terrible scene. At first, the men's relationship is antagonistic, but once the knight has explained his actions they unite in will and purpose, and the revenge is endorsed and abetted by Nastagio.

As I have noted earlier, the specific act of slaughter engaged in by Guido is heavy with sexual overtones. The knight impales the woman with his sword; then he turns her over and cuts opens her kidneys (*rene*)[30] to remove her entrails. The brutally violent penetration and evisceration of the woman mimics the sexual activity in which the man was never able to engage during his lifetime. The fantastic vision figures a possible fulfillment of two of Nastagio's impulses: first to have sex with the girl, and second to punish her for denying him his pleasure.

If we treat the *caccia* as a fantasy, we can see that Nastagio projects an image of himself into a very different position from the one he occupies in the relationship he has tried to establish with the girl. Instead of imagining Guido being run out of town by the girl, he imagines him hunting her down and butchering her. Guido can be read as realizing actions Nastagio would have liked to perform and, Guido therefore acts as a mirror image of Nastagio that has been corrected. In this fantasy scenario, Nastagio, aware of his deficient performance in his courtship, imagines a scene wherein the spurned lover triumphs and exacts revenge. Of course, the fantasy has the advantage that Nastagio does not actually have to get his hands dirty, because the revenge is acted out by Guido degli Anastagi. In addition, the *caccia* provides Nastagio with the opportunity to watch his most terrible revenge taken on a woman (who is easily identifiable with the girl he has pursued) without fear of reprisal or failure, because it is performed with divine sanction.

Yet, Nastagio does not stop here. It is not enough for him to see the vision himself; he wants to impose it on others as well. What initially occurs as a bizarre supernatural vision, Nastagio appropriates and presents as a sign to a select audience. He directs their vision and their interpretation of the spectacle. As I discussed earlier, this active appropriation

and presentation of the vision inaugurates Nastagio's reentry into society. His bizarre personal fantasy becomes generalized and incorporated into the social structure. The violence with which the punishment is effected leads to a change in the social structure that previously sent him into exile for his behavior. Thus Nastagio, as proprietor of the vision, reconfigures the social realm to fit his preferences.

I do not believe that this means that the story is simply a cautionary tale that reflects and promotes the subordinate position of women. As we have seen throughout this chapter, a simple and straightforward message such as the one given by Filomena is greatly complicated by the fact that certain elements in the story itself offer resistance to it. In addition, the dynamics of identification that characterize the reader–text relationship promote subversive and unstable readings that tug at the fabric of the tale and open up space for readings that contradict or are contrary to the dominant interpretation. As I noted in Chapters 1 and 2, with respect to Griselda and Ghismunda, identification is a complex and fluid practice; it creates the possibility for multiple and successive identificatory positions, which means that readers can assume several different perspectives over the course of the narrative. Thus, the assumption that the reader identifies with Nastagio is too simplistic and facile; it clearly does not cover or exhaust the spectrum of possible interpretations of the story. Throughout this chapter I have tried to delineate alternative positions in the text with which a reader may identify, in an effort to call into question the explicit claims to didacticism Filomena makes.

I have attempted to present the case that a recognizable censorship is demonstrated in this *novella*. My attempt to adopt a strategy of reading the visual imagery that escapes the verbal censorship has been met here with both opposition and success. Although my "visual" reading of Boccaccio's text implicates Guido and Nastagio as victimizers rather than victims, Botticelli's paintings stubbornly refuse to acknowledge their guilt. Instead, the paintings insist on privileging the men as focalizors, at the expense of the women.

The paintings' particular emphasis is reflected on many different levels. First, as one would expect, the visual texts exploit paradigmatic rather than syntagmatic associations by deemphasizing chronology and

sequence and by taking advantage of the potential for enhancing detail. Thus, in Botticelli's work the same *caccia* scene is repeated almost obsessively. Second, the focalization within the paintings promotes identification with Nastagio and Guido, because there is no opportunity to see the scene through the women's eyes. Because the paintings encourage the viewers to identify with the men, the process of viewing the paintings takes on a cruel and controlling tenor. We are encouraged to take pleasure in gazing at the sexually charged mutilation of the naked woman and, at the same time, to experience a sense of mastery. Because the women never address the viewer themselves, and because they are presented to the viewer as spectacle, we are invited to enjoy their slaughter and terrorizing at the banquet with impunity.

However, as I have argued, this is only one response to the tale of Nastagio. I contend that the *novella* offers the possibility of very different interpretations. As we have seen, it is perfectly feasible to read the internal contradictions and ironic references within the *novella* as an indictment of the "*exemplum's*" morality. In addition, the fact that the *novella* allows for the contradiction of its overt project while simultaneously calling into question the integrity of Nastagio and Guido presents us with the possibility that the significance of the *novella* does not rest exclusively on the story constructed in Nastagio's interest. Instead, the nonlinear set of contentions that I have derived from the visual clues that seep into the text undermines the stated moral of the story and reflects a form of narrative that does not make absolute claims to the Christian truth proposed by Filomena. This reading calls into question not only the logic of the story but the position of the reader of the text and the viewer of Botticelli's paintings as well. As a consequence, the reader's position becomes ambiguous (In which moments does one identify with the victim and in which with the victimizer?) and allows for shifts between gender roles and power positions. By taking up the challenge to investigate these fluctuating and alternative modes of identification in this chapter, we have seen that, in fact, Botticelli's visual representation of the *caccia* scene works toward aesthetisizing the violence and condoning the aggressive behavior. We have seen that Botticelli revised the *novella's* imagery in a manner that enforces Filomena's moral, thereby curtailing the wealth of subversive and contradictory elements in Filome-

na's tale. Conversely, we have seen that by reading for the detail and imagery in the *novella,* we are able to discern ambivalences in the text that reveal to the reader alternative identificatory positions in the narrative that support an interpretation which questions the social mores that underpin the literal level of the text.

CHAPTER FOUR

IMAGINATIVE ARTISTRY
GIOTTO, BOCCACCIO, AND PASOLINI

IN THE PRECEDING CHAPTERS I have shown how juxtaposing different media representations of a single story affords critical insight into the particular narrative as well as the media themselves. Here I will consider Pier Paolo Pasolini's 1972 film *The Decameron* in an effort to explore the feasibility of using the reading model applied in the earlier arguments in the interpretation of an entirely different medium, film. In addition to being an audiovisual medium, Pasolini's film also incorporates painting and elements of the written text into its version of the stories, thus providing an opportunity to investigate the interpenetration and mutual illumination among the various media. Consideration of Pasolini's film also widens the range of subjective configurations with which a viewer/reader may identify. The social and erotic valences emphasized in the sequences of the film that I will discuss can be distinguished from the texts previously discussed in that they do not address a heterosexual aesthetic directly. Instead, the primary concern of these segments involves specifically male community and interaction.

Pasolini's *Decameron* presents ten of Boccaccio's *novelle*, augmented by ten episodes of Pasolini's own invention. The film also transfers the action from Tuscany to Naples and replaces Boccaccio's *cornice* (or narrative framing structure) and *lieta brigata* with a different framing structure animated by elaboration on two characters drawn from within the *novelle*, Ciappelletto and Giotto di Bondone, the famous Florentine

90

painter. Under this scheme, stories in the first half of the film are wo-
ven together by episodes that flesh out the character of Ciappelletto
in anticipation of the final story, which is the *novella*[1] about Ciappel-
letto (*Dec.* I, 1). The second half of the film begins with Boccaccio's tale
about Giotto. Once Pasolini reaches the end of that *novella*, he pro-
ceeds to extrapolate the figure of Giotto into an entirely original nar-
rative sequence that forms the framing structure for the tales in the sec-
ond half of the film.

In this chapter I will investigate how the figure of the artist and his
work are represented in both Pasolini's and Boccaccio's *Decameron*s in an
effort to describe the similarities among the creative and interpretative
practices employed by Boccaccio, Pasolini, and myself. I will focus on
the Giotto episodes of Pasolini's film, paying particular attention to the
parallels between the production of the fresco for the Church of Santa
Chiara depicted in the film and Boccaccio's metaliterary project in the
Decameron. Comparison of the figure of the painter (Giotto, in the film)
with the figure of the author (the "Author" in the *Decameron*) illuminates
some common elements in the works themselves and addresses some of
the common creative strategies. However, although the common points
between Pasolini's Giotto and Boccaccio's Author are many, they do not
map exactly onto one another. Important issues such as the status of fan-
tasy, imagination, and play are treated very differently by the two char-
acters. In the interest of bringing out these differences, I will call upon
the character of Calandrino as a particular version of the artist in Boc-
caccio and Pasolini. The differences between Pasolini's and Boccaccio's
practices are instructive, because they foreground the limitations and
strengths of each medium's communicative abilities. The interdiscipli-
nary initiatives displayed in the two *Decameron*s enhance my own inter-
pretative practice, because they provide me with an opportunity to in-
clude two more metaliterary approaches in addition to my own, thus
widening the range of possible interpretations.

Painters figure in several different ways in Boccaccio's *Decameron*. Out-
side of the *novelle*, in the "Author's Conclusion," the artist's freedom of
representation is called upon by the Author as justification for his own
creations. Within the tales told by the *brigata*, Calandrino, Bruno, and

Buffalmacco are perhaps the best-known examples of artists, enlivening as they do five particularly amusing *novelle*,[2] whereas Giotto (*Dec.* VI, 5) makes his brief appearance in a tale dedicated to the witty response.

Painters enjoy a close association with verbal wit in these tales where the connection between verbal and visual acuity is insisted upon. Painters in Boccaccio's *Decameron* are represented as being able to see past exterior semblances and penetrate to a deeper understanding of the object of their gaze and, as a result, to execute a painting that conveys those deeper insights. The painter's critical eye corresponds to a discerning mind, which is also able to produce acute verbal formulations. In fact, it is precisely in his formulation of the painters' verbal and visual astuteness that the Author draws upon painting to extol and defend his own literary artistry. Additionally, in his interventions, the Author implies that writers have a mental acuity comparable to that of painters and, as a consequence, are perceptive students of painting. The Author establishes an affinity between his own work and the painter's trade in the *novelle* before he calls upon them to support his claim to artistic license in the "Author's Conclusion."

My decision to discuss the connections between the figure of the artist in Boccaccio's work and the authorial voice of the *Decameron's* Author requires that I elaborate on the structural differences between them. To this end, it is important to clarify the hierarchy that orders the relationship between the narrative levels of Boccaccio's text. Boccaccio's frame narrative includes within its fictional limits an authorial voice (the Author), which interjects itself into the dedication to the lovesick ladies in the "Author's Preface" and the defense of the stories told in the book included in the introduction to Day Four and the "Author's Conclusion." A structural similarity exists between the authorial voice, which tells the entire book, and the members of the *brigata*, who tell the *novelle*. This similarity in turn parallels the structural similarity between the *brigata* and those characters in the tales who also tell stories. In the context of this framing configuration, a reader sensitive to issues of literary self-consciousness can argue that one way to interpret the *Decameron* is as a lesson on how to read and write. This said, I want to argue that the parallel between the Author and the painters in the *novelle* is motivated by more than literary self-consciousness particular to frame narratives. In

fact, in Boccaccio's *Decameron* a privileged relationship exists between the verbal and the visual arts and their practitioners, which is operative both in the didactic aspects of the book (teaching the arts of storytelling and listening) and in its aesthetic sensibilities (the realms of fantasy, play, and pleasure). The connection is made most concisely in the "Author's Conclusion":

There will, perhaps, be some among you who will say that I have taken too much license in writing these tales; that is, I have sometimes made ladies say things, and more often listen to things, which are not very proper for virtuous ladies to say or hear. I deny this, for nothing is so indecent that it cannot be said to another person if the proper words are used to convey it; and this, I believe, I have done very well.

But let us suppose that you are right (I do not intend to argue with you, for you are certain to win); then, let me say that I have a number of reasons ready to explain why I have done what I did. First of all, if there are liberties taken in any of the tales, the character of the stories themselves required it, as will be clearly understood by any proficient person who looks at them with a reasonable eye, for I could not have told them otherwise without totally distorting their form. And if they do contain a few small parts or little words here and there that are somewhat freer than a prude might find proper (ladies of the type who weigh words more than facts and who strive more to seem good than to be so), let me say that it is no more improper for me to have written these words than for men and women at large to fill their everyday speech with such words as "hole," "peg," "mortar," "pestle," "wiener," and "fat sausage," and other similar expressions. Moreover, my pen should be granted no less freedom than the brush of a painter who, without incurring censure or, at least, any which is justified, depicts Saint Michael wounding the serpent with a sword or a lance and Saint George slaying the dragon wherever he pleases, not to mention the fact that he shows Christ as a man and Eve as a woman, and nails to the cross, sometimes with one nail, sometimes with two, the feet of Him who wished to die there for the salvation of mankind.[3]

As we can see from the "Author's Conclusion," not only are painters witty speakers and writers visually acute but proficient readers are called upon to be visually sensitive in their interpretation of texts. The Author exhorts us to "look" with "a reasonable eye" at the undistorted "form" of the *novelle* and endorse his inclusion of certain "freer small parts." His address specifically demeans as "prudes" the ladies (with whom, if we are

good readers, we will not identify) who clearly are unable to see past exteriors to a deeper meaning and therefore are concerned solely with appearances. The Author's insistence on demanding that double entendres be acknowledged as having more than one meaning – that is, a nonsexual meaning as well as a sexual one – backs up his claim that "a corrupt mind never understands a word in a healthy way! And . . . a healthy mind cannot be contaminated by words which are not so proper"[4] and underlines the subjectivity of the interpreter. In his defense of his "words" the Author calls upon liberties taken in religious painting as a justification for his own artistic license. Initially, the comparison seems less than appropriate, because at first glance the examples appear devoid of sexual subtexts.[5] Perhaps the sexual connotations of religious art are not as readily apparent to the average viewer as those of verbal double entendres, yet one need only read Leo Steinberg's *Sexuality of Christ in Renaissance Art and in Modern Oblivion* to see that this is not because they are absent from the painting but rather because the average viewer ignores sexuality when interpreting religious art. Of course, there are many scholars who object to the range of Steinberg's claim;[6] nonetheless, the point that viewers tend to ignore the representations of the physical bodies of religious figures still holds. The Author thus defends his literary art by likening it to painting, which enjoys less censorship in spite of its similar content.

In order to continue investigating the relationship between verbal and visual art in Boccaccio's and Pasolini's *Decamerons*, it is important to examine the role of artists in Boccaccio's *Decameron* and their relationship to storytelling. The first artist to appear in the *Decameron* is Giotto, the hero of a story told by Panfilo on the sixth day of storytelling, the day on which the witty retort is celebrated. The tale begins by introducing Messer Forese and Maestro Giotto as ugly men. Once these men have been described, Panfilo lingers for a while, describing Giotto's great fame and skill as an artist. The anecdote begins abruptly with a description of Giotto riding to Florence in the company of Forese, who is a renowned attorney. The two men encounter foul weather and as a result are reduced to a very bedraggled condition. As the mud-besmirched pair rides on, Forese comments to Giotto that because Giotto looks so ugly now, anybody who did not already know him would not believe that he was

the best painter in the world, as he is. Giotto minces no words and responds that, for the same reason, anyone who did not know the great lawyer would not believe that he knew the alphabet.

Obviously, verbal riposte, not painting, is the point of the story. Indeed, in this light, we can see an affinity between Giotto's witty retort and the Author's defense in the introduction to the Fourth Day and the "Author's Conclusion." The Author's humorous and clever rebuttals of his critics depend on his ability to undermine their claim to authority. In his defense, the Author argues that either the critics are unworthy of commenting on his work because their moral and aesthetic sensibilities are inadequate or distorted, or that their concern for the Author's propriety is misplaced. In the same way, Giotto discredits Forese's observation by pointing out that the criteria Forese uses to poke fun at Giotto apply to the attorney as well, and so, if appropriate, would impeach his judgment. In fact, if the Author were to designate his own interventions to any particular day in the *Decameron*, it could easily be argued that he would choose Day Six, given the similarity in the strategies employed by the witty retorters and by the Author in his defense of the *novelle*. It is noteworthy that Giotto is represented under these circumstances. One might imagine that space could be made for a tale that centered on (or at least involved) his painting prowess rather than focusing on his clever conversation. Furthermore, although Panfilo's story extols Giotto's artistic skills, it does so in almost a perfunctory way. In his article on Florentine painters in the *Decameron*, Paul Watson points out the formulaic evaluation of Giotto's skill in Panfilo's praise of Giotto, demonstrating that Boccaccio virtually repeats the principles of art criticism in Pliny's *Natural History* to evoke Giotto's art. Watson argues that Boccaccio praises Giotto's mimetic ability in terms that few art historians deem accurate, pointing out that many critics have commented that although Giotto was certainly innovative in his representation of people (humanizing biblical figures, giving ethereal bodies physical weight, etc.),[7] "[n]o one nowadays considers his works masterpieces of *trompe l'oeil* illusionism nor probably, did any of his contemporaries."[8] Whereas it is certainly possible to explain Boccaccio's rhetorical excess with regard to Giotto's realism as "a poet's" approach to art criticism, which calls upon the institutionalized authority of the ancients as a way of emphasizing Giotto's greatness,[9] I

would argue that it also points to a particular notion of representation that is common to both Giotto's and Boccaccio's work. Even if no one mistook Giotto's figures for live people, the naturalistic way in which they are represented (especially relative to the Byzantine figures with which they could have been compared) created radically different avenues for interpretation of divine figures by the average churchgoer.[10] In much the same way, Boccaccio's celebrations of humanity, although clearly not to be considered nonfiction by the readers (notwithstanding the Author's protestations to the contrary), provided anthropocentric critiques of the material fact of everyday life by criticizing powerful institutions such as the Church and the state while holding up examples of triumphant individuals who got their success outside or in spite of traditionally oppressive structures. Thus, both Boccaccio and Giotto created texts that offered access to individual critiques of contemporary life.

In a different take on the figure of the artist in Boccaccio's *Decameron*, the Calandrino stories chronicle the vast imaginative powers of artists both in developing madcap fantasies and in inhabiting them. The cycle turns on the ability of Bruno and Buffalmacco to deceive the gullible Calandrino and Master Simone. The elaborate ruses employed by Bruno and Buffalmacco to trick Calandrino have as their goals general amusement and personal gain. In the stories, Bruno and Buffalmacco's artistic skills are celebrated for their ability to generate illusion; they make the others believe things that are simply not true. Although the duplicitous duo occasionally call upon their trade for this purpose (e.g., painting bruises on their bodies to fool Simone [*Dec.* VIII, 9]), their verbal control over situations and things is the key to their success as pranksters. Yet, although verbal manipulation is the stuff of which their pranks are made, painting is still central to the way in which they proceed. The connections between Bruno and Buffalmacco's trade and illusion have been remarked upon at great length by many critics,[11] including Watson, who, in his discussion of Giotto, Bruno, and Buffalmacco, concludes that

what other men value, painters assail. Not only is the painter a satirical rogue but he is also a potential subversive. Subversive too is his art which can mislead the visual sense of most men . . . Feigned or real, the license that a painter enjoys in his workshop is the counterpart to the license some painters employ off

the job: the freedom, somehow, to be exempt from society's usual constraints, to satirize, even to shock.[12]

Watson's argument is made with the Author's self-defense in the "Conclusion" against charges of obscenity in mind. In this vein, Watson emphasizes the subversive potential of art as an effective response to the accusations that the stories are corrupting and evil. It is worth noting, however, that although this is certainly a reasonable argument, it glosses over the fact that Calandrino, the butt of most of Bruno's and Buffalmacco's jokes, is also an artist. Watson's point that "eighty percent" of the artists in the *Decameron* have "a '*visivo senso*' more discerning than that of other men and that acuity of vision enables painters to discern error and folly in others"[13] applies only to the artists who come out laughing in the end, not to Calandrino, who cannot tell when his leg is being pulled.

In making the claim for superior visual acuity of painters, Watson discounts Calandrino by explaining that he was just in the lower twentieth percentile in wit. Other critics, such as Marcus, incorporate Calandrino's incompetence as yet another example of how literary self-consciousness in the *Decameron* undermines claims to absolute Truth in narrative. Marcus argues that whereas Bruno and Buffalmacco reflect the ability of the storyteller to fool his or her public (as seen in characters from Ciappelletto to the Author himself), Calandrino reflects the limitations on authority, "for no one within the human order can claim the possession of absolute and unconditional knowledge."[14] Still, the notion that the multiplicity of positions promulgated by the frame narrative undermines absolute authority relegates Calandrino to a negative function, that of authorial caveat – it does not consider the character in positive terms.

The positive fact of Calandrino's prodigious imagination is brought into play by Giuseppe Mazzotta in his discussion of *beffe* in the *Decameron* when he considers the "visionary" possibilities of Calandrino's behavior, in an analysis that flips Marcus's theory on its head. Mazzotta states,

[I]n contrast to the freedom of their own characters [Calandrino and characters like him] . . . these writers will at best take refuge in the safety of ironic distance or what could be called a mixture of fascination and skepticism toward the

dreams of the characters. In this sense, Calandrino is something of a threat to the ironies of the artists who give up, a priori as it were, the possibility of finding utopia and accept its irrevocable absence within the world . . .

[T]he thought of utopia, romances and visionariness which are always deflated by Boccaccio's art, but which in turn, topple our assumptions about reality, norms, laws, reason, virtues, the stuff that scholarship from DeSanctis down has taken to be the boundary of the heart.[15]

It is Mazzotta's notion of the positive, creative aspects of Calandrino's character that I want to work with in developing an interpretation of the artist common to both Pasolini and Boccaccio. First, however, I want to reconsider the rhetorical range of the terms involved in Mazzotta's discussion of Calandrino's flights of fancy by questioning the characterization of his imagination as idealistic and utopian. It seems to me that, on one level, calling Calandrino's delusions utopian or visionary extends the range of his power beyond the scope of the stories, elevating his idiocy to a sublime characteristic. Certainly, disabusing Calandrino of his fantasies would mean a lot less hilarity for us and the *brigata*, in addition to begging some rather uncomfortable questions about the use of laughter as an antidote for difficult circumstances. Still, it is important to consider the implications of Calandrino's fantasies on the level of the individual creating/interpreting subject, keeping in mind that this freedom of imagination is not necessarily liberating.[16] My desire to examine Calandrino's imagination as a "positive" object does not mean that I want to ascribe to it positive moral or political value. Obviously, unless one chooses to lose sight of the fact that Calandrino is a fool who is repeatedly taken advantage of and who punishes his wife as the consequence of his mad flights of fancy, Calandrino's example does not offer instructions or prescriptions for cultivating a utopian subjectivity. If Calandrino's imagination allows him to indulge provisionally in the fantasy of escape from the gaze (with the heliotrope) or freedom from biology (in his pregnancy), it is clearly not to be celebrated as a panacea. In weighing the value of Calandrino's imagination, it is important to consider the consequences of maintaining the illusion of utopia for the characters and readers of the *Decameron*. For Calandrino, ignorance and delusion mean he will never learn; he will continue to be fleeced by his companions. For the *brigata*, if it never acknowledges that

its quest to escape the plague by fleeing to a *locus amoenus* is similarly flawed, it risks alienation from society. For the lovesick ladies to whom the book is addressed, if we never see that the stories are simply offered as a way to pass the time and not to change our circumstances, then we will have gained nothing once we finish the book.

Let us now consider the relationship between Bruno and Buffalmacco's inventions and Calandrino's assimilation and use of them. It is clear that the land of Bengodi, the heliotrope, the bitter cookies, the human reproductive system, and Niccolosa are considered from radically different points of view by the characters in the stories.[17] Whereas we, as readers, share Bruno and Buffalmacco's understanding of these key elements, as mediated by the members of the *brigata* who tell the stories, Calandrino perceives them quite differently. We see humor in the wacky misrecognition that characterizes Calandrino's response to Bruno's and Buffalmacco's discourse. Calandrino's dogged credulity strains our own. The fact that he keeps coming back for more makes him appear as bird-brained as his onomastic cousin,[18] the *allodola*. This bird's proverbial penchant for *méconnaissance* is reflected in the well-known Italian phrase used to describe any strategy designed to fool the gullible: "uno specchietto per allodole" (a mirror for [catching] larks). The metaphor of a bird confused by his own specular image quite nicely sums up Calandrino's confusion in the face of illusion. Unfortunately for Calandrino, but much to the *brigata's* delight, his encounters with illusion, whether "seeing" himself invisible or pregnant, never are recognized by him as self-delusion. Instead of getting the joke, Calandrino blames his misfortunes on his wife, Monna Tessa, beating her savagely for breaking "the spell" and rendering him visible once more, and prohibiting her from being "on top" in sexual intercourse in order to forestall another pregnancy. Calandrino never learns to recognize himself as others see him, because his imagination keeps him suspended in a state of belief. Thus, Calandrino's imagination is a positive, conservative force that allows him to continue with hope in spite of his disasters, yet clearly it would be a mistake to celebrate it as utopian, because it brings with it so much misery.

In Boccaccio's *Decameron*, Giotto and Calandrino represent two ends of a spectrum of visual experience. Giotto's barb to Forese signals a break

between appearances (they look too ugly to be talented) and material fact (they are both accomplished men). Giotto's ability to discriminate between the way things look and the way they are is integral to his ability to generate illusion. Calandrino, on the other end, is unable to separate his sensory impressions from other manifestations of the objects themselves. It would seem that the difference between these two poles is unbridgeable, because if Giotto were to lose sight of the fact that he is in the business of generating illusions, he would lose the critical distance that allows him to develop new techniques of representation. Likewise, if Calandrino were ever to recognize his folly, the illusion would disappear. What I am trying to get at is the irrevocable change that occurs once illusion is recognized as such. Calandrino is in some ways like a child in the realm of the imaginary, jubilantly misrecognizing himself as invisible, pregnant, or sexually attractive because Bruno and Buffalmacco lead him to believe that he is; in this sense, he is the *allodola* confusing an illusion with the self.

Whereas the separation between Giotto, who recognizes illusion as illusion and is therefore able to create it for others, and Calandrino, who is deluded, may be unbridgeable in Boccaccio's *Decameron*, Pasolini is able to generate a representation of the *Decameron* that provisionally reconciles the two.

The second half of Pasolini's *Decameron* begins with Giotto,[19] Forese, and two other men driving through the pouring rain. Suddenly they stop their cart and make a mad dash across a field to a small hut. Gennaro (the farmer in the hut) gives them some old rags to cover themselves with, and the motley crew continues its journey in the rain. Forese looks over at Giotto and starts to laugh, asking, "Maestro, do you think that if someone who didn't know you came across you in the state you're in, he could believe that you were one of the greatest painters of our day?"[20] This is the end of the scene. Giotto makes no verbal response as he and Forese melt into great belly laughs.

From this beginning it is clear that Pasolini's Giotto is very different from Boccaccio's. When Forese makes his comment to Giotto about his appearance, no offense or reprimand is evident in the artist's responding laughter. Pasolini's Giotto apparently does not think much about it: he just figures that he must look pretty ridiculous. Furthermore, from the

perspective of the plot, this portrayal of Giotto is different from Boccaccio's. In contrast to Panfilo's story, this version of the anecdote does not seem to have a point; Forese's less than remarkable comment hardly seems to warrant a place in the pared-down version of Boccaccio's tales. If, on the other hand, we consider this as one of many partial segments of a fragmented Giotto framework, it works quite nicely as an introduction to the character of Giotto. Giotto's camaraderie (helping Forese stumble across the field), his modesty (discouraging Forese from identifying him to Gennaro), and his sense of humor as he gets a kick out of Forese's impression of him in spite of the aggravation of the rotten weather are established in this truncated version of the *novella*.

Further elaboration of the character of the master artist holds together the last half of the film as Giotto serves the function of "narrative thread."[21] After traveling through the rainstorm, Giotto finally arrives in Naples and begins to work on a fresco for the Church of Santa Chiara. As the camera follows Giotto's progress on the fresco, it periodically extends its range to include the other *novelle* presented from the *Decameron*. First, the tale of Caterina and the nightingale (*Dec.* V, 4) is mediated through Giotto's search for models in the nearby marketplace. Once the tale concludes, Giotto again appears in an amusingly accelerated meal with the monks of the monastery associated with the Church. This scene opens with the impatient monks waiting dinner for Giotto, who finally arrives late and then proceeds to shovel food into his mouth at double speed. When Giotto has finished stuffing food into his mouth, he gets up and runs back to work. This scene cuts to a *novella* character, Lisabetta, contemplating the pot of basil at the beginning of her tragic tale (*Dec.* IV, 5). Lisabetta's story told, we encounter Giotto once again, watching people in the marketplace. As he watches Compare Pietro enthusiastically kiss a horse, the episode of pinning the tail on Gemmata begins (*Dec.* IX, 10). At the conclusion of this *novella*, the film cuts to the church interior, where Giotto's assistants whistle while they work. An outside shot of the church pans to the marketplace, where the story of Tingoccio and Meuccio begins (*Dec.* VII, 10). In the middle of this tale, Giotto's vision of his fresco about the Last Judgment appears. At the end of Tingoccio and Meuccio's story we return to the church interior, where the completion of the fresco is being celebrated.

The framing device in this second half of the film centers on Giotto's progress on the fresco in Santa Chiara. However, the separation between frame and stories is never as clear-cut as it is in Boccaccio's text, because the figure of Giotto inhabits the time and space of the characters in the tales; he walks through the same marketplace at the same time they do. Thus, Giotto exists with the various characters from the stories of the *novelle*, rather than fabricating them. This is significant, because it is precisely by virtue of his intermingling with the characters that Pasolini's Giotto spans the gap between Boccaccio's Giotto and Calandrino.

On one level, Pasolini's Giotto acts as "the eyes that see Naples"[22] in order to render it a work of art, both the intradiegetic mural and the film that we see. The camera follows his gaze as he picks out people from the marketplace to populate his fresco. He plucks them from their daily routine and fixes them in the sacred narrative he paints. In the film itself, Giotto's gaze functions as an embedding device, a consistent point of view that we identify with the "gaze" of the camera. Yet, at the same time, Giotto is also the object of the camera's gaze, along with the other characters, as his and their stories unfold over the course of the film: he is simply one more character in the stories and therefore is not always able to assume the critical distance necessary to separate illusion from reality. This integration of the narrative from the fresco with the film is most obvious in the last two *novelle* shown. Whereas in the first *novelle* Giotto's activity of painting mediates the other stories told, he loses some of his framing distance with the tale of pinning the tail on Gemmata, where he becomes integrated into the margins of the *novella*'s narrative. In the beginning of this tale, the camera follows the movement of a donkey walking obliquely away. As the animal moves out of the frame, Giotto, clad in a ridiculous straw hat, is revealed to be sitting quietly in observation. A reverse shot shows that Giotto's gaze is directed at Compare Pietro, who is covering a horse with kisses. There follows a peculiar moment when the spectator expects a reverse shot to show what Giotto makes of this scene, followed perhaps by another painting sequence. Instead, the story of Don Gianni, Pietro, and Gemmata simply flows out from under Giotto's gaze, rapidly obliterating his diegetic presence by transferring the action out of his visual range. This

novella is followed by the whistling scene and the beginning of the story of Tingoccio and Meuccio, where the attenuation of Giotto's narrative, framing presence is increased. Giotto appears in this final *novella* when he is shown waking up during Meuccio's sleep (and Tingoccio's death) right in the middle of the narrative. In this instance, Giotto blends into the story, in spite of the fact that his vision of the Last Judgment is both artifice (a jumble of texts taken from art history) and pure imagination, two elements that contrast with the "realism" of the representation of Tingoccio and Meuccio's story. As strange as Giotto's vision is, it makes narrative sense in the progress of the *novella*, because it addresses the question of what happens when we die, which is precisely the debate with which Tingoccio and Meuccio begin the story. Finally, in the sequence that closes the film, Giotto pauses in the middle of the celebration to ponder the nature of artistic creation in terms that clearly refer back to his vision of the Last Judgment: he asks whether it is not better to simply dream a work of art and thereby inhabit the illusion, rather than to actually realize the work of art and generate the illusion. It is this theme of Giotto as both creator and subject of illusions that I want to explore further. In order to proceed, we need to return to the end of the Forese episode at the beginning of the second half of the film.

From the friends' laughter, the film cuts to a long shot of Giotto's arrival in Naples. Here, Giotto seems lost, hesitant, and uncertain as he obliviously walks past the crowd of elegantly dressed church dignitaries who have assembled to await his arrival. Giotto proceeds uneasily until he is on the threshold of the church, at which point he suddenly assumes authority and walks in as if he owns it. Giotto's abrupt transformation on the church's threshold signals the extent to which Santa Chiara, soon to be inhabited by his visions, will become his domain. As Giotto enters the church, a reverse shot shows two giggling monks to be the agents of our gaze. Shots of the monks ogling Giotto are intercut with shots of Giotto staring at the enormous blank wall in front of him. This sequence culminates with a long shot of Giotto from the place of the scaffolding as he intently looks straight ahead. A reverse shot of the blank wall cuts to a few seconds of blank screen. The blank screen provides a pause be-

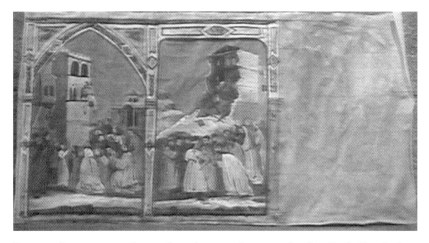

Figure 9. Design on parchment for a fresco to be painted in Pier Paolo Pasolini's film, *Il Decamerone*, 1973.

fore Giotto's activities are taken up again at a later point in time when he has settled down to the work at hand.

The blank screen cuts to a brief shot of a finished design on parchment for a giottesque tripartite fresco, in which only the left-hand and center portions are filled in, and the right-hand portion of the parchment where the third panel would normally be is blank (Figure 9). The details of the sketch are not easily discernible to the viewer of the film, because after a few seconds the film cuts to a medium shot of Giotto, shown in profile, squatting as he regards the parchment for a moment. He then slowly stands. The film cuts to a frontal head shot of Giotto and then reverses to another fleeting shot of the design. This sequence is followed by a long shot of three assistants on the scaffolding, who are preparing the wall. One of the assistants looks over the edge of the scaffolding, and we see an unbroken sequence of Giotto's consideration of the parchment, his standing, climbing the scaffolding, and beginning the sketch in the center of the wall.

In this portion of the first Giotto episode, we are introduced to his trade. His deliberate and serious behavior inside the church contrasts with the Forese segment that precedes it. The difference is especially evident because it is given relief by the intercut giggling, ogling monks.

The stark simplicity of the vast, undecorated church interior, only min-imally altered by the scaffolding and the plain figures of Giotto and his assistants, creates a tranquil setting. Giotto's contemplation of the blank wall records the moment of creation – the imagining of the work as it will be. The shot of the blank wall that cuts to the blank screen signals the beginning of the parallel movements of the production of the fres-co (begun by sketching a design on the prepared wall) and the produc-tion of the film (the vision of Naples through "Giotto's eyes") that I will trace through the film. Later I will elaborate upon this parallel on an ex-tradiegetic level; for the time being however, I will concentrate on the reading strategies in the diegesis of the film proper.

The shot that begins the last portion of this first Giotto episode erupts loudly with a pan of the Neapolitan marketplace, swarming with peo-ple, which cuts to a close shot of three gourds hanging from a stall. As a hand pulls the gourds out of our line of vision, Giotto's puckish face is revealed to be peering with great animation through a rectangle he has formed with the index and middle fingers of his hands, a shape that works as a rudimentary viewfinder (Figure 10). Turning his head toward the camera, he frames us for an instant before he pulls his fingers away from his face to get a better look. A reverse shot shows that Giotto has found Caterina (heroine of the next *novella*) and her family at one of the stalls. The camera briefly shifts to another group of people, and then to some boys sliding on the roofs of the stalls, only to return to a medium shot of the family. This shot then reverses to a close-up of Giotto as he lifts his fingers back to his eye in his framing gesture. The camera pro-ceeds to frame a series of close-ups of Caterina's family: first her father, then her mother, and finally the smiling Caterina herself. The film cuts back to the interior of the church, where the painting is about to begin. Giotto is poised with brush in hand as his assistants mix the pigments. The camera lingers on the colors and textures of the individual bowls of paint in a sequence that rhymes with Giotto's surveillance of the people in the marketplace. The camera's concentration animates these various elements of color, form, and texture that comprise the work of artifice in such a way that the bowls of pigment become the shades of the charac-ters in the *novelle* just as they are the hues of the filmmaker's palette.[23] Next, a long shot shows the assistants filing up the scaffolding stairs to

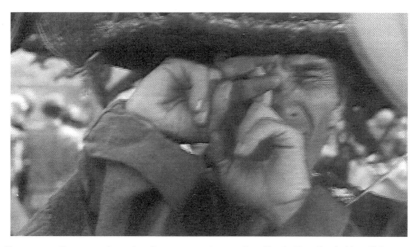

Figure 10. Giotto making his framing gesture in Pier Paolo Pasolini's film, *Il De-camerone*, 1973.

bring Giotto the various pots of paint. The scene ends with a close-up of Giotto's hand painting one brown stroke on the wall, from which the film cuts to the opening shot of the story of Caterina and the nightingale.

The structure of this Giotto segment, with Giotto "framing" Caterina and her family in the marketplace followed by his beginning to paint the fresco, might lead one to imagine that the film of Caterina's story is what Giotto is about to paint on the wall. That is, because the editing juxtaposes the initiation of the two visual representations, the fresco and the film of the *novella*, they appear to begin almost simultaneously and so might be one and the same. Certainly, the order in which they are begun – first the stroke of paint, followed by the entire *novella* – generates the illusion of continuity of story line across the different media. In spite of the fact that it would have been highly irregular for the monks of Santa Chiara to commission Giotto to paint secular stories on the walls of their church, the fleeting glimpses of the design for the fresco and of the fresco itself do very little to contradict the impression that Giotto is painting scenes from the *Decameron*. However, this impression frames its own corrective: it is gradually undermined by the progressive integra-

tion of the frame narrative (Giotto episodes) into the diegesis of the *novelle*, leaving the viewer with the sense that the frame does not so much create the *novelle* as complement them.

From the brief shots of the design and the fresco, it is difficult to tell what subject Giotto is actually painting. In the treatment for the film Pasolini mentions that because the frescoes that the historical Giotto painted in the Church of Santa Chiara in Naples have been lost, "they will have to be reconstructed" for the film.[24] In light of this information, we might imagine that the subject of the two panels could be identified. Although it is certain that a type of tripartite composition is planned, the fact that the frames around the first two sections are different from each other (see Figure 9), combined with the fact that there is nothing, not even an empty frame, where the third portion should be, makes it difficult to determine what this fresco is supposed to represent. Vigorelli and Baccheschi record that Giotto's original frescoes for Santa Chiara were to be "various stories from the Old and New Testaments among which the Apocalypse would follow Dantesque iconography." According to Previtale, at least one of the original Neapolitan frescoes was *La mensa del Signore*. However, the photographs of the remains of the fresco provided in Previtale's book do not even vaguely resemble either of Pasolini's creations.[25] Whereas the brief shots of the fresco shown in the film allow the viewer to see that the first frame of the series shares some compositional as well as stylistic elements with the fresco called *The Slaughter of the Innocents* (Figure 11), in the Scrovegni Chapel in Padua, and that the second frame resembles the *Miracle of the Spring* in the Upper Chapel at Assisi, these two fresco sections hardly make sense as parts of the same tripartite composition.

Thus, in spite of archival scrutiny, the question of what Giotto is painting in the film remains open. Rather than attempt to clarify the two sections that seem to be deliberately vague and general, I would suggest that the very obscurity of the works may be the point. Perhaps it is sufficient to note that they are giottesque, and that in their elusiveness what they represent is not a fixed narrative but a fixed form. In order to grasp the meaning of this "formness" that overrules narrativity, what I would like to discuss is not so much the indecipherable frescoes that eventually are painted by Giotto in the film but the somewhat enigmatic blank

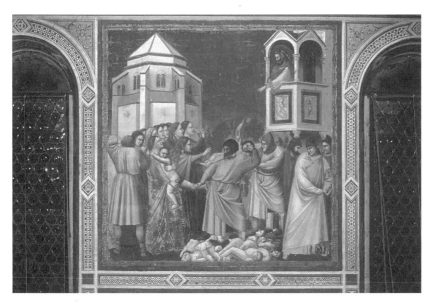

Figure 11. Giotto di Bondone, fresco of "The Slaughter of the Innocents," c. 1305. (Scrovegni Chapel, Padua. Photo courtesy of the Scrovegni Chapel, Padua.)

space on the right-hand portion of the wall. Lawton discusses the formal configuration of the fresco, noting that it "is an incomplete triptych, composed of a Gothic, heaven directed arch in the first panel, an anthropocentric rectangle whose top line is perfectly horizontal in the second, and a third panel which is completely blank."[26] Marcus adds that "the juxtaposition of adjacent panels in the fresco cycle . . . suggests the celluloid strip."[27] Whereas Lawton sees the blank space as an unpresumptuous admission of ignorance regarding the future and Marcus sees it as a hint of something "imperfect (in the etymological sense of the term)" in the film itself, I would suggest that it also functions as a movie screen. I do not offer this as simply iconic similarity between square, blank spaces on a wall (although that is involved as well), but more particularly as an interpretation of the blank panel as the screen on which Pasolini's Giotto, in his imagination, projects his vision of the *Last Judgment*.

This explicit equation of vision/dream with cinema is clearly outlined

in Pasolini's critical interventions in film theory. Throughout his critical works on film, Pasolini again and again asserts that "all dreams are series of imsigns which have all the characteristics of the cinematic sequence," insisting upon the "profoundly oneiric nature of cinema."[28] It is my contention that this "fundamental" similarity between dreams and cinema is posited in Pasolini's film when Giotto "dreams" a version of his fresco *The Last Judgment* from the Scrovegni Chapel and then muses, at the end of the film: "perchè realizzare un'opera, quando è così bello sognarla soltanto?" (Why produce a work of art when it is so beautiful to simply dream it?) as he gazes at the blank space (Figure 12, esp. G and H).

The rather sticky paradox that Giotto the artist would rather "dream" the work of art that Pasolini the filmmaker has realized is one of the ways that Pasolini's Giotto leans toward Boccaccio's Calandrino, and it occurs, as I have pointed out, during the sequences of the film that integrate Giotto most fully into the diegesis of the narrative. At the same time, Pasolini's Giotto is not so enthralled with fantasy that he entirely loses critical distance, because he still manages to produce two panels of the fresco. His blank panel represents an effort to reconcile the two elements of artistic creation: concrete (and therefore corruptible) form and the infinite potential of imagination. Pasolini's Giotto is allowed this luxury only at the expense of Pier Paolo Pasolini the filmmaker's concession to give form to the idea of fantasy in his film.

As we shall see in a closer look at the last part of the film, Pasolini's reorganization and reinterpretation of Boccaccio's *Decameron* and Giotto's frescoes radically change the representation of the figure of the artist as well as the work of art itself. Pasolini's Giotto not only has access to different media (film/dream and painting) than Boccaccio and the historical Giotto used; he also plays them off each other in such a way that the creative impulse is granted a wider range of temporal and imaginative flexibility.

During the last of Boccaccio's tales included in the film (*Dec.* VII, 10), the integration of Pasolini's Giotto into the Boccaccian narrative is almost complete. The tale of Meuccio and Tingoccio is interrupted and expanded when, halfway through the story, a shot of Tingoccio sleeping (observed from Meuccio's point of view) cuts to a shot of several oth-

Figure 12. Tableau vivant of the Last Judgment and Giotto's unfinished fresco in Pier Paolo Pasolini's film, *Il Decamerone*, 1973.

er men sleeping in a similar room. Subsequently these men are identified as Giotto's assistants by a brief shot of paint on a table, but the transition is so smooth that it is not difficult to miss the shift in story line. Next, the sleeping figure of Giotto is shown as he suddenly raises his head with his eyes open and looks straight at us. The camera reverses to reveal a long shot of an outdoor tableau vivant of Giotto's fresco *The Last*

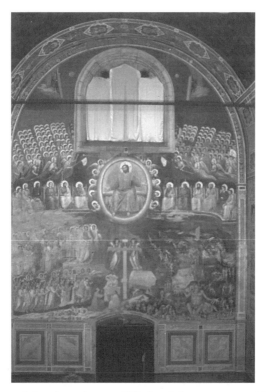

Figure 13. Giotto di Bondone, fresco of *The Last Judgment*, c. 1305. (Scrovegni Chapel, Padua. Photo courtesy of the Scrovegni Chapel, Padua.)

Judgment from the Scrovegni Chapel (Figure 12A and Figure 13). This is cut by a head shot of what in Giotto's fresco is Christ sitting in judgment but is now the Madonna enthroned, with the infant just out of view on her lap (Figure 12B). This scene, which is often referred to as *Madonna Enthroned*, looks very much like Giotto's *Ognissanti Madonna*, in the Uffizi Gallery in Florence (Figure 14). From this "portrait" of the Madonna the film cuts back to Giotto in bed, still staring at us (Figure 12C). A series of partial shots follows: the tableau vivant, intercut with increasingly closer shots of Mary's face. The enactment of torture, homage, and beatitude are shown in brief, static medium shots (Figures 12D and E). The only camera movement occurs when two separate medium shots of Mary

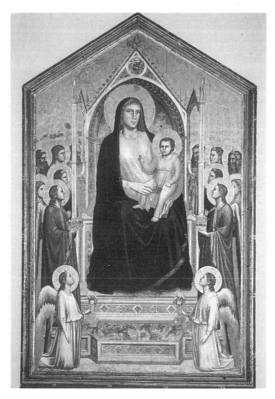

Figure 14. Giotto di Bondone, *Ognissanti Madonna,* 1310. (Uffizi Gallery, Florence. Photo courtesy of the Uffizi Gallery, Florence.)

pan (one to her right and the other to her left) away from her to show the hosts of angels singing beside her. The sequence ends with a final shot of Giotto as his head falls back on his pillow and his eyes close. Giotto's sleeping attitude prefigures the next sequence, which shows the dead body of Tingoccio being carried through the dark, narrow streets of Naples (Figure 12F).

The play back and forth between Giotto's vision and the story of Meuccio and Tingoccio is complicated enough to engender more than one extraordinary critical response that reflects an unclear understanding of the sequence. For example, Freixe believes that Giotto, during his

vision, sees "the blessed Virgin . . . strike erotic poses, her smile quite provocative," a bizarre impression to have taken away from the sequence, yet understandable, given Freixe's contention that Pasolini typically represents the "blasphemous . . . pairing of the Immaculate conception and the Prostitute."[29] For a viewer familiar with Pasolini's oeuvre, it seems that almost anything is possible. Furthermore, it is not difficult to sympathize with viewers who are baffled by the sequence because the transition from the *novella* to Giotto and back again is visually smooth. In fact, the sleeping figures parallel each other in a way that creates narrative continuity. Meuccio relays to Tingoccio, who turns into Giotto's assistants, who in turn lead to Giotto. Similar lighting and attitude give all the figures a certain homonymic resonance. This is not to say that they are exactly interchangeable but that they rhyme with one another. Their similarities are highlighted by the extreme difference between them and the vision of the Last Judgment. In the same manner as the scene preceding the Last Judgment, the closing shot of Giotto falling back to sleep easily flows into the dead figure of Tingoccio lying on its bier.

In addition to visual continuity, the placement of Giotto's vision also contributes to narrative coherence, because although the vision of the Last Judgment is striking, it does not make any less sense in the tale of Tingoccio and Meuccio than it does in the Giotto episode. Both the frame and the *novella* narratives foreshadow something of this nature. Tingoccio and Meuccio most obviously provide for this kind of narrative turn, because the *novella* opens with the two friends making a pact that whichever of them dies first will return and tell the other what happens after death. Therefore, in light of Tingoccio's subsequently revealed death (which must have occurred at some point after the last shot of Meuccio watching him go to sleep and the end of the vision), the Last Judgment could be Tingoccio showing Meuccio what happened when he died. Following the interjection of Giotto's vision, the *novella* continues, with Tingoccio returning from death to tell Meuccio what happens. Although his account does not resemble the vision, it does not preclude it. Of course, the vision is Giotto's vision, as we can see in the film from the shot/reverse-shot editing of the sequence. The

attribution of the vision to Giotto makes narrative sense in the final frames of the film, when Giotto refers back to "dreaming" a work of art (Figure 12H): nevertheless, while the vision is flickering away on the screen, it is not entirely contained by its narrative frame. The tableau vivant, in spite of Giotto's mediation, is stylistically different from the rest of the film.

Although distinguishing the separate narrative threads that intertwine in this sequence of the film as I have done is possible, I suggest that if we attend to the various elements that set the vision apart from the rest of the film and consider the effect of their combination, the vision itself will provide interesting testimony to the concept of artistic creation. The playful juxtaposition of the various levels of narration and visual representation in the sequence provides a critique of the individual elements while at the same time addressing them as an integrated, compositionally whole unit. This vision segment of the film is a pastiche of many sources: Boccaccio's *Decameron*, Giotto's *Last Judgment*, and Giotto's *Ognissanti Madonna*, all planted in the middle of two embedded film narratives. This mélange opens up new meanings to each element by scrambling genre, chronology, and narrative. The configuration and placement of the vision beg questions such as, What ramifications does replacing Christ the Judge with the Madonna and the Infant Jesus have? The nurturing mother and unformed infant hardly embody the end of time. One could say that at the heart of this "last" judgment lies the beginning, rather than the end. Furthermore, what are we to make of the additional complication that this Last Judgment occurs not at the end of time (or even at the end of the narrative), as its promise of ultimate narrative closure would demand, but instead is merely a brief interlude in the narratives that support it? And how is this compromised finality affected by the fact that this prototypical terminal scene is represented not in its compositional entirety but rather cut into numerous brief medium shots?

I would suggest that these questions emphasize the interpenetration and resulting proliferation and fragmentation of forms that comprise Giotto's vision. The internal contradictions in Giotto's vision seem to be working very hard against the kind of rigid, linear progression that sep-

arates beginning from end and orders events into an irreversible chronology. One possible reinterpretation of this transgressive composition might be that the creation of a work of art, even one as emblematic of the kind of final closure as the Last Judgment is for Western culture, is open to revision for Pasolini's Giotto. In fact, in the film, Giotto's desire to maintain this formal and temporal flexibility is so strong that in the end he does not represent it but keeps it to himself as his dream, his illusion. In providing for himself this space for his indulgence of pure imagination, Pasolini's Giotto seeps into the imaginary of Boccaccio's Calandrino. We must not forget, however, that Pasolini's Giotto actually does produce two panels of the tripartite composition, an action that emphasizes that he is not entirely devoted to illusion (as Calandrino is) but is attempting to straddle the two, being critical of each at the same time. Even if Pasolini manages to create a figure of Giotto that celebrates the autonomy of the artistic imagination ("Why bother . . . ?"), in practical terms this obviously is not a feasible artistic practice. As I mentioned earlier, Pasolini's Giotto manages to suggest the beauty of imagination only because Pasolini creates it. In other words, Pasolini has to create the fiction of Giotto and represent it in order to suggest the possibility of simply dreaming.

I have tried to show that Pasolini's Giotto shares both the imaginative and the critical capacities of Boccaccio's artists while at the same time, in his critical insight into the production and reception of a work of art, he occupies a position parallel and sympathetic to that of the *Decameron*'s Author. In conclusion, I would briefly like to consider how these similarities extend to the limits of both narratives and bleed over into the experience of the reader/viewer. In particular, I want to discuss the effect on our own reading of the intervention in the texts by the Author and Pier Paolo Pasolini.

Boccaccio's *Decameron* is addressed to love-sick women. The task it sets for itself is to divert them from their confined, melancholic state and give them imaginative release through the stories. We, the readers ("oziose donne"), are being given a temporary respite from the difficult situation in which we find ourselves, just as the members of the *lieta brigata* get a temporary reprieve from the ravages of the plague with their idyllic so-

journ. But the context of these directed fantasies is, explicitly, life-threatening disease and pain (love-sickness and the plague). The treatment administered is not curative – it only buys time – it opens up an imagined space where for a period of time the stories allow the reader to escape from her circumstances. Likewise, Pasolini's *Decameron* is a fantasy (for Pasolini, a specifically preindustrial, sexually liberating one) that imagines joyous access to prelapsarian plenitude and pleasure:

As far as my films of now are concerned, seen subjectively, from my own, internal viewpoint, I must say that the last ones of the *Trilogy of Life* represent a fascinating and marvelous experience. I don't think that any of the critics have been able to understand the meaning this experience has had for me – independently of the results – this experience of entering into the most mysterious workings of artistic creation, this proceeding into an ontology of narration, in the making of cinema-cinema, cinema as we see it as children, without however falling victim to commercialism or lack of care. I find it the most beautiful idea I have ever had, this wish to tell, to recount, for the sheer joy of telling and recounting, for the creation of narrative myths.[30]

Both Boccaccio's tales and Pasolini's narrated fantasies are politically charged. Boccaccio does not extend his project to include a social revolution that would obviate the restricted and unhealthy circumstances of his target audience, and Pasolini's nostalgia for a mythical, preindustrial, exuberant sexuality caters exclusively to the privileged, First World upper classes. As I have tried to demonstrate, however, individual readers and viewers are not simply constructed by the author/text, we are able to scavenge the language, images, and emotions that respond to our own reading/viewing desires and develop from them an interpretation that is sympathetic to us. By deliberately setting out this reading strategy, I have attempted to expose tensions within the texts that respond to my investigation of the representation of sexual difference. Specifically, I have tried to show how juxtaposing multiple representations of the *Decameron* allows us to appreciate the enormous potential derived from the acknowledgment and use of imaginative flexibility in the reading process. Yet, up to this point in my interpretation, I have not fully explored the ramifications of the particular homosexual aesthetic operative in Pasolini's Giotto sequences. In the next chapter I will continue my dis-

cussion of the connections among Boccaccio's book, Pasolini's film, and Giotto's *Last Judgment,* paying special attention to the specific ways Pasolini's homosexuality is transformed into a public, cultural fact in his production of the *Decameron.*

CHAPTER FIVE

LIVING PICTURES

HIGH ART PASTICHE AND THE CRUISING
GAZE IN PASOLINI'S *DECAMERON*

IN THE PRECEDING chapters I have concentrated on using a feminist, literary critical approach to interpret the various representations of the texts under consideration in this book. My approach has led me to focus on the heterosexual sensibilities in the texts. However, it seems to me that in order to discuss Pasolini's *Decameron* it is important to consider the specifically homosexual aesthetic that underlies his film. Because I agree with Eve Sedgwick's contention that "the study of sexuality is not coextensive with the study of gender; correspondingly, antihomophobic inquiry is not coextensive with feminist inquiry,"[1] I deem it important to address Pasolini's film from an antihomophobic as well as a feminist perspective. To fail to question the commonplace of collapsing the notion of sexuality into the dominant reading of it as heterosexuality is not only homophobic but also, paradoxically, heterophobic. (Sedgwick argues that to do so ignores not only homosexuality but the possibility of the different desires and pleasures available in heterosexuality as well.[2]) It also precludes important and interesting interpretations of the text. So, in an effort to follow Sedgwick's lead and explore the asymmetries of gendered desire in Pasolini's film, I will once again address Boccaccio's, Giotto's, and Pasolini's works, only this time I will concentrate on the impact of a particular gendered aesthetics – in this case homosexual – on the representation of artistic vision.

I recognize that as a straight American woman, my attempts to dis-

118

cuss and theorize a homosexual aesthetic in Pasolini's work will be controversial; consequently, I think that it is important to outline my concerns and goals. My intervention here is a response to the cultural discourse of Pasolini's film, which addresses me as a viewer. Because part of that cultural discourse is determined by Pasolini's sexuality, it is necessary to acknowledge and to account for his gay perspective as it bears on the political-cultural object that is his film. Although it is impossible for me to identify directly with the homosexual sensibilities in Pasolini's film, to ignore them would be worse. It would be hypocritical to artificially bracket Pasolini's homosexuality in this book, which has acknowledged the *straight male* perspective as an active force in all the other texts under consideration. Because my project is to develop an emancipatory semiotic, in order to understand how Boccaccio is visualized, it is crucial for me to account for the many different modes of vision, including Pasolini's, which participate in that visualization.

In this chapter, I will consider how the homosexual aesthetic operative in Pasolini's *Decameron* influences the film's particular version of the tales. It is my contention that in the *Decameron* Pasolini represents a fantasmatic negotiation of his subjective homosexuality in his particular time and place, an eroticism that is intimately informed by the homophobic, consumerist culture in which it developed. In order to address these elements in Pasolini's *Decameron*, I will expand my analysis from Chapter 4 to include the Ciappelletto as well as the Giotto segments of the film. Central to my thesis will be the notion of a homosexual "cruising" gaze, exemplified by Pasolini's distinctive, nonnarrative camera work, which commonly rests on enigmatic, tight shots of men looking. Pasolini's abrupt camera works against narrative coherence in his cinema by obsessively focusing on men's eyes as they stare or peek out from behind an obstacle or, in some cases, by flashing from one face to another like an erotically alert person visually "grazing" in the field of vision. The centrality of this "cruising" gaze visualizes Boccaccio in an unexpected way, not by concentrating the visual field on the construction of the narration of the tales but rather by expanding visual fragmentation in the text. This gay, cruising stance, combined with the remarkably ambiguous pastiche of high art tableaux vivants in the film, works

against the kind of coherent narrative discourse produced in some of Boccaccio's *novelle* in accordance with the doctrine of courtly love.[3] In Pasolini's film, this homosexual aesthetic also alludes to gay militantism in its elaboration on casual encounters. The nonnarrative aspects of visuality in this film result in the suspension of narrative judgment and the fragmentation of narrative coherence.

Specifically, it is important to examine how issues of popularity, scandal, and obscenity are framed when the representation is informed by a gay sensibility, and how that compares with the discussion of those issues in a heterosexual context. I will focus on the ways in which Pasolini's eroticism affects such aspects of his as critical reception, theories of representation, and the construction of sexuality. I will explore how Pasolini's homosexual vision is brought to bear on the framing device he created for the film, and how that vision is emphasized by the frame's juxtaposition to the selection of Boccaccio's tales represented – all of which focus on illicit and transgressive heterosexual encounters. It is my contention that the homosexual aesthetic in Pasolini's *Decameron* shapes certain modes of vision represented in the film, as well as the construction of high art spectacle in the tableaux vivants. In order to make this point, we need to explore how vision and the scopic drive, two fundamental elements of the homosexual "cruising" gaze, relate to the "eye" of the camera and viewership in Pasolini's cinema. In addition to formulating a theory of this "cruising" gaze, I will consider how ambiguity and pastiche in representational codes also distinguish the homosexual aesthetic in the *Decameron*. I will trace the nonnarrative, fragmenting modes of representation as they develop in the film and detail how they ultimately inform the character Giotto's artistry.

To begin this analysis, I want to return to the discussion developed in Chapter 4 regarding the parallels and common points among the works of Boccaccio, Giotto, and Pasolini. We shall see how the critical reception of the works – the praise, popularity, and scandal that surround them – demonstrates a reverence for, and understanding of, social and cultural norms as well as individual subjectivity.

As I discussed in Chapter 2, from its earliest circulation Boccaccio's book was enormously popular and was disseminated rapidly throughout

Europe. In his doctoral dissertation, Watson sketches the emergence of Boccaccio's popularity in Florence, stating that there was

in the late fourteenth and early fifteenth century a profound and affectionate veneration of Boccaccio's poetry by the literate citizenry of Florence . . . Primary evidence for the citizens' cult of Boccaccio lies in the number of manuscript copies of his works that survive . . . The humanists saw in Boccaccio a predecessor. Poets and citizens revered him for his literary grace and poetic truth.[4]

To an even greater extent, Giotto enjoyed enormous popularity during his lifetime. Giotto's fame as a revolutionary artist and wit (as seen in Dante's *Purgatory* XI as well as in *Dec.* VI, 5) were well established while he was still producing his work.[5] In spite of the fact that some of Giotto's most impressive works, such as the frescoes in the Scrovegni Chapel, were painted for private use and were therefore unavailable to all but a very select audience,[6] he was widely held to be a master painter and was the only artist in the fourteenth century to amass a true personal fortune.[7] Although Boccaccio's reputation suffered a temporary reversal of fortune near the end of the fifteenth century (which I will discuss later in relation to the notion of scandal), both his work and Giotto's have become fixtures in the canon of Western culture's high art.

Pasolini's oeuvre, on the other hand, has not yet become classified so rigidly. Although currently his films are regarded as art house or avantgarde classics and scholarship continues to reexamine his writing (theory, poetry, prose, and journalism that was produced starting in 1941 and continuing up until his death in 1975), his works are still considered quite controversial. Pasolini himself shifted in his estimation of his own influence, variously describing himself as a "minor civil poet"[8] and as a "force from the past."[9] As is manifest in the collections of his writing – *Scritti corsari, Empirismo eretico,* and *Lettere luterane* – while Pasolini was alive he performed the function of gadfly to groups as diverse as semioticians, the Italian Communist Party (PCI), the Christian Democrats (CD), the Roman Catholic Church, student revolutionaries, feminists, and fascists of both the Left and the Right. The effect of Pasolini's oeuvre may continue to be debated for many years to come, but it seems unlikely that it will simply evaporate. His status and output as an *intellettuale* remain op-

erative in Italian culture, demonstrated by the fact that he is frequently called upon in newspaper articles, magazines, and television shows as a reference point in current Italian culture. In addition, Pasolini is undergoing something of a "canonization" process in the United States.[10]

During his career as a filmmaker, Pasolini ran the gamut from arcane, hermetic avant-garde cinema to popular, widely released movies. After making many esoteric films, Pasolini began the *Trilogy of Life* series in a deliberate effort to garner mass appeal.[11] The first film in the trilogy, the *Decameron*, was received enthusiastically by a wide audience,[12] and Greene characterizes it as a "huge popular success."[13]

It is not surprising that each of these innovative and popular artists engendered debate and scandal. Even Giotto's frescoes, which would appear to be the most widely accepted and least scandalous of the group, have provided the occasion for considerable controversy. Miles discusses the unsettling effect that Giotto's "realism" may have had on his audience:

In the paintings of Giotto . . . a new relationship is created between viewer and painted figures. The viewer is placed *within* the depicted event through the intensity of feeling he or she shares with the human beings of the painting . . . [A] public accustomed to the authoritative and powerful figures of the thirteenth century must have been initially dismayed at Giotto's simplified, humanized and humble figures . . . [L]ost perhaps would have been a sense of the powerful protection of a divine cosmic ruler.[14]

In addition, evidence exists that the politics of Giotto's iconography may have been somewhat scandalous. In his analysis of Boccaccio's "Author's Conclusion," Watson undertakes to clarify the reference to the representation of Christ's masculinity and the number of nails used in medieval paintings of the Crucifixion, arguing that

[d]uring the thirteenth and early fourteenth centuries . . . Tuscan painters began to model the figure of Christ with increasingly convincing contrasts of shadow and light, as well as progressively lowering the loincloth to hint at what it conceals . . . [B]oth Cimabue and Giotto provide instances [of this practice] . . . During the thirteenth century there occurred a shift away from showing the Crucifixion in the traditional manner, where four nails transfix Christ . . . , to a Gothic mode, where Christ's feet are crossed, so that three nails appear.[15]

Watson cites an interesting early response to this question of the number of nails:

Around 1230 Bishop Luke of Tuy comments on the new mode of crucifying Christ only to condemn it as distressing, disrespectful, and heretical . . . The bishop objects because this way of crucifying emphasizes the sufferings of Christ and hence his humanity, not his divinity. But he also condemns it because it is a new and thus a wanton departure from tradition on the part of artists, who have no right to do so.[16]

Although it is certainly true, as Watson suggests, that Cimabue and Giotto painted Christ with a low-slung loincloth (Figures 15 and 16), I would argue that the shadow and light in these paintings, coupled with the amount of abdomen exposed, create the distinct impression that Christ has no penis. Perhaps this is most striking in the Cimabue *Crucifixion*, where the tie in the gossamer fabric actually looks like a hole in Christ's body precisely where one would expect his genitals to be. And, although Giotto's more modest loincloth does not draw as much attention to Christ's crotch as Cimabue's does, under close examination it does not appear that Giotto was attempting to endow Christ with any new, human attributes. If we look at Giotto's Scrovegni Chapel frescoes (executed at a later date), we find clear evidence that Giotto did not make Christ physically "maschio." In both the *Baptism* (Figure 17) and the *Crucifixion* (Figure 18), Giotto depicts Christ without a penis. This is markedly different from the scene of Hell in the *Last Judgment* section of the same chapel (see detail of the *Last Judgment* in Figure 19), where several characters are painted with large, active penises. If Giotto stops short of humanizing Christ's anatomy, he does emphasize it "as a matter of course"[17] in his style of transfixing Christ to the cross with three nails. My point is that Giotto appears ambiguous in the politics of iconography. He draws attention to Christ's crotch with the low-slung and sometimes transparent loincloth, a gesture that by itself could be considered risqué, and he clearly follows the three-nail school of crucifixion. Giotto's negotiations of these politically charged questions of iconography demonstrate the one aspect of the revolutionary and scandalous vein in his work. At this point, I will interrupt my consideration of the implications of focusing on Christ's loincloth and how many foreign objects

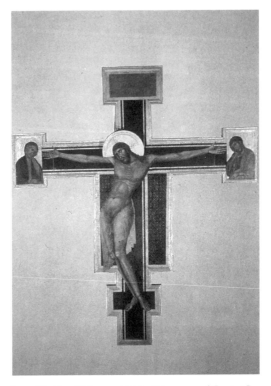

Figure 15. Cimabue, *The Crucifixion*, c. 1288. (Museum of Santa Croce, Florence. Photo courtesy of the Museum of Santa Croce, Florence.)

penetrate his body in *extremis* in order to pursue the topic of controversy in Giotto's oeuvre, but I will return to it later when we discuss Pasolini's version of the Last Judgment.

Taking an entirely different tack, Kristeva argues that Giotto's decentering use of color in the Scrovegni Chapel has a disruptive effect on the traditional narrative:

[C]olor (conpact [*sic*, compact?] within its triple dimension) escapes censorship; and the unconscious irrupts into a culturally coded pictorial distribution . . . Color might therefore be the space where prohibition foresees and gives rise to its own immediate transgression. It achieves the momentary dialectic of law – the laying down of One Meaning so that it might at once be pulverized, into plural meanings . . . [This effect, called] "Giotto's joy" is the sublimated jouis-

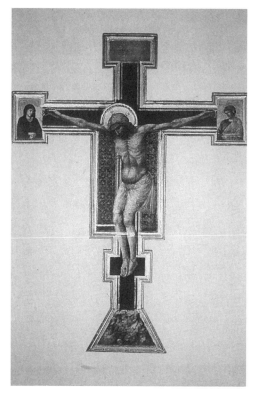

Figure 16. Giotto di Bondone, *The Crucifixion*, 1337. (Basilica of Santa Maria Novella, Florence. Photo courtesy of the Basilica of Santa Maria Novella, Florence.)

sance of a subject liberating himself from the transcendental dominion of One Meaning (white) . . . This chromatic joy is the indication of a deep ideological and subjective transformation; it discreetly enters the theological signified, distorting and doing violence to it without relinquishing it.[18]

In her speculation on the resonances in Giotto's chromatic transgressions Kristeva states,

[T]hat this chromatic experience could take place under the aegis of the Order of Merry Knights commemorating the Virgin is, perhaps, more than a coincidence (sublimated jouissance finds its basis in the forbidden mother, next to the Name-of-the-Father).[19]

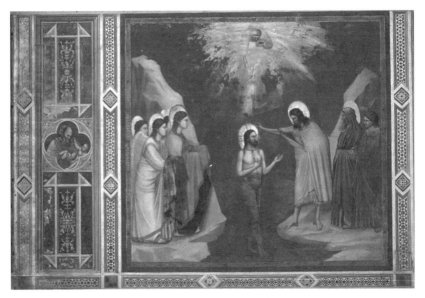

Figure 17. Giotto di Bondone, fresco of *The Baptism of Jesus*, c. 1305. (Scrovegni Chapel, Padua. Photo courtesy of the Scrovegni Chapel, Padua.)

Kristeva's notion of the chromatic jouissance in a work of art paid for by a devotee of the Virgin hints at an interesting approach to Pasolini's *Last Judgment* in the *Decameron*. This too, I will defer until I discuss the particular way Pasolini's homosexual aesthetic informs his version of Giotto's Scrovegni fresco. For the present, I want to underline the intriguing constellation of concerns occasioned by the rigidly regulated representation of the Crucifixion. We might want to ask ourselves about the preoccupation with the sexed or unsexed character of Christ's body, especially with respect to the manner in which it is obsessively foisted upon the worshiper who is instructed to gaze at and meditate upon it for inspiration.[20] The spectacle of Christ, coupled with the unusually prominent part played by his mother in the Scrovegni Chapel frescoes, sheds some interesting light on Pasolini's representation of the "forbidden" mother as she usurps the place of the "Name-of-the-Father" in his version of the Last Judgment. As we move on, I just want to note that Watson's and Kristeva's discussions of scandalous and disruptive forces at work in

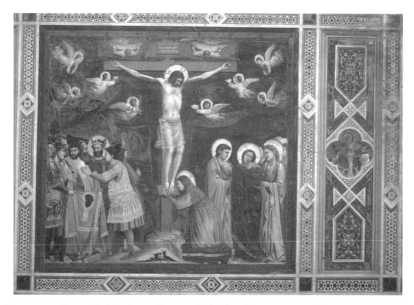

Figure 18. Giotto di Bondone, fresco of *The Crucifixion*, c. 1305. (Scrovegni Chapel, Padua. Photo courtesy of the Scrovegni Chapel, Padua.)

Giotto's frescoes indicate that both the surface chromatic values and the iconography of Giotto's paintings are distinctly controversial.

The scandals surrounding Boccaccio's and Pasolini's work were much more vocal and personalized than the debates over Giotto's painting. As I mentioned in Chapter 4, Boccaccio's detractors were already upset after only the first thirty *novelle* had been circulated, and by the time the book was completed it included not only the defense of the stories, in the introduction to the Fourth Day, but another rebuttal of the critics in the "Author's Conclusion" as well. In addition to the criticisms that he addresses within the *Decameron*, Boccaccio came under fire from his friend and colleague Petrarch, who told Boccaccio that he did not have time to read such a trivial book as the *Decameron* in its entirety and reprimanded Boccaccio for wasting his talent by writing bawdy tales in a vulgar language.[21] Certainly, the attacks on the book did not end there. Boccaccio himself, in his old age, denounced his book and suggested that if it were possible he would have destroyed all copies of it. Watson details

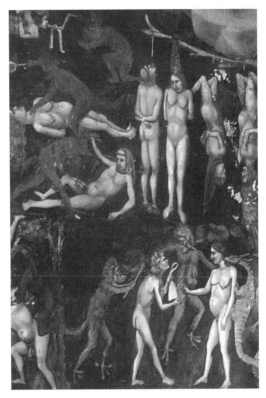

Figure 19. Giotto di Bondone, fresco of *The Last Judgment* (detail), c. 1305. (Scrovegni Chapel, Padua. Photo courtesy of the Scrovegni Chapel, Padua.)

further controversy occasioned by Boccaccio's work as manifested in the humanist controversy over "Johannes Tranquillitatum" in the first two decades of the fifteenth century.[22] Later, in the wake of the Reformation, when the Roman Catholic Church took up the issue of censorship of literature and monumental art in earnest, Boccaccio's *Decameron* was included on the Index of Prohibited Books drawn up and made official by the Council of Trent in 1560.[23] After its initial banning, the *Decameron* was subsequently recirculated in an extensively expurgated form. Even today, although many complete editions of the *Decameron* are available, our libraries still contain many editions that demonstrate an embarrassed reluctance to allow patrons to read the entire *Decameron*.[24]

If Western culture's penchant for repressing human sexuality is one way in which critics have tried to reduce the *Decameron* to a product "safe" for consumption, six hundred years of Boccaccio studies has also managed to restrict the field of meaning in the stories to an endless proliferation of philological inquiry that comprises the bulk of the scholarship. It is symptomatic of this conservative approach that although there has been no end to the representations (verbal, visual, and performance) of the *Decameron* executed since its release, there remains a stodgy insistence on a necessarily hypocritical, "chaste" (in Stephanie Jed's sense of the word, in her book *Chaste Thinking*) understanding of the book in traditional Boccaccio scholarship.[25] Clearly, a history of priggishness accompanies the *Decameron*. Yet, this is not to say that critics' objections are motivated exclusively by an aversion to the representation of sexuality; Boccaccio's caustic anticlericism, his inventive renovations of literary genres such as the *exemplum*, and his use of vulgar Italian also contributed to the scandal that has permeated the book's critical reception.

Similarly, the scandal that characterizes Pasolini's entire oeuvre has not been directed solely at his representation of sexuality, although many of the most virulent attacks against his work have involved homophobic accusations.[26] Most scholars and friends who have contributed to the wealth of essays and books about Pasolini make mention at some point of the "scandal" of Pasolini. In Pasolini criticism, this term broadly refers to issues of jurisprudence, Catholic mysticism, yellow journalism, sexuality, pornography, and "political correctness."[27] In her discussion Pasolini's polemical stances in his final years, Greene comments that "to no one's surprise," his:

inflammatory comparisons met with severe charges: at best, Pasolini's glorification of a rural past was "nostalgic" and "romantic"; at worst, instead of being an organic intellectual, he was seen as a "reactionary" and "regressive" one. Critics did not hesitate to point out that, despite his condemnation of neocapitalism, he himself – as the costly and lavish films of the trilogy made amply clear – was exploiting one of its showiest markets: that of film. (Still harsher critics pointed to his involvement in another "market" – that of masculine prostitution.)[28]

Over the course of Pasolini's life he underwent a long string of legal battles against charges of obscenity and indecency leveled at his per-

sonal conduct and his work.[29] Many of his critics have commented that scandal increased his stature as an *intellettuale*. And, indeed, it is possible that the scandalous quality of Pasolini's work is one of the factors that renders it interesting and fruitful.

Although scandal led to popular consumption of Pasolini's work, it also subjected him to close scrutiny by a variety of agencies, including the legal system and his colleagues (novelists, filmmakers, poets, and journalists) as well as politicos of all stripes. The debate that surrounded his work was often vitriolic and personal. In the copious response to his trilogy, many critics and colleagues criticized Pasolini's utopian conception of "liberating sexuality," the prelapsarian bliss he attributes to preindustrial society, and his idyllic depiction of the modern underclass. Critics condemned his exoticism, which used naked Third World bodies to figure innocence and jouissance, his bourgeois sensibility that idealized the underclass as somehow childlike and adorable in their disadvantage, and his utopian fantasy that the preindustrial past was pure and joyful. Pasolini's response to the deluge of criticism was his essay "Abiura della *Trilogia della vita*" ("Abjuration of *The Trilogy of Life*"). In this essay, which was first published in his column for the daily newspaper *Corriera della Sera* and also prefaces the published versions of the screenplay of *Trilogia della vita*, Pasolini responds to the critics by disavowing some aspects of the trilogy for which they condemn him, while insisting that they have missed the point of his celebration of life and, in fact, have degraded it in their misinterpretation:

I disavow the *Trilogy of Life*, although I do not regret having made it. In fact, I cannot deny the sincerity and necessity that pushed me to represent bodies and their culminating symbol, sexual organs . . . Now everything is overturned.

First: the progressive fight for expressive democratization and sexual liberation has been brutally overwhelmed and thwarted by a decision on the part of consumerist power to concede a vast (and equally false) tolerance.

Second: even the "reality" of innocent bodies has been violated, manipulated and tampered with by consumerist power; indeed, such violence against bodies became the most macroscopic fact of the new human epoch.

Third: private sexual lives (like my own) have suffered trauma from false tolerance and bodily degradation, and that which in sexual fantasies once was pain and joy has become suicidal delusions and shapeless sloth . . .

However, to those who were displeased or demeaning in their criticism of

the *Trilogy of Life,* don't think that my disavowal leads to their "duties." My disavowal leads to something entirely different . . . It leads me to adaptation . . . So, I am adapting to degradation, and I am accepting the unacceptable . . . I readapt my commitment to a greater legibility (*Salò?*).[30]

Pasolini's rejection of liberation through sexuality hinges on his recognition that the disruptive, scandalous, and challenging artistic possibilities available through the representation of taboo sex are undermined when appropriated by consumerist society, because this appropriation changes the role of the body from that of a transformative force to a consumed product. His response (the film *Salò* or *The 120 Days of Sodom*) is a brutal slap in the face to audiences who want to "consume" the bodies on screen. Lawton calls *Salò* a "disturbing, bothersome, even disgusting experience,"[31] and Greene describes it as "disturbing and unbearable," to which she further adds:

For this reason, I believe that the few critics who have argued that *Salò's* "real" message lies, precisely, in its desire to be unbearable, that is, its refusal to be consumed, have been very close to the truth. Discussing *Salò's* scenes of coprophagy – perhaps the most unbearable moments of the film – Pasolini deemed them a metaphor for the fact that "the producers, the manufacturers, force the consumer to eat excrement. All these industrial foods are refuse." Denouncing a bourgeois public that consumes every piece of "worthless refuse," *Salò* deliberately makes itself "indigestible."[32]

In this interpretation, Pasolini's response to criticism regarding his bourgeois, utopian, and exoticist sensibilities was to generate a remarkably unconsumable representation of bodies, desires, and sexuality that indicts everyone involved in the process, from the director (Pasolini), to the characters depicted, to the viewers (us).

In his article "The Evolving Rejection of Homosexuality, the Sub-Proletariat, and the Third World in the Films of Pier Paolo Pasolini," Lawton argues that Pasolini came to reject the elements of his work that he had intended to be revolutionary. Lawton makes the claim that once homosexuality (as the "strongest weapon" in Pasolini's arsenal) was appropriated and thereby trivialized by the consumerist system Pasolini was trying to undermine, the filmmaker rejected it: "Pasolini's strongest indictment of homosexuality comes in *Salò o le 120 giornate di sodoma* . . . homosexuality in the film [works] as a metaphor, for it is, as one of the lib-

ertines says, a mortal gesture, one which leads to nothing and produces nothing."[33] Lawton's description of homosexuality in *Salò* conforms to Dante's moral formula in the *Inferno*, where sodomites and moneylenders alike are condemned for their "unproductive" practices. It is well known that *Salò* is organized according to Dante's map of Hell, so Lawton's point is neither outrageous nor remarkable, but rather obvious in one sense. Yet, it seems to me that an element of inevitability underlies Lawton's argument, one that concentrates on a single thread of the discourse and ignores the complicated and manifold presence of homosexuality in Pasolini's work. Certainly, I do not want to argue that homophobia should be held up as a liberating force in human intercourse, but I do want to consider how, within the oppressive and hateful homophobic structures where Pasolini worked, his homosexuality was "productive" and powerful. In saying this I most definitely am *not* endorsing the moral, spiritual, and material values posited by the categories productive–unproductive in Dante's Hell but rather am using the term "productive" to refer to Pasolini's creation of artistic works, his personal jouissance both in his art and his sex life, and the social intercourse among friends, critics, colleagues, and audiences that developed out of his interventions.

In order to explore how Pasolini's homosexuality is made productive in his work, I will return to his *Decameron*, but first I will briefly outline the terms and structures that inform my understanding of the homosexual aesthetic in Pasolini's work. To begin, the category of homosexuality that I use in this chapter refers to Sedgwick's foucaultian designation of the homosexual–heterosexual dichotomy as it becomes operative in Western culture at the turn of the twentieth century. This means that although I attempt to outline a gay or homosexual aesthetic, I am always implicitly referring to the heterosexual "norm" against which definition emerges. It is important to understand that the heterosexist and homophobic structures that pervade the ground from which the homosexual aesthetic will be distinguished are not entirely fixed, although they are certainly stable enough to be recognizable as an overwhelming force. So, rather than simply declare that the homosexual aesthetic is thus, or means such and such, what I would like to do is set up a discourse that questions how the hetero–homo categorizations work, that is, to inves-

tigate "what enactments they are performing and what relations they are creating."[34]

I will discuss several different templates, fantasies, and narrative devices that have been designated "homosexual" and consider how these relate to the homosexual aesthetic in Pasolini's *Decameron*. First, I will discuss the psychoanalytic description of homosexuality, especially in reference to the oedipal family triangle. From there, I will investigate vision and the scopic drive in reference to homosexual "cruising," the "eye" of the camera, and spectatorship. This discussion will lead us to consider the category of ambiguity in representational codes and focus on how it is effected in the tableaux vivants in the film. I will discuss in detail how the nonnarrative, fragmenting impulses of the "cruising" gaze and the ambiguity shape the film, beginning with its division into two halves (*primo tempo* and *secondo tempo*), and then how each half is further disaggregated by the framing segments, which revolve around Ciappelletto and Giotto. The stability of the provisional delimitations of narrative content that I use (e.g., referring to specific "episodes") is belied by the continued effort on the part of viewers to discern precisely where each "episode" begins and ends.[35] In some ways this anatomizing process has proven to be difficult and unenlightening, but for my purposes it serves to index the slipperiness of the *novelle's* forms. In addition, I will consider the manner in which, in each half, the development of the narrative surrounding the frame characters is interrupted by a tableau vivant that acts as a fragmenting lens through which the ostensible narrative is refracted and further segmented. We shall see how the optic of the tableaux vivants shatters the film's narrative, multiplying and scattering meanings. Finally, I will end my survey of the homosexual aesthetic in Pasolini's film by discussing preterition; I will use language to write over the totemic elision of homosexuality by Western culture, from Saint Paul to many later writers, as the "unmentionable crime." By bringing all these strands together, I hope to build a vocabulary, however limited and incomplete, that will allow me to discuss specific aspects and moments of Pasolini's film which I categorize by the inchoate term "homosexual aesthetic."

That Pasolini's cinema was deeply concerned with Freudian psychoanalytic paradigms is clear. Furthermore, that Pasolini's personal under-

standing and experience inform his films is also manifest. Indeed, one of his most autobiographical films (both in his own opinion and that of his critics) is based on one of the best-known literary works discussed by Freud in formulating his theory of psychoanalysis, Sophocles' Oedipus trilogy. In fact, Pasolini's film version of the first two plays in the trilogy incorporates extensive biographical information and inspiration from Pasolini's own life.[36] In addition, when we view and read others of Pasolini's works and we read interviews with the artist himself, his heavy investment in the cynosural oedipal phase and the relations among members of the oedipal "family" in Freud's theory of the subject's development is readily apparent.

To describe the theory briefly: in the oedipal phase the subject (the child) develops a sense of self and body through interaction with a mother figure and a father figure. The nature of the child's affect directed at the parents is loosely divided into "identification" (desire to be the parent) and "love" (desire for the parent). Traditionally, Freudian psychology configures the triangle so that the child identifies with the same-sex parent and desires the parent of the opposite sex. However, as Silverman has argued, gender does not dictate that the paths of identification and desire must intersect and cross over. Rather, any given subject may "deviate" from the classical paradigm at any given moment. For example, in her book the *Acoustic Mirror*, Silverman makes a case for a "negative Oedipal" relation, in which the daughter both identifies with the mother (as her primary caregiver and role model) and desires the mother (who, as the center of her universe, figures all that is desirable). The multivalent and variable affective ties available in oedipal triangles derive their effectiveness and power from their relation to the "fantasmatic," which Silverman defines as "that variable unconscious *combinatoire* or libidinal paradigm governing each subjects' libidinal and narcissistic existence . . . which always assumes a 'scenic form.'"[37] The envisioning of a mise-en-scène represents the subject's negotiation of the various affective impulses and responses that constitute the subject. Of course, this arrangement is not an inflexible, archetypal, unitary "sexual orientation," but a subjectivity whose "complex and mutually structuring interaction between an unconscious fantasmatic, and the external images through which that fantasmatic must express itself . . . both play a determining

part."[38] In this reading, the homosexual components of the scenario are neither monolithic nor indistinguishable but protean, in the sense that they can assume very different statuses depending on which elements are foregrounded. For our purposes, the psychoanalytic formulation will be used to address the homosexual aesthetic in Pasolini's film. I will follow Cowie's lead and regard his *Decameron* as "fantasy in the most fundamental sense of this term in psychoanalysis."[39]

In order to enter into a discussion of representations of desire in the frame sequences, I will concentrate on the positions occupied by the characters Ciappelletto and Giotto. As I pointed out in Chapter 4, although Giotto is the central character in the framing sequences he is also a liminal character, because he occupies a position both within and external to the *novelle*. In addition, as an artist, a creator of picture-stories in the frescoes, Giotto acts as a metaliterary figure for the production of the film. Furthermore, the role of Giotto is played by the screenwriter and director of the film, Pasolini, a casting move that does quite a lot to foreground the comparison between filmmaking, fresco painting and their roles in creating a narrative world for audiences and characters alike, as well as to emphasize the notion that subject positions are infinitely flexible.

Although Pasolini's film is sufficiently complex and ambiguous to preclude neat dichotomies and formulations, I want to broadly outline two complementary movements in the film that are determined by the homosexual aesthetic. In the Giotto sequences, the *bottega* (workshop) and the monastery attached to the Church of Santa Chiara set the stage for the creativity and spirituality in which the gay aesthetic is manifested. It is noteworthy that male pulchritude, camaraderie, exuberant creativity, and reverence for the artist pervade Giotto's all-male frame sequences. On the other hand, in the Ciappelletto segments issues of lying, comprehension, misinterpretation, and trust cluster around vignettes of theft, commerce, extortion, and death. However, the thrust of both the Ciappelletto and the Giotto sequences is mitigated by the tableau vivants. For example, the tableau vivant of the Last Judgment, in the Giotto frame segments, brings up questions about the mostly sublimated homosexual elements of the last half of the film. And, although the film figures Giotto as the object of adoring gazes from the *fraticelli*

(monks) and rapt attention of his apprentices and workers, one of the effects of this tableau vivant is to heighten appreciation for maternal creativity as well as artistic and spiritual creativity.

The Ciappelletto sequences of the film associate the homosexual aesthetic with an entirely different world from Giotto's, one where murder, theft, usury, pederasty, and deception reign. Here the "cruising" gaze appears in an unambiguous form as it chronicles Ciappelletto picking up a young boy and as it repeatedly zooms in on bulging codpieces and chiseled musculature. Yet interestingly, this rather less metaphoric homosexual aesthetic is complexly related to issues of verbal clarity and interpretation. Deception, misunderstanding, and lack of trust are central to Ciappelletto's relations in the film. The wonderful irony this occasions (resulting in the worst of sinners being canonized) finds its visual accompaniment in the Bruegel compositions that invade Ciappelletto's *novella* and permeate the subsequent scenes. In this first half of the film, a weird pastiche of Peter Bruegel the Elder's art increases the complexity of the presentation of the frame sequences, and, as visual and musical elements of the tableau are recycled in Ciappelletto's final scenes, the apparently negative portrayal of homosexuality is opened to question.

In order to describe how Pasolini's homosexual aesthetic informs his film, I will begin by walking through a chronological analysis of the scenes and segments that I find most representative of the variability and that influence his gay sensibility. Because, according to my formulation, it is precisely ambiguity and fragmentation that characterize Pasolini's homosexual aesthetic, we will be reviewing elements in the film that challenge the narrative impulse toward coherence. As a result, often the object of our inquiry will itself be fragmentary.

To begin, we will look carefully at the Ciappelletto half of the film. Appropriately, our introduction to Ciappelletto begins at the end of a story, the beginning of which is left untold. The film opens with a very unclear murder scene: a medium shot of Ciappelletto savagely beating a bundle, which laments "You didn't understand anything" (Non hat capito niente) before it is bludgeoned into emitting only pained grunts and finally is silenced by Ciappelletto by a blow with a large rock. This quick scene is, above all, confusing; it is filmed in poor light, and the camera frames only the upper portion of the laboring Ciappelletto, with the re-

sult that the viewer is left uncertain as to exactly what has transpired. Once Ciappelletto finishes off the body in the bag, he heaves the load over his shoulder and lugs it through poorly lit alleyways on his way out of town, then throws it off a cliff just as the sun is starting to cast an orange glow over the scene. After Ciappelletto disposes of the body, the camera tightens in for a close shot of his face as he spits after it in hatred. As I mentioned, we never learn whom Ciappelletto has murdered or why; this dark and confusing scene abruptly ends as the film cuts to the light, cheery opening scene of the Boccaccian tale of Andreuccio.[40] Ciappelletto's victim's cry that his aggressor has not understood anything seems to sum up pretty well our own bewilderment at this odd ending that paradoxically opens the film. Later in the film, during the final segments that chronicle Ciappelletto's demise, visual echoes from this murder will reverberate in the darkened archways that recall Ciappelletto's trajectory to the dump. Yet the difference between the fate of this first dead body, which is completely obscured and anonymous and left in what appears to be the town dump, and that of Ciappelletto, who, when he dies, is canonized, put on display, and adored as a divine intercessor, negates any direct comparison between the two.

Following this opening fragment, Ciappelletto is obliquely recalled, in the tale of Andreuccio, by the figure of the *guaglioncello* (young boy) who booby-traps the bathroom and arrogantly appraises Andreuccio (Fig. 20). The parallel begins when the camera shows a hand sawing through the plank floor over the cesspool. Initially, we do not know who is doing the sawing; however, after many different shots we see a boy emerge from a door that we later learn leads to the toilet. The boy slouches insolently and provocatively against the door frame, then looks over and spits on the floor, very much as Ciappelletto does after he has tossed the body off the cliff. This short segment sets up this *guaglioncello* as an arrogant mini-Ciappelletto. Later in the *novella*, Andreuccio's newfound "sister" tells him to sleep in the room because it is too dangerous to walk the streets of Naples after dark. As the "sister" tells Andreuccio this ironic bit of information, the camera frames Andreuccio and the boy together. In this shot, Andreuccio faces the camera directly and somewhat ingenuously, while on the right side of the frame the boy slouches. Andreuccio's earnest face and codpiece are his most no-

Figure 20. Andreuccio da Perugia getting ready to retire in Pier Paolo Pasolini's film, *Il Decamerone*, 1973.

ticeable features. In contrast to Andreuccio's upright posture the *guaglion-cello's* roguish, S-shaped slouch looks cocky and provocative. When the "sister" tells Andreuccio that she is leaving the boy there in case Andreuccio should want anything, the camera isolates the boy in a medium shot as he smiles slyly. After the women servants and "sister" have bid Andreuccio good-night, an ambiguous relay of looks follows between Andreuccio and the boy. The first impression derived from the way the boy grins when the "sister" tells Andreuccio that the boy is there to serve him is that the boy is being offered as a replacement to Andreuccio in recompense for his thwarted sexual adventure (Andreuccio had expected quite a different reception from his "sister"). However, as the camera records the next few moments the presumed roles are reversed. As Andreuccio undresses, the boy blatantly stares, as if he were sizing him up. In response, Andreuccio whistles a little nervously and shrinks behind the baseboard of the bed, hiding all but his mop of curly hair and his wide eyes as he removes his clothes (Figure 20C). The boy's frank stare and sly smiles generate the impression that he, not Andreuccio, will be the seducer in this bedroom (Figure 20D). This brief visual exchange between the boy and Andreuccio has almost nothing to do with the plot

A

B «Once upon a time in Lombardy»

C «in a monastery most famous for holiness»

D

E

F «of noble blood and wondrous beauty»

G

H They saw the pair dallying

Figure 21. Ciappelletto cruising and picking pockets in Pier Paolo Pasolini's film, *Il Decamerone*, 1973.

of the tale, but it represents one of those moments in Pasolini's film where what I am referring to as the "cruising" gaze appears and diverts our attention from the story and leads us in other directions for a moment.

The next segment immediately follows the end of Andreuccio's *novella* (Figure 21). Once again, Ciappelletto is indexed by a dark, narrow alleyway; however, this time it is teeming with people who have gathered to hear a story. This short episode, which does not appear in Boccaccio's

book, depicts most concisely how the "cruising" gaze competes with, appropriates, and ultimately overwhelms the narrative in Pasolini's film. In order to clarify what I mean, I will describe the two competing modes of representation in the scene: the image track and the sound track. The visual sequence records Ciappelletto picking the pocket of a man who is listening to the storyteller, while at the same time Ciappelletto is cruising the crowd to pick up a boy. The sound track is dominated by the voice of an old man telling Boccaccio's story of the mother superior who mistakes a priest's underpants for her wimple (*Dec.* IX, 2).[41] The old man begins by reading the story from a book but soon decides to tell it "the Neapolitan way," one that in Italy is famous for its reliance on gestures and physical demonstration. As the old man tells the story, the camera follows Ciappelletto's line of vision as he threads his way through the crowd, apparently completely uninterested in the tale. The camera frames Ciappelletto looking intently (Figure 21D) and then reverses to show that the object of his gaze is a good-looking boy of about eleven who is engrossed in the story (Figure 21C). As the boy is framed, the storyteller is describing the monastery, where "chastity and sweet piety pervade." Subtlely, the image appropriates the storyteller's words, giving rise in the viewer's mind to an association of this boy with chastity and piety. After returning to Ciappelletto, the image track once again reverses back to a profile head shot of the boy as the storyteller says, "endowed with wondrous beauty" (Figure 21E). Just as the storyteller utters this appraisal of pulchritude, the pretty young boy looks straight at the camera/Ciappelletto and then turns back to the story (Figure 21F). From the boy's glance we are able to see just how appealing he is, and at the same time we understand that he is aware of being under someone's gaze. As the storyteller proceeds, the camera follows Ciappelletto as he sidles up to a very large man and steals a coin out of the small leather purse hanging from the man's belt (Figures 21 G and H). During this activity, the camera frames a close shot of the man's crotch area and Ciappelletto's hand dipping into the hanging leather bag. Ciappelletto sneaks away and then reappears next to the pretty boy, just as the storyteller says, "What'd she do?" (Figure 22A). The storyteller continues, "In a panic, she mistook the father's underpants for her wimple and put them on her head." Here, the camera shows a tight shot of Ciappelletto's index fin-

Figure 22. Ciappelletto picking up the young boy in Pier Paolo Pasolini's film, *Il Decamerone*, 1973.

ger rubbing the boy's crotch (Figure 22B), then cuts to a head shot of the boy as he turns to look up at Ciappelletto with a startled expression on his face (Figure 22C). Next follows a reverse to a head shot of Ciappelletto as he smiles and nods his head, indicating that the boy look down (Figure 22D). The boy does, and then we see a shot of Ciappelletto's hand as it flips a coin, next to the boy's crotch (Figure 22F). In the next shot the boy looks up at Ciappelletto and smiles (Figure 22G) and then

turns back to the storyteller, who finishes saying, "'Ahh, so even you were screwing in your cell, I can tell because you have the priest's underpants on your head.' So it went that in that convent all the nuns had sexual intercourse as well."[42]

I have tried to give the reader a sense of what this scene looks and sounds like because I think Ciappelletto's looking, stealing, and propositioning distracts our attention from the storyteller's narration in a way that epitomizes the manner in which the homosexual aesthetic works against the narrative coherence in the film. Several people to whom I have spoken about this scene have mentioned that they find the visual and verbal cues muddled on the first viewing. Most people claim that they come away not having followed the storyteller's narration entirely, even though it is familiar to them, because they were distracted by the visual sequence. And, although it seems clear to me that the visual cues refer to theft and sexual assignation, some individuals I spoke with thought that even the visual track was not entirely clear and questioned whether Ciappelletto actually made sexual advances. These responses demonstrate that, in this brief sequence, the "cruising" gaze competes directly for our attention with Boccaccio's story and the competition results in the fragmentation of the narrative coherence of the *novella*. It is important to point out that the image track, which demonstrates the "cruising" gaze, does not finally add up to a coherent plot either but remains a fragment as well. By this I mean that the "pick(pocket)up" sequence does not exceed the bounds of a vignette, even as it reduces the wimple story to background noise. Ultimately, what we are left with is two vignettes in which the activities of storytelling and listening, and theft and sex, are as much at issue as Boccaccio's *novella*. The nexus in this scene of theft and storytelling as distraction–deception–pickup and commerce condenses many of the issues that are involved in the way Pasolini's homosexual aesthetic is figured by the character of Ciappelletto. The stealth, visual acuity, and posturing necessary to pick the man's pocket are skills that also make for successful sexual pickups, and, as we shall see when we consider Ciappelletto's false confession, they are also integral to the creation of stories.

Pasolini's film continues with the *novelle* of Masetto and Peronella, Ciappelletto returns to the screen in a discontinuous series of segments

Figure 23. Tableau vivant of a pastiche of Peter Breugel the Elder's paintings in Pier Paolo Pasolini's film, *Il Decamerone*, 1973.

that is scripted primarily by Boccaccio's tale of Cepperello/Ciappelletto (*Dec.* I, 1). We begin with Ciappelletto talking with Musciatto as the latter asks Ciappelletto to go north to collect money from some of his delinquent debtors. Musciatto tells Ciappelletto that he will arrange with some expatriot Neapolitan usurers of his acquaintance to host Ciappelletto during the time he remains to collect the money. The final image in this segment shows a shot of Ciappelletto's agreeing face as Musciatto exhorts him to "come back with the gold!"[43]

Suddenly the screen is occupied for a few seconds by a tableau vivant of a peculiar, pastoral pastiche of paintings by Peter Bruegel the Elder, which is accompanied on the sound track by a men's choir singing a hymn (Figure 23). This first screen includes an array of images taken from various Bruegel paintings set against a lush, green meadow in a long shot reminiscent of the Theatrum Mundi presentation of Bruegel's early works.[44] In this first shot, the center front is occupied by a young and beautiful woman, who is clearly modeled on the character "Lent" from Bruegel's *Fight between Carnival and Lent*, yet, this figure is not old and haggard (as is Bruegel's Lent); instead she looks far more like Hope, from Bruegel's *Allegory of Hope*.[45] In another deviation from Bruegel's iconography, this Lent/Hope has a human skull rather than two herrings on her

143

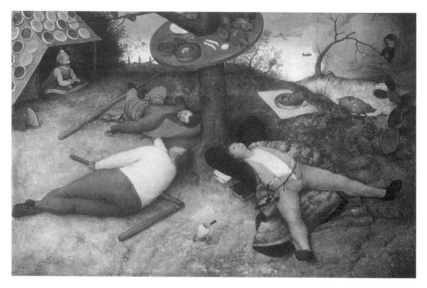

Figure 24. Peter Bruegel the Elder, *The Land of Cockaigne*, 1567. (Alte Pinokothek, Munich. Photo courtesy of the Alte Pinokothek, Munich).

baking paddle. To the right of this figure we can see a group of men passed out under a round table laden with goodies, an image clearly taken from Bruegel's *Land of Cockaigne* (Figure 24), and to the left of this figure lies a man in peasant dress, passed out next to a cart in an attitude reminiscent of the man sleeping under the pear tree in Bruegel's *Wheat Harvest*. Directly behind Lent/Hope is the pedestal upon which Ciappelletto's corpse will later be displayed; the location of this pedestal associates it with the fishpeddler's stand in *Carnival and Lent*. Behind the pedestal, on the far right, is a group of soldiers clad in black armor who hold long, pointed spears. These soldiers generally resemble soldiers in many Bruegel paintings but do not look exactly like any in particular. Behind these soldiers, to the left, is a gigantic barrel (similar to the one "Carnival" mounts in *Carnival and Lent*) upon which several young men play at switching hats with each other. Further to the left, a crippled man struggles to make his way forward across the lumpy meadow. In the far left corner of the screen is a circle formed by a bishop and several monks wearing white cassocks who toss a human skull around to each other playfully. The location of this group and their white cassocks recall the

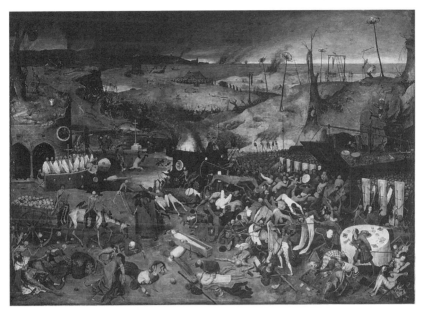

Figure 25. Peter Bruegel the Elder, *The Triumph of Death*, c. 1561–2. (Museo del Prado, Madrid. Photo courtesy of Museo del Prado, copyright © Museo del Prado, Madrid.)

group of skeletons in Bruegel's *Triumph of Death* (Figure 25). Following this brief long shot, the film cuts to a stationary medium shot of Hope/Lent and three women who are clustered behind her (Figure 26A). The stillness of the central figure and her solemn bearing give the impression that she is the main figure around whom all the other activity and people in the tableau vivant radiate. Her importance and strange combination of features give rise to questions about the kinds of messages articulated by her enigmatic construction. Her youth and beauty lend her iconographic credence as a symbol for hope; her beehive headgear, which various scholars have interpreted as signifying prosperity in Bruegel's *allegory of Hope*,[46] the Church,[47] and the memory of days of honey (plenty) during times of fasting,[48] sets her off and increases her statuesque and symbolic aspect. And although, because of her cart and baking paddle, she is most obviously like Bruegel's Lent, these features, taken out of the context of the parodic joust with "Carnival," only increase her ambigui-

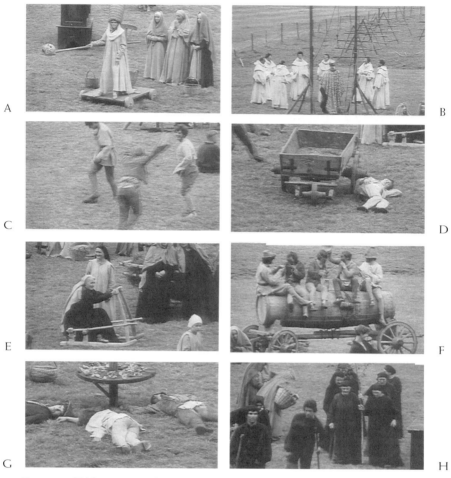

Figure 26. Tableau vivant of a pastiche of Peter Breugel the Elder's paintings in Pier Paolo Pasolini's film, *Il Decamerone*, 1973.

ty. The skull poised on her baking paddle lends a gruesome touch that adds to the viewer's confusion. In the conspicuous absence of the figure of Death in this tableau vivant, this woman with a skull on her baking paddle has a rather more frightening than hopeful aspect.

After a few seconds, the film cuts to a medium shot of the monks playing "toss-the-skull" (Figure 26B). In a self-enclosed circle, exiled to a far corner of the tableau, these religious men play a game in which some

poor, long-dead person's head is tossed about for fun. In light of their future role in Ciappelletto's canonization, their sport might symbolize the attitude and influence that the monks, particularly the bishop, exercise over the fate of the dead. Along another tangent, the fusing of play with death and possibly the plague (and as the cartful of skulls that will shortly be seen implies), recalls Boccaccio's introduction to the *Decameron*, where he explains that the context of the *lieta brigata*'s sojourn was the plague of 1348. The scene of toss-the-skull cuts to a medium shot of several young men playing and performing gymnastics in what looks like a detail from Bruegel's *Children's Games* (Figure 26C). Their mirth and joy, as well as mischievousness, add a genuinely lighthearted touch to the tableau and begin an interlude of play and pleasure in the film's re-presentation of the tableau. The camera turns to a medium shot of the man asleep beside the empty cart (Figure 26D), followed by a medium shot of an old woman astride a strange wooden rocker/horse in the company of several women (Figure 26C). Next, the camera fixes on the young men playing the hat game (Figure 26F). The goofy antics of these fellows replace the parodic caricature of "Carnival" in the Bruegel painting with the playfulness of youth. The animation of the game and the gymnastics lend the "life" to this tableau. The game of switching hats, exchanging identities in a small way, lends itself to the fluidity of subjectivity portrayed in the tableau (which ranges from life to death) and at the same time rhymes with the monk's game of toss-the-skull.

The camera cuts from the hat game to a medium shot of the *Land of Cockaigne* group (Figure 26G). Gibson relates the folklore behind this scene in Bruegel's picture:

[F]or this picture he [Bruegel] drew upon an old folk theme whose humour particularly captivated sixteenth-century Europe. A Dutch poem of 1546 describes Cockaigne as a land abounding in food and drink. Pigs and geese run about already roasted, pancakes and tarts grow on the rooftops and fences consist of fat sausages; these are only a few of the gustatory delights obtainable without cost or effort. To reach this glutton's paradise, the traveller must eat his way through three miles of buckwheat porridge.[49]

To a reader of Boccaccio, this little group calls to mind Maso el Saggio's description of the County of Bengodi,

where they tie up vines with sausages and where you can have a goose for a penny and a gosling thrown in for good measure . . . and there was a mountain made entirely of grated Parmesan cheese upon which lived people who did nothing but make macaroni and ravioli and cook them in capon broth and later toss them off the mountain . . . and nearby flowed a stream of Vernaccia [wine].[50]

With the inclusion of the Cockaigne group, Pasolini brings to his pastiche a little corner of Calandrino's imagination. But, this is only one corner of the tableau. The landscape of fun and pleasure is also the setting for piety, abstinence, and death. Passing from the debauched Cockaigne group, a Lenten procession of penitential women from *Carnival and Lent*, preceded by a man on crutches, threads its way through the meadow (Figure 26H). Next the camera rests on a medium shot of several people pulling a cart in which a dead body wrapped in a winding sheet rests (Figures 27A and B). This image looks much like one of the central figures in Bruegel's *Triumph of Death*, namely, the dead body pulled along in an open coffin by two skeletons. This scene is cut by a shot of two men struggling to roll a large cart filled with human skulls over the lumpy meadow, an image similar to the "death cart" in *The Triumph of Death*. The difficult labor of these men struggling with the skull cart is cut by a line of women carrying a prayer chair (Figure 27C), an image taken from the upper left-hand corner of *Carnival and Lent*, where people emerge from church after a "long sermon."[51] In the film, the absence of a church lends this line of people a less mundane air than they have in Bruegel's painting and elevates the prayer chair to the status of holy relic or icon in a religious procession.

The procession is cut by the medium-long shot of Lent/Hope as the body cart lurches along behind her (Figure 27D). The camera then closes in to record the progress of the cart and its occupant from an angle that emphasizes the haphazard, ill-fitting match between the corpse and the cart. The corpse's feet protrude awkwardly as the people try to unstick the cart and push it forward (Figures 27E and F). The camera's emphasis on the angle of the body will later parallel imagery from Ciappelletto's death scenes.

Finally, the portion of film recording this tableau vivant comes to a close by framing a head shot of Hope/Lent (Figure 27G) and then following her gaze to end on a close-up of the skull on her baking paddle

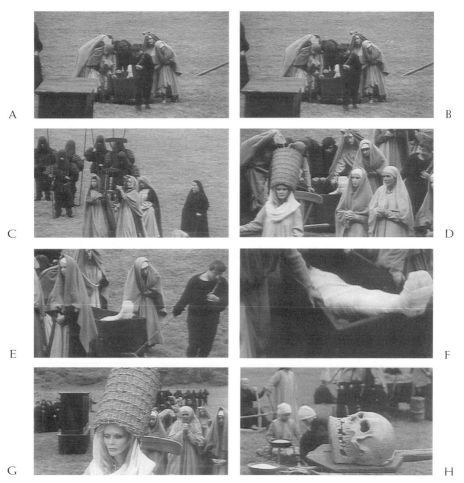

Figure 27. Tableau vivant of a pastiche of Peter Breugel the Elder's paintings in
Pier Paolo Pasolini's film, *Il Decamerone*, 1973.

(Figure 27H). The agency of vision of this tableau vivant is obliquely at-
tributed to Ciappelletto by the first non-Bruegel image following the seg-
ment, which is a close shot of Ciappelletto's face staring at the camera as
if transfixed (Figure 28A). Continuity between the vision of the tableau
vivant and Ciappelletto's transfixed stare is enhanced by the continuation
of the choir's singing during the time the shot of Ciappelletto is shown.

The tableau segment is truncated by a long outside shot of a building

149

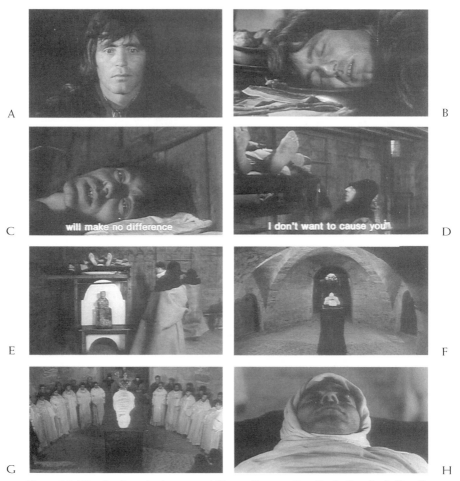

Figure 28. The death and adoration of Ciappelletto in Pier Paolo Pasolini's film, *Il Decamerone*, 1973.

that is revealed to be the house of the usurers with whom Ciappelletto has come to stay. As the Boccaccian tale continues, we see that Ciappelletto has come far north in Europe to where the German language is spoken and spaghetti is not eaten ("glaub nicht das hier Spaghetti gegessen werden"). As he and his hosts eat their meal, Ciappelletto curses the usurer's trade, spitting to emphasize his point. The usurers respond hesitantly, unsure of Ciappelletto until he professes that he was only

making a joke. At this point, Neapolitan sentimentality overtakes all of them, and they join voices to sing the melancholy Neapolitan ballad "Fenestre che lucive" with great drama. In midsong Ciappelletto's head crashes onto his plate, coming to rest in a position similar to the skull's on Lent/Hope's paddle (Figure 28B).

The shot of Ciappelletto's head on his place cuts to the usurers whispering outside of Ciappelletto's bedroom door about what they should do with their doomed guest. From inside the room Ciappelletto hears them and calls them to his bedside (Figure 28C). The composition of many of the shots as well as the camera angles that record the colloquy that follows repeat images from the Bruegel tableau. For instance, as Ciappelletto speaks to his hosts, the combination of the dim lights casting long shadows on his sunken features and the way the camera frames his head makes Ciappelletto look exactly like the closing shot of the skull on the paddle. Further, when the camera travels away from Ciappelletto's bedside it moves to an oblique angle at the foot of his bed where it records Ciappelletto's feet protruding awkwardly from his sheets and bed in a manner that quite clearly recalls the dead body being hauled through the tableau (Figure 28D). Later, during Ciappelletto's confession (Figure 28E), the same angles and compositions are recycled, with the difference that in these scenes the animated exchanges between the priest and Ciappelletto turn the viewer's attention away from the fact of Ciappelletto's dying to the subterfuge he practices in his false confession. In particular, the last part, where the priest uses a wheedling, pleading tone of voice as Ciappelletto coyly resists him in the "Yes! NO! YES! NO! . . . " debate, the dialogue is almost transported from the realm of Christian confession to a subliminal, petulant sexual conquest. This comic exchange calls attention to the fundamentally destabilizing character of Ciappelletto, who, even in the most ritualized of exchanges, the last confession, manages to turn the dialogue inside out. As Musciatto tells him earlier in the film, "By now you have done everything you could here. You've falsified all the documents that could be falsified. You've murdered. You've raped women. You've blasphemed God and all the saints . . . And you're even something of a pederast."[52] Ciappelletto's carnivalesque inversion of conventional behavior (he lies, cheats, steals, rapes, and murders for a living, and his sexual appetites

lean towards "inversion") reaches the pinnacle of flexibility with his false confession. Exercising the expertise we witnessed in his pickpocket scene, Ciappelletto completely convinces the priest that his ludicrous confession is absolutely true. Of course, in his life Ciappelletto was the antithesis of a saint, yet, by the final sequences of the film, the music, tableau imagery, and sincerity of the crowd lend currency to the idea that this is not simply a mock hagiography. Ciappelletto has become a saint. The canonization of Ciappelletto by the priest during his sermon is accompanied by the same choir heard during the tableau. Once the sermon ends, the volume increases, so that the singing rings out loudly through the final scenes of Ciappelletto's story. We are shown Ciappelletto wrapped in a winding sheet, on display on a pedestal in a dim, underground crypt. We first see him in a medium long shot taken from the level of his feet, framing him in the doorway and the arched ceiling (Figure 28F). As people come into the room, the camera raises up a little to give us an oblique, superior view of Ciappelletto's corpse on display (Figure 28G). Up to this point we are unable to positively identify the body, but then the film cuts to an oblique close shot of Ciappelletto's exposed face (Figure 28H). We then get a medium shot from behind Ciappelletto's head that is nicely framed by the archways, which reverse to show us the bishop flanked by the usurers, presiding over the adoration of Ciappelletto's corpse. A longer shot from Ciappelletto's feet shows the mass of people assembled in the room, who, when the music stops, surge forward to caress the corpse.

It is true that the usurers manage to imply the possibility of parody as they smirk at each other past the bishop; however, in contrast to Boccaccio's version of the story of Cepperello/Ciappelletto, Pasolini's film does not easily resolve into straightforward dichotomies.[53] Pasolini's surreal tableau vivant combines sin (gluttony), frivolity, and death with piety and charity as well as the bizarre, enigmatic imagery of Lent/Hope and the toss-the-skull group. It strikes me that in its overdetermined composition, the tableau is immune to straightforward clarification. Even if we attempt to determine the iconographic meaning of the elements of the tableau, the message is still opaque. This opacity infects the Ciappelletto "story," which, broken up and scattered around the first half of the film, is interrupted by the Bruegel pastiche and then infiltrated by

imagery and music from the tableau vivant. The pastiche, as a visually and aurally discrete unit, breaks into the story of Ciappelletto's adoration (the episode that most closely follows Boccaccio's tale of Cepperello/Ciappelletto) and then dissolves into the image and sound track, filtering the *novella* through the lens of the pastiche. The fusion of the tableau vivant and the film of the *novella* highlights the tensions and opportunities for expanding meaning through the integration of verbal, visual, and aural elements. Whereas in Boccaccio's *novella* Ciappelletto's own rewriting of his life with his false confession points up the possibilities for deception and gain through storytelling as well as the possibility of a sincere demonstration of Christian faith, Pasolini's considerably complicated version offers a great many more layers for the viewer to fathom. The appropriation of Bruegel's images (themselves fraught with controversy over moralizing vs. parodic interpretations)[54] and their insertion in the story of Ciappelletto's canonization render the already sophisticated construction more complex as the ending resonates with the ambiguous imagery. Pasolini's synthesis of questions regarding irony and straightforward faith is greatly complicated by the resistance to narrative coherence occasioned by the contradictory elements of the composition; it is further troubled by the camera work and stage direction of the tableau, in which the overview of the Theatrum Mundi is undermined, dissected, and subjected to time and movement. This is precisely the kind of rewriting and recasting that I associate with Pasolini's homosexual aesthetic, which, although it works within specified parameters, reorganizes and, consequently, changes the values of iconographic and indexical meaning.

Ciappelletto, as a homosexual who is also a storyteller, provides the opportunity to consider the problem of being a homosexual "artist" in a homophobic society. The tableau's emphasis on play, carnival, and death could represent one approach to addressing the censorship and disenfranchisement occasioned by such a position. Perhaps we can interpret the images of the tableau not as the literal, moralizing iconography or its parodic inversion but as the deployment of an aesthetic sensibility that has at its center its own riddle: how to express itself in the face of repression and homophobic hatred. I tentatively offer this suggestion as one way of looking at the Ciappelletto half of the film, although, as we

shall see, it may make more sense in my discussion of the Giotto seg-
ments of the film.

I would like to continue this discussion in relation to the second half
of the film. Whereas in the Ciappelletto segments in the first half ho-
mosexuality was explicitly addressed, here we need to infer the homo-
sexual aesthetic in other ways. The issues of creativity and homosexual-
ity that paralleled each other in the Ciappelletto half stand in a
symbiotic relationship to each other in the Giotto sections. In addition,
focusing on Giotto as both a homosexual and art-making character in
the *Decameron*[55] greatly facilitates my effort to address Pasolini's homo-
sexual aesthetic in art. It may strike the reader as somewhat awkward to
make this evaluation, given the paucity of explicit evidence in the film
for Giotto's sexual preferences; however, I believe it is important to point
out that although in a homophobic and heterosexist culture one gener-
ally presumes everyone to be heterosexual unless a great deal of effort is
invested in proving otherwise, this presumption is simply not accurate.
I want to argue that because the importance of sexuality in any version
of the *Decameron* is paramount, a careful consideration of the types of de-
sires expressed in Pasolini's version must be made. Whereas Boccaccio's
book concentrates on stories addressed to marginalized, lovesick
women, Pasolini's frame displaces the narrative agency entirely away
from those circumstances, and even though Pasolini's film versions of the
novelle display the utmost respect and admiration for their source, the
overriding concern for the "oziose donne" in Boccaccio's book is re-
moved and replaced with a dynamic whose fulcrum is male community.

It is my contention that in Giotto's painting sequences in the film, the
beautiful blue-eyed boy with curly hair; the first assistant, whose nose
Giotto dabs with paint; the whistling scene; and the carousing at the
completion of the frescoes all celebrate the joy and community of the
bottega, where Giotto is the central force. Of course, explicit sexuality is
sublimated into homosocial camaraderie in these scenes, but at the same
time, the genuine sense of mutual fondness and kinship shown here,
coupled with the appreciative shots of youthful male pulchritude, are as-
sociated with the physical acts of love and lust in the heterosexual en-
counters that are framed by these sequences. Interestingly, the trans-
gressive character of sex in the *novelle* often contrasts with the harmony,

artistic productivity, and continuity of the painting scenes. In the *novelle* framed by the Giotto sequences, Caterina and Riccardo risk exposure and punishment (*Dec.* V, 4), Lorenzo is killed, and Lisabetta is left alone and immured by her brothers (*Dec.* IV, 5), Compare Pietro is *cornuto* (cuckolded) (*Dec.* IX, 10), and Meuccio and Tingoccio worry about damnation (*Dec.* VII, 10). The point I want to make is that even in the *novelle* that end well (e.g., Caterina and Riccardo), the threat of violence, humiliation and perdition still underlie the emotions in the story. In contrast to these *novelle* and the representation of Ciappelletto in the first half of the film, Giotto's frame sequences are carefree. I would argue that in this sense Pasolini offers a laudatory, if limited, representation of exclusively male love and affection.

Certainly, by proscribing sexual pleasure in these male relationships, Pasolini limits the range of his praise while, at the same time, the absence of homosexual erotic pleasure in the film indicates many difficulties. However, before I discuss the internalized authority that I believe underlies this sublimation, I want to briefly discuss certain instances in which the homosexual aesthetic erupts in joyful celebration: the scenes in which Zita Carapresa's wedding bursts into the tale of Gemmata. My association of these episodes with Pasolini's homosexual aesthetic depends on my previous association of the tableau vivant with the gay sensibilities in the film that disrupt the narrative. Initially, these scenes of peasant revelry are diegetically motivated, because they show the reason Gemmata cannot spend the night with Zita, which is the circumstance that leads to Don Gianni's story of turning his horse into a woman. In this first instance, we see Gemmata observing the wedding celebration from her house (Figure 29A). In yet another quotation from Bruegel, the wedding guests dance into Gemmata's view during a scene that recalls *The Peasant Dance*. As the Boccaccian *novella* continues, it is interrupted another two times by scenes of the festivities, as Zita's wedding explodes into a full-blown rowdy party (Figure 29B). These scenes are also patterned after Bruegel paintings: *The Wedding Dance* and, to a lesser degree, *The Wedding Banquet*. Although these fragments of tableaux *trés* vivants have no real narrative value in the Boccaccian *novella*, the revelry manages to seep into Gemmata's and Pietro's bedchamber on the sound track and then burst onto the image track with great commotion.

Figure 29. Zita Carapresa's wedding celebration in Pier Paolo Pasolini's film, *Il Decamerone*, 1973.

The hectic presence of the party scenes tends to distract our attention from the *novella*, because they have nothing to do with the story of how Pietro got his horns. I would argue that these superfluous fragments of Zita's party are simply a felicitous eruption of the kind of jouissance that comprises part of Pasolini's homosexual aesthetic. However, these wedding scenes do not represent anything approaching homosexual erotic

pleasure, so, in order to discuss more fully the implications and mechanisms of the foreclosure of homosexual pleasure in this part of the film, I want to return to the Virgin in the tableau vivant.

In Chapter 4 I argued that Giotto's vision of the tableau vivant of the Last Judgment enacted a version of ideal artistic creation; that is, it put on the screen a representation of the creation of a work of art in the artist's mind. Here I want to discuss the content of that creation in more detail. I will argue that Giotto's vision of his fresco of the Last Judgment represents a nodal point where conflicting notions of the issues of creation, sexuality, knowledge, and subjectivity come together and are organized into a socially and aesthetically acceptable form. It is my contention that this vision of the Last Judgment figures the fantasmatic negotiation of homosexual desire in the face of hateful prohibition and deprecation. The various influences I will describe at work in this scenario occur on both the conscious and unconscious levels, and although the product of their encounter is very stylized and marketable, it represents a problematic resolution to the conflict among the parts. Many of the strands of the argument that I will pull together here are contradictory and oxymoronic, and they will remain that way, because my intention here is not to produce a unifying explanation of the vision but simply to elucidate some of the many different impulses that resonate in the sequence.

To begin, I want to consider the effect of Pasolini's replacing Christ the Judge in the historical Giotto's *Last Judgment* with the Virgin Mother Enthroned (see Figure 12A and the discussion in Chapter 4). In an interview published in *La Stampa*, Pasolini disavowed any special purpose in this substitution, claiming that the tableau vivant is "a Neapolitan version of the Last Judgment . . . and in Naples – as you know – everyone always invokes the Madonna, not God."[56] Cultural verisimilitude probably did play a part in the director's decision to enthrone Mary instead of Jesus; however, the complex of meanings wrought by this substitution cannot be obliterated by simply invoking Neapolitan usage. Indeed, the fact that Pasolini set his *Decameron* in a city where the Madonna is popularly more exalted than God rather than leaving it in Boccaccio's Tuscany only emphasizes the arguments I want to make. Placing the Virgin Mother in the position of judging guilt and virtue and of assigning pun-

ishment or heavenly rewards reflects an identification with the cynosural position of the mother in the "deviant" male oedipal scenario. Having the mother as both the ultimate celestial being and ultimate divine authority sets up the mise-en-scène of the child's intense identification with and desire for the mother figure. As to the configuration of the subjective relations in this fantasy, it is interesting to note that in discussions of fantasy and film, psychoanalytic film criticism commonly turns to the discussion of the "A child is being beaten" scenario.[57] However, before further discussing the significance of the dominant mother in Pasolini's tableau, we will return for a moment to Giotto's Scrovegni fresco.

I want to consider here the possibility that Giotto's Scrovegni Chapel fresco might encourage the substitution wrought by Pasolini, because it seems plausible to me that Pasolini may have been responding to the overdetermined role the Madonna plays in the Scrovegni Chapel when he elevated her to the central position. We should consider that not only is the chapel officially dedicated to the Virgin but the fresco cycle depicting her life occupies as much space in the chapel as does that depicting Christ's life (which obviously includes the continuation of his mother's life as well). Furthermore, although Christ the Judge clearly dominates the wall depicting the Last Judgment, the Virgin commands a large share of the scene by appearing in no less than three separate capacities in the fresco.[58] And, if we recall Kristeva's discussion of "Giotto's joy" in the Scrovegni Chapel and her comment that part of the jouissance might be associated with the transgressive hyper-valuation of the Virgin at the expense of the Father, we can see why Pasolini might have been drawn to elevate the Virgin to remarkable heights in his version of the fresco. In addition, I would argue that Kristeva's specifically feminine notion of chromatic jouissance indicates another thematic concern that disposes the Scrovegni Last Judgment to reorganization according to the homosexual aesthetic in Pasolini's tableau. Finally, although the composition of the Scrovegni Last Judgment generally endorses a reading of the event as the end of time, one where every chaotic aspect of human history is categorized and ordered into final narrative coherence for eternity, as Kristeva points out, the trompe l'oeil details near the top of the fresco show this dramatic scene being peeled away from the wall as if it were simply a scroll. This detail intimates that even this magnificent scene of

the Last Judgment might be just one more story that can be rolled up and revisited later, and not necessarily represent the end of all stories.

To return to Pasolini's Last Judgment, it is significant that when Pasolini replaces Christ with the Madonna Enthroned he is not simply subverting the law-of-the-Father by switching gender, but he is specifically calling upon a version of the Madonna with the infant. As I noted in Chapter 4, the juxtaposition of the multiple layers of chronology (unformed infant and mother at the "end of time") and narration (inserting the tableau vivant into the *novella* of Meuccio and Tingoccio) results in the fragmentation and proliferation of forms and meanings. Likewise, this tableau vivant (like the Bruegel tableaux) represents another moment where Pasolini's homosexual aesthetic surfaces in the film and results in excessive meaning, fracturing the representation of Boccaccio's *novella*.

Earlier I commented on the subversive act of substituting the mother for the father and how that challenge corresponds to the "deviant" (homosexual) Oedipal triangle. There is another kind of fantasmatic relationship at work in Pasolini's Madonna besides the love for her as authority. In this particular case, the Madonna might also represent the acceptance of a lifestyle different from the ones rigidly outlined according to gender by society. In *Image as Insight*, Margaret Miles speculates on how medieval women might have been able to use images of Mary in different ways. She argues that perhaps one aspect of the Virgin's life that might have appealed to medieval women could have been her freedom from biological contingencies (such as repeated childbirth and nursing).[59] I would like to invoke this rather unorthodox version of the Virgin, in her freedom from biological determination and the cultural pressure to be primarily a wife, as a figure that could represent an accepted version of an alternative subjectivity. Here I want to call upon the association in Pasolini's cinema made in endnote 56 between the Virgin (Silvana Mangano) in the tableau and gay, cruising behavior. This association is significant because the Last Judgment fantasy scenario I have used to describe Giotto's vision posits multiple paths of identification as well as desire and specifies that the setting of desire for the fantasy does not allow for absolute division among the various affective investments. As Silverman explains, regarding the "A child is being beat-

en" scenario (which I take to be a rather fitting figure for the Last Judg-ment scenario): desire cannot be scrupulously differentiated from iden-tification. Freud establishes in *The Ego and the Id* that object-cathexis and identification are initially "indistinguishable," in that oral sexuality in-ternalizes its object much as the ego does. The same text suggests that the subject is throughout life able to relinquish a love-object only by in-corporating it – that "identification is the sole condition under which the id can give up its objects." The ego is "a precipitate of abandoned ob-ject-choices," and as such itself an erotic object; "identification has the great virtue of making it possible for the ego to transform itself into the desired object, and thereby to love "itself."[60]

Perhaps here is a good place to address a rather difficult problem. I realize that emphasizing the extraordinarily dominant role that the Vir-gin has in Pasolini's Last Judgment and her association with Pasolini's own mother and his homosexuality is a dangerous and fraught argument for me to make. Certainly, I do not want to participate in what Sedgwick might see as "the reinforcement it might seem to offer to unthinking link-ages between (homo)sexuality and (feminine) gender, and its apparent high congruence with the homophobic insistence, popularized from Freudian sources" when we argue "that mothers are to be 'blamed' for – always unknowingly – causing their son's homosexuality."[61] However, it is important to address the popularly held maternaphobic and homo-phobic connection that attributes precisely that kind of blame, because it is one of the operating forces in the configuration of the homosexual mythology mapped out by Pasolini. We should acknowledge that Pa-solini's Last Judgment attributes a certain responsibility to the mother when he places her in the position of the authority figure. Pasolini was an astute reader of popular mythologies and, as is clear from his recy-cling of the Oedipus myth and the Gospel, he used them both deliber-ately and also unconsciously.[62] Therefore, it is important and justified to examine how Pasolini's versions of the mother figure influence the con-struction and representation of homosexuality in his work.

I would like to clarify that this construction of the mother is not a per-sonal problem peculiar to Pasolini; on the contrary, it is symptomatic of a homophobic culture in which homosexual panic[63] positions the homosexual as despicable and at the same time needs to displace any

responsibility for homosexuality entirely away from men themselves. As a consequence, responsibility for homosexuality is foisted onto the woman with the most potentially intimate, and therefore dangerous, love relationship with the male – the mother. Sedgwick has a very insightful, and for my purposes, helpful interpretation of the role this mother occupies:

> Is it not the mother to whom both the coming-out testament and its continued refusal to come out are addressed? . . . That that woman who lovingly and fearfully scrutinizes narrator and narrative *can't* know is both an analytic inference (she never acts as if she knows, and anyway how could she know?) and a blank imperative: she *mustn't* know . . . [T]o the absolute ignorance continually ascribed to (or prescribed for) the mother is the ascriptive absoluteness of her power over the putatively inscrutable son. The result is that the mother has a power over whose uses she has, however, no cognitive *control.*
>
> This topos of the omnipotent, unknowing mother is profoundly rooted in twentieth-century gay male high culture, along the whole spectrum from Pasolini to David Leavitt.[64]

In discussing the foreclosure of homosexual erotic pleasure in the Giotto segments, we might consider one reading of the tableau vivant that posits the kind of mother figure Sedgwick discusses. As a judge in Giotto's vision, the Madonna could preside over the question of whether or not Giotto is gay. If he is, then the question becomes that of why, in a movie with numerous depictions of heterosexual intercourse, there are no homosexual sex scenes. I would like to suggest that there is no erotic homosexual love because she is there watching. As she sits on her throne in judgment, the extreme close-ups of her face pull Giotto (as the reverse shot) and us into her realm. Would she let the son into Heaven if she knew of his transgressions? Perhaps not. Therefore she must remain ignorant. This ignorance of sexual sin is cannily attributed to the "Virgin Mother," an oxymoron that rhymes nicely with the mother who does not even know of her son's sexuality, either. It is interesting that this "ignorant" mother is the reigning figure in what I have described as the ideal creative episode. In ignoring sexuality, sublimating and redirecting it toward asexual creation, there is a fantasy of identification with the mother who produces a child without intercourse.

This remarkably high concentration of meaning and affect heaped

upon the figure of the Madonna obviously does not resolve into any simple, straightforward formulation. I will resist the temptation to smooth off the edges and claim a single coherent message, and at the same time, I will resist the pull of what Sedgwick identifies as the

one-way chute from a certain specificity of discourse around gay issues and homophobia, by way of momentarily specific pluralizing of those issues, to – with a whoosh of relief – the terminus of a magnetic, almost religiously numinous insistence on the notional "undecidability" or "infinite plurality" of "difference" into whose vast and shadowy spaces the machinery of heterosexist presumption and homophobic projection . . . have had time to creep.[65]

I specifically want to avoid the danger in discussions of homosexuality of collapsing the specific attributes of male–male genital sexuality into some "metaphor" for something else (sterility, pedagogy, liberation, third worldism). To a certain extent, Pasolini does collapse these issues in both his theoretical and journalistic interventions, and, as a consequence, there is no shortage of critics lined up to condemn him for his politically incorrect and counterproductive images and theories, which they trace to his homosexuality. Yet, it is also important to look at his work as a symptom and discuss these complications openly, not just fall victim to preterition and pretend, like Filippo Balducci (*Dec.*, introduction to Day Four), that if we do not talk about it, it will go away.

The paradoxical figure of the Virgin Mother, who permeates Pasolini's oeuvre and plays a crucial role in this film, signals the homosexual subtext of the Giotto frame sequences. Of course, for the reasons that I have mentioned, this construction must be recognized as oppressive for all positions concerned. For the homosexual subject, the relationship to such a maternal judge who must not find out is destructive.[66] For the woman who must remain ignorant and unconscious of her power, it is debilitating and reductive. And finally, for the victims of homosexual panic who construct these two positions, their paranoia must be corrosive.

As I discussed earlier, the tableau supports the contradictory readings of the Virgin Mother as a celebration of the jouissance of creativity in making art and as the authority figure who sternly prohibits/ignores homosexuality. I have tried to argue that these two messages have been incorporated into a form of the tableau vivant that at once indexes the homosexual investment in the work and sublimates its literal expression. I

162

have further argued that the ambivalence of this construction works against narrative coherence in the film. Given the homophobic context in which Pasolini's *Decameron* was made, even this simple suspension of judgment might be considered an affirmation of the homosexual presence. Clearly, we must recognize that the antiutopian quality of minority discourse is operative here in the internalization of the oppressive culture's values. This internalization can be read in Giotto's sublimation and the ambivalent condemnation of Ciappelletto, as well as the elements of the Last Judgment tableau, which imply that the mother is to "blame" for the son's sexual "inversion." I want to make it clear that in holding up the subversive aspects of the homosexual aesthetic in Pasolini's film, I am not making the claim that narrative fragmentation creates a utopia. It is important to recognize that discourse is never free from current ideologies, and that it can never escape the oppression that conditions it. Rather, in a bahktinian framework, what matters is activism within the aesthetics. To expect a utopian ideal to result from this activism is not only futile; it also contradicts the concept of culture as heteroglossia[67] that is precisely the condition that makes Pasolini's "scandalous" voice possible and audible.

According to this qualified understanding of the way Pasolini's film incorporates a homosexual aesthetic embodied in the "cruising" gaze and the disruptive fragmentation occasioned by the tableaux vivants, I believe the character Giotto is an example of the visual artist who does not get entrapped in the (attempted) coherence of narrative and whose modes of representation allow nonnarrative elements to develop and eventually take over his work. I have argued that although Ciappelletto may be the subject of the transformative possibilities afforded by Pasolini's homosexual aesthetic and marginally makes use of them to rewrite his own history, Giotto, as the figure of an artist/filmmaker/ writer, is the character offered as a role model for the practice of art. We can find support for this idea in the adoring gazes of the *fraticelli*, who represent and direct the viewer's infatuation with Giotto and his art. These monks are the agents of our vision of Giotto when we first enter the Church of Santa Chiara, and later as they witness his "eccentric genius" at work during the amusing "fast supper," and finally, as they signal the celebration of the completion of the fresco by ringing the church

bells. In addition, a less silly focalizor available to the film's viewers is afforded by the diverse group of workers and apprentices who comprise Giotto's *bottega*. These fellows watch with respect and admiration as Giotto paints the fresco in Santa Chiara. Significantly, however, these artists and assistants sleep through Giotto's vision; only Giotto and the film's viewers actually witness artistic imaginative vision. Thus, we are left alone to identify with and admire Giotto's artistry.

I began this project in an effort to bring a feminist critique to the visualization of the *Decameron* and to visuality in the *Decameron*. I had hoped that by using a comparative arts strategy I might develop an interpretation of certain *novelle* that would recognize and account for tensions in the texts that were generated by sexual difference and that supported hierarchical relations within the texts. I chose to work with visual representations because of the access they provide to questions that might otherwise have been unavailable in verbal texts. I wanted to use the feminist strategy of reading for the unsaid, unwritten account of the oppressed in the visual texts, hoping that they might not demonstrate the same repression exercised by the written texts and thus allow for comparative evaluation. In order to account for the different modes of vision exercised in Pasolini's film, I found that a feminist approach, concerned as it was with women's issues, needed some amplification in order to respond to questions of homophobic repression and its effects on the production of art.

In the texts under consideration in this book, I have found that vision tends to be articulated in terms of power and, in that capacity, serves to construct the categories of gender. Vision in this sense is not generally "liberating," because it is dictated literally from above and conforms to structures and systems that reinforce this power. Vision, as I outline it here, is often marshaled by the impulse toward narrative coherence and used to reinforce its integrity and support for the hierarchical gender relations in place. Visuality and imagery in the texts, on the other hand, occasionally work against the narrative and, through this disjunction, open up space for the alternative interpretations contained in this book. I hope these interpretations have challenged some of the biases in the texts and the traditional scholarship that accompanies them.

NOTES

INTRODUCTION

1. Millicent Marcus, *An Allegory of Form*, pp. 108–9.
2. Giovanni Boccaccio, *The Decameron*, trans. Mark Musa and Peter Bondanella (New York: Norton, 1982). Unless otherwise noted, all English translations of the *Decameron* are taken from this translation.
3. Dante, *Inferno*, in *The Divine Comedy*, ed.–trans. Charles S. Singleton (Princeton University Press, 1980), V, line 137. All quotations from *The Divine Comedy* are from this edition.
4. Constance Penley, *The Future of an Illusion*, p. 22.
5. Among them Norman Bryson, Mieke Bal, Margaret Miles, and Wendy Steiner.
6. Claire Richter Sherman, "Observations of the Iconography of a French Queen," p. 102.
7. Stephanie Jed, *Chaste Thinking*, p. 131.
8. Vittore Branca, "Boccaccio Visualizzato." Page 112, my translation.
9. Otto Pächt, *Book Illumination in the Middle Ages*, p. 8.

CHAPTER ONE. BEASTLY GUALTIERI

1. Page 600 in Musa and Bondanella.
2. Page 672 in Musa and Bondanella.
 "[N]on cosa magnifica ma una matta bestialità, come che ben ne gli seguisse alla fine; la quale io non consiglio alcun che segua, per ciò che gran peccato fu che a costui ben n'avenisse" (p. 892). All Italian excerpts are from Giovanni Boccaccio, *Decameron*, ed. Vittore Branca (Milan: Oscar Mondadori, 1985), cited hereafter by page number only.
3. Page 675 in Musa and Bondanella.
 "[L]unga esperenzia e con cose intollerabli" (p. 896).

4. Page 677 in Musa and Bondanella.
 [E]ra ora] "di fare l'ultima pruova della sofferenza di costei" (p. 898).
5. Page 680 in Musa and Bondanella.
 "[B]uon cambio" (p. 901).
6. Page 680 in Musa and Bondanella.
 "[M]a quanto posso vi priego che quelle punture, le quali all'altra, che vostra fu, già deste, non diate a questa, ché appena che io creda che ella le potesse sostenere, sì perché più giovane è e sì ancora perché in dilicatezze è allevata, ove colei in continue fatiche da piccolina era stata" (p. 902).
7. My translation.
 "[C]iò che io faceva a antiveduto fine operava, volendoti insegnar d'esser moglie e a loro di saperla tenere, e a me partorire perpetua quiete" (p. 902).
8. My translation.
 "[E]ssendo ogni uomo lietissimo di questa cosa" (p. 903).
9. Page 681 in Musa and Bondanella.
 "[A]nche nelle povere case piovono dal cielo de' divini spiriti, come nelle reali di quegli che sarien più degni di guardar porci che d'avere sopra uomini signoria" (p. 903).
10. For an extensive review of critical responses to the tale of Griselda, see Millicent Marcus, *An Allegory of Form*, chapter 6.
11. For a discussion of performative language, see J. L. Austin. *How to Do Things with Words*.
12. In *The Subject of Semiotics* (pp. 44 ff.), Silverman explains Althusser's notion of "hailing" and "interpellation" as follows:

 The French Marxist philosopher Louis Althusser helps us to understand that discourse may also consist of an exchange between a person and a cultural agent, i.e., a person or a textual construct which relays ideological information . . . The agent addresses the person, and in the process defines not so much its own as the other's identity. In "Ideology and the Ideological State Apparatuses," Althusser refers to the address as "hailing," and its successful outcome as "interpellation." Interpellation occurs when the person to whom the agent speaks recognizes him or herself in that speech and takes up subjective residence there.

13. For a discussion of focalization, see Mieke Bal, *Narratology*, especially page 104.
14. Page 672 in Musa and Bondanella.
15. Page 675 in Musa and Bondanella.
 "[E]ntratogli un nuovo pensier nell'animo, cioè di volere con lunga esperienzia e con cose intollerabili provare la pazienzia di lei" (p. 896).
16. Page 676 in Musa and Bondanella.
 "[M]a non bastandogli quello che fatto avea con maggior puntura trafisse la donna" (p. 897).
17. Page 678 in Musa and Bondanella.

18. See pp. 677, 899, and 900 in Musa and Bondanella.
19. See *Dec.* II, 9; II, 10; III, 5; III, 8; III, 9; VI, 7; VII, 1–9.
20. For a discussion of the lacanian signifier, see Lacan's "Agency of the Letter in the Unconscious" in *Écrits: A Selection.*
21. For an excellent discussion of the significance of the absence of the mother for the daughter, see chapter 7 of Mieke Bal's *Death & Dissymmetry: The Politics of Coherence in the Book of Judges.*
22. Page 678 in Musa and Bondanella.
"[Q]uello che io stata con voi da Dio e da voi il reconoscea, né mai, come donatolmi, mio il feci o tenni ma sempre l'ebbi come prestatomi" (p. 899).
23. Page 892 in Branca, ed., *Decameron.*
24. Page 673 in Musa and Bondanella.
"E il dire che voi vi crediate a' costumi de' padri e delle madri le figuole conoscere . . . è una sciocchezza, con ciò sia cosa che io non sappia dove i padri possiate conoscere né come i segreti delle madri di quelle: quantunque, pur cognoscendogli, sieno spesse volte le figuole a' padri e alle madri dissimili" (p. 893).
25. Petrarca, "On Boccaccio's *Decameron* and the Story of Griselda," trans. James Harvey Robinson and Henry Winchester Rolfe, *Petrarch: The First Modern Scholar and Man of Letters,* pp. 191–6.
26. Page 174 in Froma Zeitlin, "The Dynamics of Misogyny: Myth and Myth-making in the *Oresteia.*
27. Page 97 in Marcus's *Allegory of Form.*
28. Page 682 in Musa and Bondanella.
"[A]ssai le donne, chi d'una parte e chi d'altra tirando, chi biasimando una cosa, un'altra intorno a essa lodandone, n'avevan favellato" (p. 905).
29. Laura Mulvey, "Visual Pleasure in Narrative Cinema," *Screen* 16 (Autumn 1975):6–18.
30. Page 108 in Marcus's *Allegory of Form.*
31. In the "Author's Preface" (page 3 in Musa and Bondanella), the narrator explains that he will write this book in order to ease the discomfort and melancholy of lovesick ladies by telling them stories. "These stories will contain a number of different cases of love, both bitter and sweet, as well as other exciting adventures . . . In reading them, the ladies just mentioned will, perhaps, derive from the delightful things that happen in these tales both pleasure and useful counsel, inasmuch as they will recognize what should be avoided and what should be sought after."
"Nelle quali novelle piacevoli e aspri casi d'amore e altri fortunati avvenuti . . . delle quali le già dette donne, che queste leggeranno, parimente diletto delle sollazzevoli cose in quelle mostrate e utile consiglio potranno pigliare, in quanto potranno cognoscere quello che sia da fuggire e che sia similmente da seguitave" (p. 7).

32. Marga Cottino-Jones reads the name "Griselda" etymologically as "figure of Christ" (*Chrisos-eidos*) in her article "Fabula vs Figura: Another Interpretation of the Griselda Story."

33. Page 679 in Musa and Bondanella.
 "Signor mio, io son presta e apparecchiata" (p. 900).

34. Page 679 in Musa and Bondanella.
 "Come che queste parole fossero tutte coltella al cuor di Griselda" (p. 900).

35. Page 679 in Musa and Bondanella.
 "Benvenga la mia donna" (p. 901).

CHAPTER TWO. ILLUMINATING METAPHORS

1. Page 240 in Musa and Bondanella.

2. Page 250 in Musa and Bondanella.
 "Tancredi, prencipe di Salerno, fu signore assai umano e di benigno ingegno, se egli nell'amoroso sangue nella sua vecchiezza non s'avesse le mani bruttate; il quale in tutto lo spazio della sua vita non ebbe che una figliuola, e più felice sarebbe stato se quella avuta non avesse" (p. 337).

3. Page 253 in Musa and Bondanella.
 "[S]enza essere stato da alcuno veduto o sentito entratosene . . . trovando le finestre alla camera chiuse e le cortine del letto abbattute, a pié di quello in un canto sopra un carello si pose a sedere; e appoggiato il capo al letto e tirata sopra sé la cortina, quasi come se studiosamente si fosse nascoso, quivi s'addormentò" (p. 340).

4. Page 256 in Musa and Bondanella.
 "[C]he tu più ami, come tu hai lui consolato di ciò che egli più amava" (p. 345).

5. Guido Almansi, *The Writer as a Liar,* p. 135.

6. Giuseppe Mazzotta, *The World at Play,* p. 139.

7. Mazzotta, *The World at Play:*

 The epithet, *"invidiosa"* alludes to the traditional figuration of blindfolded fortune. *"Invidia"* is also . . . used . . . to designate . . . envy as well as blindness, according to the current etymology of the word from *"non video."* These discrete hints of blindness reverse the dominant metaphoric pattern of the *novella* in which love, far from being *"caecus,"* opens the lovers' eyes, the prince's power comes forth as a function of vision (with the suggestion that surveillance is the essential ingredient of political practice). Ghismunda is *"avveduta."* In this world of Fortune's randomness everyone's vision is impaired by blind spots. Claims of omniscient perspective by critics, lovers, prince or author are, thus, deflated by Boccaccio's text. Each of us can only afford transversal perspectives, limited viewpoints and partial truths (p. 157).

8. Andreas Capellanus, *De amore,* page 2: "Love is a certain inborn suffering derived from the sight of and excessive meditation upon the beauty of the opposite sex,

which causes each one to wish above all things the embraces of the other and by the common desire to carry out all of love's precepts in the other's embrace."

9. Page 251 in Musa and Bondanella.

"Fara'ne questa sera un soffione alla tua servente, col quale ella raccenda il fuoco" (p. 251).

10. Both Tancredi and Ghismunda make the claim that Guiscardo was raised at court through Tancredi's benevolent charity and care. Guiscardo seems to have been favored by Tancredi before this episode and so in some respects might be considered an adopted son. For instance, Tancredi claims, "Guiscardo . . . was raised at our court from the time he was a small child until today almost as an act of charity" (p. 254). And later Ghismunda tells Tancredi, "I do not trust the judgment of any other person concerning the virtue and valor of Guiscardo – I trust only what you yourself have said about him . . . [W]ho has praised him more than you in all those praiseworthy matters of a valiant man?" (p. 256).

11. "[P]iagnendo sì forte come farebbe un fanciul ben buttuto" (p. 342).

"[W]ept like a child who had been severely beaten" (page 254 in Musa and Bondanella).

"[E] con lagrime, come il più le femine fanno" (p. 342).

"[W]ith cries and tears, as most women do . . . " (page 254 in Musa and Bondanella).

12. In *The World at Play*, Mazzotta asserts that it is precisely at the point in the tale where Tancredi sees Guiscardo and Ghismunda making love that "Tancredi sees his own exclusion from their pleasure, and thereby, confronts the limits of his power" (p. 139).

13. See Mary F. Wack, "Imagination, Medicine and Rhetoric," p. 106, also Freud's *Three Essays on the Theory of Sexuality*, pp. 22ff.

14. For a good discussion of the legibility of courtly bodies, see Norman Bryson, *Word and Image*, chapter 2, "The Legible Body."

15. Many critics, beginning with Alberto Moravia, have discussed the incestuous undertones of Tancredi's love for Ghismunda. The theme of incest is important to the readings of the tale made by Mazzotta, Almansi, and Marcus.

16. My translation.

"[B]ellissima del corpo e del viso alquanto alcuna altra femina fosse mai" (p. 337).

17. Page 254 in Musa and Bondanella.

"[E]ssendo . . . di carne, [lui deve] aver generata figliuola di carne" (pp. 342–3).

18. Page 253 in Musa and Bondanella.

19. Page 256 in Musa and Bondanella.

"[R]affreddare il suo fervente amore" (p. 345).

20. Page 256 in Musa and Bondanella.

"[C]iò che egli più amava" (p. 345).

21. See Marcus's *Allegory of Form* for a reading of Tancredi as a wronged husband.
22. Page 253 in Musa and Bondanella.
 "[C]hetamente in alcuna camera di là entro guardatofosse" (p. 341).
23. Page 256 in Musa and Bondanella.
 "[D]ue che Guiscardo guardavano che senza alcun rumore lui la seguente notte strangolassono" (p. 345).
24. Wack, "Imagination, Medicine and Rhetoric," p. 106.
25. Ibid., p. 110.
26. See, for example, *Dec.* V, 4, the tale of Caterina and the nightingale.
27. Wack, "Imagination, Medicine and Rhetoric," pp. 109–113.
28. Many critics have commented on the status of Guiscardo's heart; here are excerpts from a few:
 Almansi, *The Writer as a Liar*, pp. 150–2:

Clearly Guiscardo's heart acquires a multiplicity of meanings, and the successive handling and passing around of the bleeding organ hardly arouses a sense of horror because it merely represents a nodal complex of symbols; it becomes the meeting point for a varied but not irreconcilable set of symbolic effects. Ghismonda states that for her the heart is the 'dear sweet vessel of all my joys'. In other words it is the resting-place of love in all its manifestations whether physical or spiritual. It is also the dwelling place of the soul . . .

Tancredi, on the other hand, [sees] the heart as pre-eminently an organ to be torn out and away. For both of them it is the vital physical component without which Guiscardo . . . must lose all human faculties. Over and above all these correspondences, however, the heart has a supreme function in the close of the story: it is the justification, even the subject, of the final play on words which fixes the pattern of the last page far more effectively than the psychology of the characters . . . [In the exchange between Ghismunda and the servant] young woman transfers the play of words from the level of language to the level of deed. She lives out the metaphor which father and daughter have set up. This makes her washing of the heart into what amounts to a religious ceremony because it actualizes the metaphor into a normative mode of behaviour, as with transubstantiation in the Holy Communion.

There is surely no need to accept Muscetta's view that Ghismonda's bathing of the organ with her tears is an act 'which purifies all the macabre elements of the situation'. There is nothing macabre about it because by this stage in the *novella* everything takes place at the level of metaphor; in the same way there is nothing macabre about the wine drunk in lieu of blood at Communion. The emotional properties of Boccaccio's scene have little to do with an expansive sentimental heroism, but simply derive from Ghismonda's extreme intellectual coherence and choice of phraseology. Her sacrifice is not a victory of the spirit, but a triumph of the word.

Marcus, *An Allegory of Form*, pp. 58–9:

Tancredi's punishment is accompanied by a linguistic transgression as shocking as the revenge itself. When the prince sends his daughter the token of her lover's ex-

cised heart, he has literalized the central metaphor of courtly love. What tradition had deemed the locus of the most intangible and ethereal human virtues, Tancredi reduces to a mass of bleeding tissue. Ghismonda makes explicit the linguistic nature of Tancredi's trespass . . . In this poignant lament, Ghismonda reveals the vast difference between her own refined sensibility and her father's reductive rage. By making Guiscardo's heart visible to "gli occhi della fronte," Tancredi has restored the metaphor to its origins in human physiology . . . Operating on the assumption that his daughter's love is of a purely carnal sort, the prince presupposes that the extinction of Guiscardo's body will extinguish the passion as well . . . But Ghismonda proves that her love transcends mere concupiscence by restoring a metaphoric dimension to the lover's heart which Tancredi has placed before her eyes. Ghismonda's language reverses the reductive movement of Tancredi's when she assigns to this anatomical part "the resting place of love in all its manifestations whether physical or spiritual." In the order of her discourse, Ghismonda gives primacy to the metaphoric interpretation of this topos, as she inverts the temporal sequence of events, lamenting first the accessibility of Guiscardo's heart to "gli occhi della fronte" and returning to the season when it was visible only to "quegli della mente." This movement back in time fittingly ends with the figurative attribution of eyes to the mind, making the distinction between "then" and "now" – between the past of amorous bliss and the present of cruel revenge – the distinction between metaphoric and literal truth.

Mazzotta, *The World at Play*, p. 149:

Ghismunda is lost in a delirious experience which yokes together hallucination and physical reality. As she looks at the physical heart, she charges it with the illusory attributes and conceits of love poetry, and revives, in effect, a dead metaphor. In his jealous anger the father tears out Guiscardo's heart, lays bare and disfigures, that is to say, the root of all love literature, which in the heart finds the metaphoric source of nobility, virtue and love, and thus, mistakes the metaphor for a process. She mistakes the literal, dead heart for a living metaphor. Like her father, she is now at the threshold where the differences between life and death, the metaphorical and the literal, have vanished and are no longer recognizable. For all her convictions firmly rooted in reason, she strays to a dazed imaginary world comparable to that of her father's darkened judgments.

29. For a discussion of "reading" suicide, see Margaret Higonnet, "Speaking Silences: Women's Suicide."
30. Page 257 in Musa and Bondanella.
 "[C]he con gli occhi della fronte or mi ti fa vedere! Assai m'era con quegli della mente reguardati a ciascuna ora" (p. 346).
31. According to Wack, this argument is textually supported by dialogue E in *De amore*, where it is evident that "just looking" does not satisfy the lover. In "Imagination" (p. 112), Wack argues convincingly that physical intercourse is the lover's goal.
32. In "Interpretazioni visuali del *Decameron*," Vittore Branca discusses his identifi-

cation and study of Doc. Hamilton 90 in Berlin. Included in the essay are several reproductions of the ink portraits by Boccaccio.

33. Vittore Branca, "Boccaccio visualizzato," p. 102.

34. Ibid., p. 113, my translation.

35. Ibid., p. 117.

36. Here is perhaps the place to discuss the rather complicated circumstances of the subjects I call into play in this interpretation. First, whereas the illuminations reproduced here are in French manuscripts, I call upon the standard Italian version of the *novella* edited by Vittore Branca (Milan: Oscar Mondadori, 1985) for the verbal text. The miniatures under discussion are also reproduced in an earlier Branca edition (Florence: Sadea/Sansoni Editori, 1966), which is where I first came across them and began this work. The Sadea/Sansoni edition is a large, printed book filled with reproductions of various visual renditions of the stories from the *novelle* (frescoes, illuminations, miniatures, furniture). The text is in Italian, typeset – not handwritten. Some of the illuminations include blocks of script; others are entirely cropped and included as "floating" illuminations. I have also examined the French manuscripts and will discuss the relationship between word and image as it can apply to these different editions.

I do not wish to privilege any edition over the others in terms of authenticity. I am not interested in assigning a value judgment to the different constructions of each edition. For my purposes, the French manuscripts provide four instances among thousands of texts a reader might be able to enjoy. The fact that the Sansoni edition recycles the same images with another particular version of the text does not affect its status as yet another example of an edition of the *novelle*. Because the focus of my argument is the relationship between verbal text and image, I will be discussing the unique way the visual layout of a particular page allows me to address this question.

37. Michael Camille, "The Book of Signs," pp. 137, 149.

38. Wendy Steiner, *Pictures of Romance*, pp. 37ff.; Otto Pächt, *Book Illuminations*, pp. 192ff.

39. I employ deconstructive strategies in order to facilitate my effort to counter the dominant interpretations of both the *novelle* and the visual representations under examination here. Specifically, in calling upon derridean notions of "parergon" and "supplement" I hope to question a dominant metaphoric of presence and authority that restricts interpretation by narrowing the field of signification to certain traditionally valorized elements.

40. Mazzotta, *The World at Play*, p. 156.

41. Steiner, *Pictures of Romance*, p. 20.

42. Camille, "The Book of Signs," p. 142.

43. Bryson, *Word and Image*, p. 98.

CHAPTER THREE. BOCCACCIO, BOTTICELLI, AND THE TALE OF NASTAGIO

1. Joy H. Potter, *Five Frames for the "Decameron,"* p. 38; Vittore Branca, *Boccaccio Medioevale,* p. 180.
2. Branca, *Boccaccio medioevale,* p. 180
3. The series comprises four separate panels, three of which are reproduced here. The fourth panel is in a private collection and has been previously published in Ronald Lightbown's *Sandro Botticelli: Life and Work* (1989), p. 117.
4. Brucia Witthof, "Marriage Rituals and Marriage Chests," p. 43.
5. Bal, "Myth à la lettre," p. 3; Branca, *Boccaccio Mediovale,* pp. 180–183.
6. Page 309 in Musa and Bondanella.
 "[C]iò che a alcuno amante, dopo alcuni fieri o sventurati accidenti, felicemente avvenisse" (p. 414).
7. My translation.
 "Amabili donne, come in noi è la pietà commendata, così ancora in noi è dalla divina giustizia rigidamente la crudeltà vendicata: il che acciò che io vi dimostri e materia vi dea di *cacciarla* del tutto da voi, mi piace di dirvi una novella" (p. 481, emphasis added).
8. Potter, *Five Frames for the "Decameron,"* p. 38.
9. One of the overarching themes in Marcus's *Allegory of Form* is precisely the parodic use of the form of *exemplum* to question form and didacticism in literature.
10. Branca, *Boccaccio Medioevale,* p. 175.
11. Stephen Nichols explains the literary interpretations and intentions of medieval monks and scholars in his book *Romanesque Signs: Medieval Narrative and Iconography,* p. xi.

They [the monks] wanted to make the past present to show that the present belonged to a coherent cosmogony, that it manifested the divine plan of the universe. The key to this plan lay in certain transcendent events in the past, particularly the Christ story, which they interpreted as revealing the whole trajectory of Salvation history, from the beginning to the end of the world. They had elaborated a philosophical anthropology, building on the work of philosophers like Saint Augustine, Pseudo-Dionysius, and John Scottus Eriugena, which allowed them to make connections and comparisons between what might appear, to us at least, to be widely divergent domains, events and phenomena. The comparison between history and theology, for example, led to a theory of historical meaning with profound implications for the development of narrative. By showing that historical events – including the present – could be represented as resembling and rephrasing significant past events, notably those found in religious texts, one might then demonstrate that secular history did indeed belong to Salvation history. Life could then be seen as part of a larger picture, a divine plan, rather than as simply a formless accident.

Such a program obviously possessed clear religious and political implications.

The activity of representing history according to this logocentric telos must be seen as a function of the social, institutional, and ideological situation of the monks who initiated worlds: one marked by discontinuity and chaos, one characterized by a historically continuous, transcendent order.

12. Marcus, *An Allegory of Form*, p. 11.
13. My translation.
 "[T]utte le ravignane donne paurose ne divennero, che sempre poi troppo più arrendevoli a' piaceri degli uomini furono che prima state non erano" (p. 487).
14. Ovid, *Metamorphoses* 6, 550 ff., p. 147.
15. Dante, *Purgatorio* (XXVIII, lines 16 ff.): "la pineta in su 'l lito di Chiassi."
16. Dante, *Inferno* (I, lines 1-4).
17. Boccaccio, *Commentary on the Inferno*, p. 205: "Per questo si può compredere il bosco dovere esser stato salvatico e per consequente orribile."
18. Page 360 in Musa and Bondanella.
 "[U]n boschetto assai folto d'albuscelli e di pruni" (p. 483).
19. Dante, *Inferno* (XIII, lines 2 ff.):

 . . . da neun sentiero segnato.
 Non fronda verde, ma di color fosco;
 non rami schietti, ma nodosi e 'nvolti;
 non pomi v'eran, ma stecchi con tosco.

20. Branca, *Boccaccio Medioevale*, p. 147.
21. Dante, *Inferno* (XIII, lines 116 ff.):

 nudi e graffiati, fuggendo sì forte,
 che de la selva rompieno ogne rosta . . .
 Di retro a loro era la selva piena
 di nere cagne, bramose e correnti
 come veltri; ch'uscisser di catena.
 In quel che c'appiatto miseri li denti,
 e quel dilacaran a brano a brano;
 poi sen portar quelle membra dolenti.

22. For "analeptic," see Bal, *Narratology*, p. 59.
23. Freud, *General Psychological Theory*, p. 74: "a process . . . [that] consists in the instinct directing itself towards an aim other than and remote from, that of sexual gratification."
24. Page 360 in Musa and Bondanella.
 "[U]n cavalier bruno, forte nel viso crucciato, con uno stocco in mano, lei di morte con parole spaventevoli e villane minacciando" (p. 483).
25. Steiner, *Pictures of Romance*, p. 44.
26. In *Sandro Botticelli: Life and Work* (1989), pp. 114-19, Ronald Lightbown elaborates on these particular panels:

It had long been the custom in Florence to adorn the state-chambers of a house with the type of wainscoting known as a *spalliera*, consisting in its simplest form of framed wooden panels. The purpose of the *spalliera* was not purely decorative: it kept the rooms warmer and less damp, and it also served as a backboard for the furniture – beds, couches, cupboards, chests – which stood against it and sometimes was fitted into it. Several sorts of room were panelled with a *spalliera*, the great family *sala*, the studio or study, the bedchambers of the head of the family and his sons – for even after marriage sons generally continued to live with their parents in the family house . . . [T]he usual complement of (*spalliere*) seems to have been four.

It seems that *spalliere* with painted panels were often ordered to decorate the marriage chamber [*camera nuziale*] of the bride and bridegroom on the occasion of marriages between the great families of the city – such marriages were always celebrated with such magnificence of feasting, dancing and gifts. And it was for the *spalliera* of the marriage chamber of his son Giannozzo (1460–97) that Antonio Pucci ordered four panels from Botticelli. Giannozzo's first wife Smeralda, daughter of Ugolino, marchese di Monte Santa Maria, died on 8 August 1482, and a new marriage seems to have been arranged for him almost at once with Lucrezia, daughter of Piero Bini. Its *mezzano* [negotiator] was Lorenzo de' Medici himself, whose arms and devices appear in one of the panels. We do not know exactly when the marriage took place, but it was certainly in 1483, possibly before 24 March. It was customary to choose for the paintings of marriage chambers some history of love or marriage or of womanly virtue, whose theme complimented or admonished the bride.

For the Pucci panels a subject of courtly compliment was taken from Boccaccio's *Decameron*, the story of Nastagio degli Onesti.

And in *Sandro Botticelli* (1978), p. 81. Lightbown further claims that in the Pucci panels "Lucrezia Bini is obliquely praised in the shape of Boccaccio's heroine."

27. See Callman, "The Growing Threat of Marital Bliss," p. 73; Lightbown, *Sandro Botticelli: Life and Work*, p. 119.

28. Lightbown, *Sandro Botticelli*, p. 50.

29. My translation. *Decameron*, p. 487.

30. In the *Decameron* some references to *rene* appear as euphemisms for sexual activity (see, for example, *Dec.* III, 1).

CHAPTER FOUR. IMAGINATIVE ARTISTRY

1. In this chapter I will refer to stories represented in the film that are not Pasolini's elaborations on Boccaccio's Giotto but are specifically taken from the *novelle* in the *Decameron* as *"novelle,"* as "stories" or "tales." Here is a brief synopsis of the tale of Ciappelletto:

Ciappelletto is a notary, infamous for his delight and success in cheating, lying, stealing, blaspheming, and stirring up scandal and enmity among friends, relatives, and anyone else. A rich man asks Ciappelletto to collect some debts for him from some dangerous and difficult people. While Ciappelletto is dis-

charging his duties, he stays with some of his compatriots. Suddenly, Ciappelletto falls deathly ill. His hosts are at a loss about what they should do. They do not want to throw Ciappelletto out in his condition, but they also do not want Ciappelletto to confess his enormous and manifold sins to a local priest. Ciappelletto overhears his hosts discussing their dilemma and tells them to summon the holiest priest they can find. On his deathbed Ciappelletto lies to the priest, giving a ludicrously whitewashed false confession. After Ciappelletto dies, the priest declares him to have been an uncommonly holy man and encourages the local population to pray to him for intercession on their behalf. Ciappelletto becomes renowned as Saint Ciappelletto, and many claim that God has performed miracles through him.

2. Here are brief synopses of the five tales:

 Dec. VIII, 3: Calandrino, Bruno, and Buffalmacco go to the Mugnone River in search of the magical stone, the heliotrope, which Calandrino believes can make him invisible. They find some stones. Bruno and Buffalmacco pretend that they cannot see Calandrino, and so he thinks he has found the heliotrope and has been made invisible. Calandrino returns home with lots of stones, and his wife, Monna Tessa, sees him and scolds him. Calandrino believes his wife has broken the spell of invisibility, so he beats her up. Bruno and Buffalmacco show up and tell Calandrino it is his own fault that he became visible again, because he knows that women cause everything to lose power.

 Dec. VIII, 6: Bruno and Buffalmacco steal a pig from Calandrino, then pretend to help him find it again by means of a test where the thief would taste ginger cookies and Vernaccia wine and find them bitter. The two tricksters give Calandrino two cookies, one after the other, made from cheap ginger seasoned with bitter aloes, thus making it appear that he stole the pig himself. Bruno and Buffalmacco then threaten to tell his wife about the affair and force Calandrino to pay them a bribe for their silence.

 Dec. VIII, 9: A foolish doctor named Master Simone wants to become a member of an imaginary club of expeditioners. He is persuaded by Bruno and Buffalmacco to go one night to a certain spot, where he is thrown by Buffalmacco into a ditch full of sewage and left there.

 Dec. IX, 3: Urged on by Bruno, Buffalmacco, and Nello, Master Simone causes Calandrino to believe that he is pregnant. Calandrino gives the four pranksters capons and money in return for medicine that they say will end his pregnancy. Thus Calandrino believes that he has been cured of pregnancy without giving birth.

 Dec. IX, 5: Calandrino falls in love with a young woman. Bruno arranges with the woman to pretend that she reciprocates his affection, which leads Calandrino to perform many ridiculous antics. Bruno gives Calandrino a magic for-

mula guaranteed to get the woman to sleep with him, and then Bruno calls
Monna Tessa to come see just as Calandrino and the woman are in the hayloft.
Monna Tessa interrupts the two and beats up Calandrino.

3. My translation. *Decameron*, "Conclusione dell'Autore," pp. 909–10:

Saranno per avventura alcune di voi che diranno che io abbia nello scriver queste
novelle troppa licenzia usata, sì come in fare alcuna volta dire alle donne e molto
spesso ascoltare cose non assai convenienti né a dire né a ascoltare a oneste donne.
La qual cosa io nego, per ciò che niuna sì disonesta n'è, che, con onesti vocaboli di-
cendola, si disdica a alcuno: il che qui mi pare assai convenevolmente bene aver
fatto. Ma presuppognamo che così sia, ché non intendo di piatir con voi, che mi
vincereste. Dico a rispondere perché io abbia ciò fatto assai ragion vengon pron-
tissime. Primieramente se alcuna cosa in alcuna n'è, la qualità delle novelle l'hanno
richesta, le quali se con ragionevole occhio da intendente persona fian riguardate,
assai aperto sarà conosciuto, se io quelle della lor forma trar non avessi voluto, al-
tramenti raccontar non poterlo. E se forse pure alcuna particella è in quella, alcuna
paroletta più liberale che forse a spigolistra donna non si conviene, le quali più le
parole pesan che fatti e più d'apparer s'ingegnan che d'esser buone, dico che più non
si dee a me esser disdetto d'averle scritte che generalmente si disdica agli uomini e
alle donne di dir tutto dì "foro" "caviglia" e "mortaio" e "pestello" e "salsiccia" e "mor-
tadello", e tutto pien di simiglianti cose. Sanza che alla mia penna non dee essere
meno d'auttorità conceduta che sia al pennello del dipintore, il quale senza alcuna
riprensione, o almen giusta, lasciamo stare che egli faccia a san Michele ferire il ser-
pente con la spada o con la lancia e a san Giorgio il dragone dove gli piace, ma egli
fa Cristo maschio e Eva femina, e a Lui medesimo, che volle per la salute della umana
generazione sopra la croce morir, quando con un chiovo e quando con due i piè
gli conficca in quella.

4. Page 686 in Musa and Bondanella.
"Niuna corrotta mente intese mai sanamente parola . . . così quelle che tanto
oneste non sono la ben disposta non posson contaminare" (p. 911).
5. On page 61 of "The Cement of Fiction," Paul Watson makes a broad Freudian
analysis of this language: "Boccaccio's first proofs of artistic freedom, Michael
and George, continue visually the verbal game that precedes them. Their
weapons, *spada* or *lancia*, are the ferrous counterparts of a *salsiccia*: innocuous im-
plements which only a corrupt mind would read, or see, as phallic. In most de-
pictions of these warrior saints . . . the dragon receives the spear through the
mouth. If we look at such pictures perversely . . . they image nothing less than
fellatio."
6. For example, see Carolyn Walker Bynum's rebuttal of Steinberg's thesis in "The
Body of Christ in the Later Middle Ages: A reply to Leo Steinberg."
7. For modern evaluations of Giotto's painting, see Bonnefoy; Kristeva; Watson;
Miles; Vigorelli and Baccheschi; Previtale and Bellosi.
8. Watson, "The Cement of Fiction," p. 51.

9. Ibid., p. 51.

10. For the effect on viewers of Giotto's painting, see Bellosi; Miles; Previtale and Bonnefoy.

11. Some critics who have discussed illusion and painting with respect to Bruno and Buffalmacco are Baratto, *Realtà e stile nel Decameron*, pp. 309–18; Cottino-Jones, "Magic and Superstition in Boccaccio's *Decameron*"; Layman, "Boccaccio's Paradigm of the Artist and His Art," p. 30; Marcus, *An Allegory of Form*, pp. 79–92; Mazzotta, *The World at Play*, pp. 196–9; and Russo, *Letture critiche del Decameron*, pp. 245–74.

12. Watson, "The Cement of Fiction," pp. 60–4.

13. Ibid., p. 58.

14. Marcus, *An Allegory of Form*, p. 92.

15. Mazzotta, *The World at Play*, pp. 199, 268.

16. In this argument I concentrate on the kind of activism that takes place within the cultural constraints described by Bakhtin in *Rabelais and His World*.

17. See note 2 for synopses of the tales.

18. According to *Il Nuovo Zingarelli*, 11th ed., 1990: "*Calendra*: uccello dei Passeroformi simile all'allodola ma più grosso con una lunga unghia nel dito posteriore" (*Calendra*: a bird in the thrush family similar to the lark except that it is larger and has a long toenail on the rear toe). "*Allodola*: uccello dei Passeroformi di color grigio bruno con macchie più scure, becco acuto lunga unghia posteriore il quale emette durante il volo un trillo armoniso (*Lark*: a bird in the thrush family of a grey-brown color with dark spots, a sharp beak and a long rear toenail, which emits a harmonious trill in flight [my translation]).

19. There is some debate as to whether or not the character referred to as "Giotto" in Pasolini's published screenplay *Trilogia della vita*, as well as in the treatment Pasolini wrote for the film, is correctly called "Giotto" or "Giotto's apprentice." The confusion arises because when Forese starts to introduce the character to Gennaro and refers to him as "Il Maestro," the character flashes Forese a warning glance. Forese laughs and changes the introduction by calling him "Giotto's best pupil." Rather than extend this discussion further, I will simply accept the screenplay's convention of referring to the character as "Giotto." P. P. Pasolini, *Trilogia della vita*, ed. Giorgio Gattei (Oscar narrativa, 1990), p. 45.

20. My translation.
"Maestro . . . Tu credi che se ci venisse incontro uno straniero che non ti conoscesse e ti vedesse combinato così, potrebbe mai pensare che tu sia uno dei più bravi pittor del momento?"

21. Pasolini, "Treatment for *il Decameron*," p. 70: "Qui finisce l'aneddoto del Boccaccio; ma ora proseguiamo per conto nostro, introducendo il nostro nuovo filo conduttore" (This is where Boccaccio's anecdote ends; now we continue on our own account by introducing our new narrative thread [my translation]).

22. Pasolini, "Treatment for *Il Decameron*," p. 73: "Gli occhi di Giotto che guardano Napoli sono un po' come la soggettiva di una macchina da presa che fa un breve documentario" (Giotto's eyes as they view Naples are something like the point of view of the movie camera as it makes a brief documentary [my translation]).

23. Pasolini, "Treatment for *Il Decameron*," p. 78:
 Giotto sta affrescando le pareti di Santa Chiara, aiutato da alcuni operaietti che gli preparano i colori. Questi colori sono i colori su cui si fonda tutto il film: la scena ha quindi una funzione quasi "poetica" del film stesso. Non solo, ma ciò che è più importante, i personaggi della scena sacra che Giotto sta umilmente dipingendo sulle pareti ancora vuote, sono le faccie degli uomini e delle donne che egli ha visto per la strada."

 [Giotto is frescoing the walls of Santa Chiara, helped by some workers who prepare the colors for him. These colors are the colors on which the film is based: so the scene has an almost "poetic" function in the film itself. That's not all, what he is painting is even more important, the characters in the sacred scene Giotto is humbly painting on the still blank walls are the faces of the men and women that he saw out on the street {my translation}.]

24. Pasolini, "Treatment for *Il Decameron*," p. 68: "Il filo è costruito dalla vicenda di Giotto che viene a Napoli ad affrescare la chiesa di Santa Chiara. Tale vicenda non è trattata dal *Decameron*, che non ne parla (gli affreschi di Santa Chiara andranno dunque del tutto recostruiti)" (The narrative thread is built on the episode of Giotto, who comes to Naples in order to fresco the Church of Santa Chiara. This event does not happen in the *Decameron*, which does not mention it at all [therefore the frescoes will have to be entirely reconstructed {my translation}.])

25. Giancarlo Vigorelli and Edi Baccheschi, *L'opera completa di Giotto*, p. 125: "varie storie del Vecchio Testamento e Nuovo di cui l'Apocalisse sarebbe risalita, per ideazione iconografica a Dante" (my translation).

26. Ben Lawton, "Theory and Praxis in Pasolini's Trilogy of Life," p. 408.

27. On page 408 of "Theory and Praxis in Pasolini's Trilogy of Life," Lawton interprets the blank space as a statement regarding Pasolini's artistic relationship to Boccaccio and Giotto, arguing that Pasolini "has taken a step forward through an imaginative retrieval of the past. He moves back in time to the medieval world which was their point of departure and then, using them as a springboard, he vaults into the contemporary world, completely bypassing the implicitly desperate opposition of life and death . . . He presumes to have done no more than this and has no simplistic answers for the future, thus, the blank third panel."

 On the other hand, Marcus's argument in "*The Decameron*: Pasolini as a Reader of Boccaccio," p. 178, asserts that Pasolini "fails to give his film an exposito-

ry introduction or a conclusion which would retroactively explain and organize the whole. In fact, the concluding frame story fragment shows Giotto before the three panels of his fresco, but only two of them have been completed. The third panel remains empty, making the fresco cycle as imperfect (in the etymological sense of the term) as the film itself . . . The complete fresco panel is the inqᴜadratura, the smallest complete unit of meaning . . . In the juxtaposition of adjacent panels in the fresco cycle Pasolini suggests the celluloid strip itself with its succession of still photographic compositions. Contiguity in the fresco cycle provides the linkage." Both Lawton and Marcus remark on the general similarities between Giotto's frescoes and Pasolini's film, and Pasolini himself discussed the analogy in his script for his film *The Gospel According to Matthew*, calling upon the interpretative authority of the Vatican in his discussion of the contemporary similarities between mural painting and film, quoting La Pro Civitate Christiana, which "clarified the Council's instructions: Now film can take the role the so-called 'poor person's Bible' of past centuries, that is, great frescoes, sculpture – basically all sacred art" (my translation). (Pasolini, *Il Vangelo secondo Matteo*, p. 265: "[C]hiariva l'indicazione conciliare: Adesso il cinema puo assumere il ruolo che nei secoli passati aveva la così detta 'Bibbia dei poveri' cioè i grandi affreschi, le sculture, insomma tutta l'arte sacra.")

28. For explicit formulations, see "La pazzesca razionalità della geometria religiosa" and "Il cinema di poesia' " in Pasolini's *Empirismo eretico*.

29. Guy Freixe, "Approche du *Decameron* de Pier Paolo Pasolini," p. 148:

> Cependent le surgissment de l'espace du rêve est différent dans le cas du songe de Giotto. Le peintre dort, il se réveille et, se redressant, regarde sa fresque avec fascination. Il n'y a pas ici apparition de personnage mais une vision de type fantasmatique: la fresque gigantesque s'anime, les personnages bibliques prennent vie et la sainte Vierge . . . se met à prendre des poses érotiques et son sourire est très aguischeur. Nous avons là un exemple de *renversement de signe* de type blasphématoire, typique de Pasolini ét dont nous rencontrerons d'autres exemples quand nous étudierons son propros hérétique: le couple Immaculée Conception e Prostiuée (Marie-Madeleine) est indissoluble. Dans cette vision fantasmatique la signification de la fresque s'inverse donc et la peintre, faciné, écarquille les yeux.

> [However, the appearance of the dream sequence is different in the case of Giotto's dream. The painter sleeps, awakens, and sits up and looks with fascination at his fresco. It [the vision] is not an apparition of a great figure, rather it is a fantasmatic vision; the gigantic fresco comes alive, the biblical characters come to life and the blessed Virgin . . . begins to strike erotic poses, her smile is quite sexually inviting, ogling (provocative). We have here an example of the blasphemous overturning of the sign, typical of Pasolini we will encounter other examples when we study his own heresy: the pairing of the Immaculate Conception and the Prostitute [Mary Magdalene] is inseparable. In that fantasmatic vision the meaning of the fresco is thus inverted and the painting, fascinates, goggles [*écarquille*] the eyes.] (My translation).

See, in addition, Michele Godego, *Da Accattone a Salò* #92: "[Del] sogno in cui l'affresco si anima . . . non è che si debba dar corso ad una ricerca filologica attorno ad un episodio "marginale" del film, nondimeno trattandosi della chiusa del film, la sequenza stride." ([With respect to] the dream in which the fresco comes to life . . . there is no need to undertake philological research with regard to a "marginal" episode of the film, however, since it involves the close of the film, the sequence clashes [my translation].) For additional readings, see Godego, *Da Accattone a Salò*.

30. Pasolini, "Pasolini Today," p. 21.

CHAPTER FIVE. LIVING PICTURES

1. Eve Kosofsky Sedgwick, *Epistemology of the Closet*, p. 27.
2. Ibid., p. 197.
3. See the second chapter of this book for examples of the narrative coherence demanded by the doctrine of courtly love, especially with respect to the troubled aspects of Ghismunda's and Tancredi's speech regarding "the heart of love."
4. Watson, "*Virtu* and *Voluptas* in *cassoni* Painting," pp. 216, 220. Also, in "Boccaccio visualizzato" Branca further underlines the extreme popularity of the *Decameron* in his discussion of the visual representations Boccaccio's work inspired, referring to the

true and autonomous masterpieces inspired by Boccaccio executed by Pesellino, Botticelli, Signorelli, Francesco Di Giorgio, Pier di Cosimo, Bachiacca, Luini, Morone, Ercole de Roberti, Antonio Solario, Carpaccio, Palma il Vecchio, Jacopo de' Barbari, Bonifacio Veronese. It is a group of painters with very strong personalities, that, in works of art entirely independent of book illustration, is fascinated by the human and poetic themes of certain *novelle*, of which they have freely visualized the meanings, even while misunderstanding and deforming them. Also in following generations the most diverse tastes and sensitivities do not escape the mirage of that great "theatre of the world and humanity" that is the *Decameron*: from the fleshy baroque of a Reubens to the rosy and spent elegance of a Boucher, to the illuministic psychologism of a Hogarth to the coloristic and expressive search of Turner, all the way to De Chirico and Chagall and on to television and film interpretations (and here I only cite the most illustrious names). Struck by the magic of Boccaccian narrative, artists from the most divergent ages and inclinations want to translate it, necessarily in the visual rhythms of their tastes and their own models. They inevitably deform, often fatally, the *Decameron*; even so, they testify to the inexhaustible vitality and the constantly renewing, overwhelming fantasy of it [My translation].

[veri e automomi capolavori ispirati dal Boccaccio al Pesellino, al Botticelli, al Signorelli, a Francesco Di Giorgio, a Pier di Cosimo, al Bachiacca, al Luini, al Morone, a Ercole de Roberti, a Antonio Solario, al Carpaccio, a Palma il Vecchio, a Jacopo

de'Barbari, a Bonifacio Veronese. è tutta una serie di pittori, di fortissima personal-
ità, che, in opere del tutto indipendenti dall'illustrazione del libro, è affascinata dai
temi umani e poetici di certe novelle e ne vuole liberamente visualizzare i signifi-
cati, pur fraintendoli e deformandoli. E anche nelle età successive i gusti e le sen-
sibilità più diverse non sfuggono al mirraggio di quel grande "teatro del mondo e
dell'umanità: che è il *Decameron:* dall'impeto corpose e barrocco di un Rubens all'el-
eganza rosea e estenuata di un Boucher, allo psicologismo illuministico di un Hog-
arth e alla ricerca espressiva e coloristica di Turner fino a De Chirico e Chagall e
fino alle interpretazioni visuali cinematografiche e televisive (e cito solo qualche
nome più sonante). Presi dalla magia della narrazione boccacciana gli artisti delle
età e delle tendenze più diverse vogliono tradurla, di forza, nei ritmi visivi del loro
gusto e dei loro modelli. Deformano inevitabilmente e spesso fatalmente il *De-
cameron*, ma ne testimoniano lungo i secoli l'inesausta vitalità e la sempre rinnovata
prepotenze fanatastica.]

5. Watson, "The Cement of Fiction," p. 47.
6. Giovanni Previtale, *Giotto, La capella degli Scrovegni,* p. 12.
7. Julia Kristeva, "Giotto's Joy," p. 50.
8. Enzo Siciliano, *Vita di Pasolini,* p. 12.
9. P. P. Pasolini, *Alì dagli occhi azzurri:*

> Io sono una forza del Passato.
> Solo nella tradizione è il mio amore.
> Vengo dai ruderi, dalle Chiese,
> dalle pale d'altare, dai borghi
> dimenticati sugli Appennini e sulle Prealpi,
> dove sono vissuti i fratelli.
> Giro per la Tuscolana come un pazzo,
> per l'Appia come un cane senza padrone.
> . . . E io, feto adulto, mi aggiro
> più moderno di ogni moderno
> a cercare fratelli che non sono più.

> I am a force of the Past. Tradition is my only love.
> I come from ruins, from Churches,
> from altarpieces, from forgotten
> villages of the Apennines and the Prealps
> where my brothers lived.
> I wander around the Tuscolana like a madman
> and around the Appian Way like a homeless dog.
> . . . An adult fetus, more modern than
> all the moderns, I roam in search
> of brothers that are no more (Translation by Greene, *Pier Paolo Pasolini,*
> p. 64).

10. See Ben Lawton, "The Evolving Rejection of Homosexuality," and Naomi
 Greene, *Pier Paolo Pasolini.*

11. Lawton briefly outlines the trajectory of critical reception of Pasolini's films in his article "Theory and Praxis in Pasolini's Trilogy of Life: *Decameron*." After discussing the popular success of *Accattone*, Lawton says the subsequent films *Oedipus Rex*, *Teorema*, *Porcile*, and *Medea*, became increasingly complex.

> While the director received the plaudits of a number of avant-garde critics, he increasingly alienated the general public. [Lawton details how Pasolini then engaged in an] attack . . . directed specifically against the would-be intellectuals and weekend revolutionaries. After the failure of the bourgeois "revolution" of 1968 in France and in Italy, Godard and Pasolini rejected their art house, intellectualizing publics . . . Pasolini rejected [the] avant-garde cinema in favor of a "liberated" cinema . . . Pasolini foreshadowed the birth of the "liberated" cinema when he said: "Obviously, the cinema is a more direct means of reaching a wide public than a book." This statement may seem excessively "obvious", but yet it lies at the heart of his decision to reject the increasingly hermetic tendencies which had characterized his intellectual, externally ideological films, and to renew his commitment to reaching a broader audience . . . [W]hile acquiring a broader and more popular audience, he alienated the greater part of the intellectuals, critics and art house patrons who had earlier championed his more esoteric works (p. 397).

12. Ibid., p. 84; Paolo Mereghetti, *Accattone a Salò*.
13. Greene, *Pier Paolo Pasolini*, p. 184.
14. Margaret Miles, *Image as Insight*, pp. 73–74.
15. Watson, "The Cement of Fiction," p. 62.
16. Ibid., p. 63.
17. Ibid., p. 62.
18. Kristeva, "Giotto's Joy," pp. 220–4. Kristeva continues this discussion:

> Yet, the narrative signified of the Arena Chapel's nave, supporting the symbolism of teleological dogma (guarantee of the mythical Christian community) and unfolding in three superimposed bands from left to right in accordance with the Scriptures, is artificial. Abruptly, the scroll tears, coiling in upon itself from both sides near the top of the back wall facing the altar, revealing the gates of heaven and exposing the narrative as nothing but a thin layer of color . . . Here, just under the two scrolls, facing the altar, lies another scene, outside of the narrative: *Hell*, within the broader scope of the *Last Judgment*. This scene is the reverse of the narrative's symbolic sequence; three elements coexist there: historical characters (Scrovegni [who is the donor of the chapel] and the painter himself), the *Last Judgment*, and two groups of the blessed and the damned. With the representation of Hell the narrative sequence stops, is cut short, in the face of historical reality, Law and fantasy (naked bodies, violence, sex, death) – in other words, in the face of the human dimension – the reverse of the divine continuity displayed in the narrative. In the lower right-hand corner, in the depiction of Hell, the contours of the characters are blurred, some colors disappear, the others weaken, and still others darken: phosphorescent blue, black, dark red. There is no longer a distinct architecture; obliquely set masonry alongside angular mountains in the narrative scene give way on the

far wall to ovals, discontinuity, curves and chaos . . . Deprived of narrative, representation alone, as signifying device, operates as a guarantee for the mythic (and here Christian) community; it appears as symptomatic of this pictorial work's adherence to an ideology; but it also represents the opposite side of the norm, the antinorm, the forbidden, the anomalous, the excessive and the repressed: Hell . . . Giotto's practice . . . and the Christian tradition of art in general, show their independence of symbolic Law by *pitting themselves* against the represented narrative (parables of Christian dogma) as well as against the very economy of symbolization (color–form–representation). Thus, pictorial practice fulfills itself as freedom – a process of liberation *through and against the norm*; to be sure, we are speaking of a subject's freedom, emerging through an order (a signified) turned graphic while permitting and integrating its transgressions. For, the subject's freedom, as dialectics sets forth its truth, would consist precisely in its relative escape from the symbolic order. But, since this freedom does not seem to exist outside of what we agree to call an "artist" it comes about by modifying the role played by the systems of referent, signifier, and signified and their repercussions within the organization of significance into real, imaginary, and symbolic (both role and organization are patterned on the function of verbal communication – keystone of the religious arch) so as to organize them *differently* (p. 224).

Earlier she says,

Color can be defined . . . as being articulated on . . . a triple register within the domain of visual perceptions: an instinctual pressure linked to external visible objects; the same pressure causing the eroticization of the body proper via visual perception and gesture; and the insertion of this pressure under the impact of censorship as a sign in a system of representation. Color is not zero meaning; it is excess meaning through instinctual drive, that is, through death . . .

Color does not suppress light but segments it by breaking its undifferentiated unicity into special multiplicity (pp. 212–22).

19. Ibid., p. 224.
20. On page 140 in *Epistemology of the Closet*, Sedgwick comments on the subversive possibilities such representations allow:

Christianity may be near-ubiquitous in modern European culture as a figure of phobic prohibition, but it makes a strange figure for that indeed. Catholicism in particular is famous for giving countless gay and proto-gay children the shock of the possibility of adults who don't marry, of men in dresses, of passionate theatre, of introspective investment, of lives filled with what could, ideally without diminution, be called the work of the fetish. Even for the many whose own achieved gay identity may at last include none of these features or may be defined as against them, the encounter with them is likely to have a more or other than prohibitive impact. And presiding over all are the images of Jesus. These have, indeed, a unique position in modern culture as images of the unclothed or unclothable male body, often in extremis and/or in ecstasy, prescriptively meant to be gazed at and adored. The

scandal of such a figure within a homophobic economy of the male gaze doesn't seem to abate: efforts to disembody this body, for instance by attenuating, Europeanizing, or feminizing it, only entangle it the more compromisingly among various modern figurations of the homosexual.

21. Petrarca, "On Boccaccio's *Decameron* and the Story of Griselda," pp. 191–6.
22. Watson, *Virtu* and *Voluptas*" (p. 251), discusses a few examples of the humanist debate over Boccaccio: "Palmieri sounds the clearest blast of the priggish trumpet, upbraiding poor Boccaccio as a purveyor of prurient tales." Watson also refers to a prominent humanist named Vespasiano who, at the end of his biography of Allesandra de' Bardi, appended a homily on virtue addressed to the matrons of the city that said, "Do not let them [young girls] read the *Decameron*, or books by Boccaccio, or the sonnets of Petrarch, well written though these may be; for the innocent minds of young girls should learn to love only God and their own husbands."
23. Burke, *The Italian Renaissance*, p. 128.
24. In 1989, when I was teaching "Introduction to Italian Literature" at the University of Rochester, I included several tales from the *Decameron* on the syllabus. Much to my surprise, students came to class with editions of Boccaccio's book that elided most of the tale of Alatiel's sexual adventure (II, 7), left the story of Rustico putting his "devil" in Alibech's "hell" (III, 10) untranslated, and in one case rendered the wordplay in French (in an otherwise English translation). Other similar prudish editing strategies abounded. For an amusing summary of some instances of repressive editing of the *Decameron*, see Leo Steinberg, *The Sexuality of Christ in Renaissance Art and in Modern Oblivion*, p. 185.
25. See n. 4 for Branca's dismay at how many artists "inevitably deform, often fatally, the *Decameron*."
26. Greene, *Pier Paolo Pasolini*, pp. 29 and 134.
27. I offer here a sampling of the way writing about Pasolini construes "scandal": Siciliano, *Vita di Pasolini*, pp. 316, 384, 414:

The country parish culture enriched in him a dynamic idea of history: – but that dynamic was inextricably bound up with the evangelical message of scandal.

Pasolini didn't intend to victimize anyone: he had inside, as always, the extremely ambiguous desire for the "evangelical scandal," and as a result a situation, even the most futile, was taken to the point of truthful revelation.

Pasolini displayed the unusual wisdom of a showman – weaving into his film tapestry plots with unsimulated sexuality, explicit male and female nudes. He shows the male sex erect, *hard core*, and often of such a size as to quadruple the scandal. And scandal meant success [my translation].

[La cultura delle pievi rurali si faceva ricca in lui di una idea dinamica della storia: – ma tale dinamicità si legava inestricabilmente al messaggio evangelico dello "scandalo."]

[Pasolini non aveva intenzione di vittimizzare nessuno: – c'era in lui, come sempre, l'ambiguissimo desiderio dell' "evangelico scandalo", per cui una situazione, anche la più futile, veniva portata al punto del veridico svelamento.]

[Pasolini rivelò un'insolita sagacia da uomo di spettacolo: – incastonò nei suoi arazzi trame dalla sessualità non simulata, espliciti il nudo maschile e femminile. Mostrò la virilità in erezione, *hard core*, esibita spesso in attributi di tale proporzione da quadruplicare lo scandalo. E lo scandalo significava successo.]

Giovanni Dall'Orto, "Contra Pasolini," in Casi, *Desiderio di Pasolini*, p. 172:

A moral traditionalist and sexist, sworn enemy of sexual liberation, he couldn't avoid causing scandal, or being a scandal with his difference, which he wouldn't have sacrificed to any catholicism in this world (either white or red).

[Tradizionalista e maschilista in morale, nemico giurato della liberazione sessuale, non poteva suo malgrado fare a meno di dare scandalo, di *essere* uno scandalo con la sua *diversità*, che non avrebbe sacrificato a nessun cattolicesimo di questo mondo (bianco o rosso che fosse).]

Paolo Mereghetti, *Da Accattone a Salò*, p. 94:

So, the *Decameron* [film] is supposed to be some innocent game; it seems exactly the opposite to us: sure it's a game, but the result is a well-known flight from historical responsibility . . . Someone will say that we are being moralists ("left-wing fascists," to be clear), but it is precisely our honesty that is the problem, because the *Decameron* is a gigantic historical mystification . . . which substitutes an eternally happy mass of country folk, who are ultimately made the repository and artifice of an autonomous and original culture that Pasolini vainly dreams. The reality of history is an entirely different thing.

[Dunque il *Decameron* dovrebbe essere un gioco innocente: a noi sembra il contrario: è un gioco sì ma che è il risultato di una ben nota fuga dalle responsibilità della storia . . . Qualcuno dirà che siamo moralisti ("fascisti di sinistra" per intenderci) ma è proprio l'onestà che fa difetto al nostro perchè il *Decameron* è una grossissima mistificazione storica . . . {in} cui sostituisce una massa contadina eternamente felice, finalmente depositaria e artefice di una cultura popolare autonoma e originale che Pasolini invano sogna. La realtà della storia è tutt'altra cosa.]

28. Greene, *Pier Paolo Pasolini*, p. 179.

29. On p. 5 of Siciliano's *Vita di Pasolini*, Angelo Romanò refers to a volume edited by Laura Betti entitled *Pasolini: Judicial Chronicle, Persecution, Death* that he says has an

incomplete list of the circumstances and dates on which Pasolini had to deal with the judicial system. It is twenty pages long, including some thirty-three proceedings, starting with the examination during the trial for the massacre at Porzûs in 1947 and ending with the decision by the Constitutional Court on his film of *The*

Canterbury Tales in 1975. Even after Pasolini's death, there was a posthumous trial regarding his film *Salò,* and of course, there was a trial for his murder" [my translation].

[Nel volume curato nel 1977 da Laura Betti, e intitolato appunto *Pasolini: cronaca giudiziaria persecuzione, mortre* (Garzanti, Milano), l'elenco, per giunta parziale, delle circostanze e delle date in cui Pasolini ha avuto a che fare con l'amministrazione della giustizia occupa venti pagine: qualcosa come trentatrè procedimenti, dal primo interrogatorio nel processo per la strage di Porzûs nel'47 fino alla decisione della Corte Costituzionale sul film *I racconti di Canterbury* del 1975. Dopo la morte di Pasolini, c'è persino un processo postumo, quello sul film *Salò,* e naturalmente c'è il processo per il suo assassinio.]

30. Pasolini, "Abiura della Trilogia," in *Trilogia della vita,* p. 8:

Io abiuro dalla "Trilogia della vita", benchè non mi penta di averla fatta. Non posso infatti negare la sincerità e la necessità che mi hanno spinto alla rappresentazione dei corpi e del loro simbolo culminante, il sesso . . . Ora tutto si è rovesciato.

Primo: la lotta progressista per la democratizzazione espressiva e per la liberalizzazione sessuale è stata brutalmente superata e vanificata dalla decisione del potere consumistico di concedere una vasta (quanto falsa) tolleranza.

Secondo: anche la "realtà" dei corpi innocenti è stata violata, manipolata, manomessa dal potere consumistico: anzi, tale violenza sui corpi è diventato il dato più macroscopico della nuova epoca umana.

Terzo: le vite sessuali private (come la mia) hanno subìto il trauma sia della falsa tolleranza che della degradazione corporea, e ciò che nelle fantasie sessuali era dolore e gioia, è divenuto suicida delusione, informe accidia . . . Però, a coloro che criticavano, dispiaciuti o sprezzanti, la "Trilogia della vita", non venga in mente di pensare che la mia abiura conduca ai loro "dovere". La mia abiura conduce a qualcos'altro . . . Mi conduce all'adattamento . . . Dunque io mi sto adattando alla degradazione e sto accettando l'inaccettabile . . . Riadatto il mio impegno ad una maggiore leggibilità (*Salò?*).

31. Lawton, "The Evolving Rejection of Homosexuality," p. 171.
32. Greene, *Pier Paolo Pasolini,* pp. 216 ff.
33. Lawton, "The Evolving Rejection of Homosexuality," pp. 170–1.
34. Sedgwick, *Epistemology,* p. 27.
35. Lawton, "Theory and Practice," pp. 400–9.
36. Greene, *Pier Paolo Pasolini,* pp. 151 ff.
37. Kaja Silverman, "White Skin, Brown Masks," p. 10.
38. Ibid., p. 49.
39. Elizabeth Cowie, "Fantasia."
40. Here is a summary of the tale of Andreuccio (*Dec.* II, 5):
 Andreuccio is a silly fellow from Perugia who goes to Naples to buy horses. At the market, Andreuccio foolishly flaunts his bag full of gold florins and attracts the attention of a beautiful prostitute. The prostitute invites Andreuccio to her

house and tricks him into believing that she is his long lost half sister. Late at night, when Andreuccio goes to relieve himself, he falls into the cesspool. When he climbs out, he finds that he has been locked out of the house where his clothes and gold are. Andreuccio creates a big disturbance in his attempt to be readmitted to the house, and the angry neighbors drive him away. On his way to the ocean to rinse off, he sees two men who frighten him, so he hides in a nearby hut. The men discover him and force him to help them rob the tomb of the recently deceased archbishop of Naples. While Andreuccio is inside the tomb, he removes the archbishop's rich ring and puts it on his own finger; then he proceeds to hand out to the two robbers all the other booty. The robbers demand the ring, and when Andreuccio claims he cannot find it, they shut the lid on him, trapping him inside with the dead body. Luckily for Andreuccio, another groups of robbers soon shows up at the tomb. As one of the new robbers is lowering himself into the tomb, Andreuccio pulls his legs. The terrified robber flees, leaving the tomb open, and Andreuccio escapes, returning to Perugia with a ring instead of his money.

41. Here is a summary of the story of the Abbess (*Dec.* IX, 2):

In a convent in Lombady, a beautiful nun takes a lover. One night another nun sees the lover leaving the nun's cell, and she goes to the Abbess to tell. The Abbess quickly gets up from her bed in the dark in order to catch the nun. The Abbess, who had been sleeping with a priest, puts his underpants on her head, thinking she is putting on her wimple. When the accused nun sees the underpants and points them out to the Abbess, she is forgiven. The Abbess declares that it is impossible to deny the desires of the flesh, and that everyone in the convent should enjoy herself whenever possible, provided that it be done as discreetly as it had been, up until that day.

42. "Ahh, ma anche tu pure stavi pomiciando dentro la cella tua, perché tieni le mutande del prevete in capo! . . . E così in chillo convento tutte le suore pomiciarono pure loro."

43. "[T]orna con la grana, eh?"

44. Walter S. Gibson, *Bruegel*, p. 77.

45. Without the cart and paddle, the woman would likely be identified as Hope because of her youthful beauty and her "beehive" hat. However, because she has several of Lent's accessories, she remains ambiguous.

46. Gibson, *Bruegel*, p. 58.

47. Ibid., p. 79.

48. Giovanni Arpino, "*Decameron* tutto nudo," p. 95.

49. Gibson, *Bruegel*, p. 178.

50. My translation.

in una contrada che si chiamava Bengodi, nella quale si legano le vigne con le salsicce e avevaisi un'oca a denaio e un papero giunta; e eravi una montagna tutta di

formaggio parmigiano grattugiato, sopra la quale stavan genti che niuna altra cosa faccevano che far maccheroni e raviuoli e cuocergli in brodo di dapponi, e poi gli gittavan quindi giù . . . e ivi presso correva un fiumicel di vernaccia (p. 648).

51. Gibson, *Bruegel*, p. 79.

52. "Ormai quello che hai fatto qui, è tutto quello che potevi fare. Hai falsificato i documenti che si potevano falsificare. Hai ammazzato. Hai stuprato donne. Hai bestemmiato Dio e tutti i Santi . . . E sei pure un poco recchione" (p. 37).

53. See Marcus's discussion of the dichotomy of readings in the Cepperello/Ciappelletto *novella* in chapter 1 in *An Allegory of Form*.

54. Svetlana Alpers, "Bruegel's Festive Peasants"; Carroll, "Peasant Festivity. . . . "

55. There is considerable evidence that Pasolini created the character "Giotto" as a homosexual. First, when we apply Pasolini's own theory of cinematic representation, which he nicely summarizes with the statement "[c]inema is the written language of reality" ("The Cinema of Poetry" and "Res sunt nomina"), we notice that in accordance with his theory, Pasolini avoided using actors in his films and instead preferred to cast people he thought in "real life" were most like the character he wanted represented. This method of using people to play themselves extended to their personal as well as physical attributes. In the earliest drafts of the screenplay and treatment for the *Decameron*, Pasolini writes that he envisions his Giotto being played by a poet. As it turns out, all of the poets he wanted to play the part were gay, Italian men. In a 1970 interview with *Epoca*, Pasolini explained that the first person he asked to play Giotto was Sandro Penna (a colleague with whom Pasolini had an ongoing competition regarding the number of sexual encounters with *ragazzi* each could "score") and, when that fell through, he called upon Paolo Volpone, who also declined the part. When neither of the men would play the part, Pasolini decided that he himself was "abbastanza piccolo e brutto per farlo" (small and ugly enough to do it). Of course, Pasolini was vain enough to set forth these physical criteria as a joke. He did not consider himself either *piccolo* or *brutto*, and, in an interview published in *L'Espresso* (22 Nov. 1970, p. 14) with his friend Dario Bellezza, he offers a less coy explanation of his casting himself as Giotto, stating, "What does my presence in the *Decameron* signify? It signifies my having ideologized the piece through the consciousness of my presence: consciousness not entirely aesthetic, but through the vehicle of physicality, of my whole way of being present, entirely" (my translation). ([C]osa significa la mia presenza nel Decamerone? Significa aver ideologizzato l'opera verso la conienza di essa: coscienza non puramente estetica, ma attraverso il veicolo della fisicità, del tutto mio modo di esserci, totale.)

Pasolini's sexuality is indisputably central to his *modo di essere* as well as to his cinematic and literary production. In spite of the fact that in a letter written immediately after he moved from Casarsa to Rome in 1950 he wrote of his ho-

mosexuality as a separate entity from his "nature" (Greene, *Pier Paolo Pasolini*, p. 116), the bulk of his work reflects, if not pride, then an insistence on public recognition of his sexuality.

In "Contro Pasolini" (p. 151), Dall'Orto speculates on the reasons why a "deviant" eroticism would be so influential in Pasolini's art, commenting, "Only a person whose sexuality constitutes a daily problem, one that has to be renegotiated day after day for his or her whole life, could create out of it a knot of interests so essential [as Pasolini did]" (my translation). ([S]olo una persona la cui sessualità costituisse un problema quotidiano, da rinegoziare giorno dopo giorno per tutta la vita poteva farne un nodo di interessi così essenziali.)

In addition, some prominent gay critics have argued that they interpret Pasolini's Giotto as gay. For example, in his piece entitled, "Omossesualità nel cinema di Pasolini," in Casi, *Desiderio di Pasolini* (p. 107), De Santi states, "[I]t's the same mold from which are cast so many religious characters, for example the two young and ingenious priests, mincing and dancing, who try to catch the eye of the giottesque painter, or Giotto himself, in the [film] *Decameron;* and in the same film, with less exaggerated caricature, the gay sacristan who . . . [appears in the *novella* of] Andreuccio of Perugia" (my translation). (É l'uguale stampo da cui sortiscono tante e tante figurettine di religiosi, per esempio i due giovani e ingenui fraticelli che vezzosi e gongolanti si presentano alla vista del pittore giottesco, o di Giotto stesso, nel *Decameron;* e nello stesso film, con una meno calcata caricaturalità, ecco il sacrestano frocetto [della novella di] Andreuccio da Perugia.)

The following excerpts from Casi, *Desiderio di Pasolini* address the influence of Pasolini's sexuality on his artistic production:

On pages 25 and 52, Casi writes,

Homosexuality was lived by Pasolini as a nocturnal encounter with boys who were always different, who came from the subproletariat classes, in situations that "good sense" doesn't hesitate to call "squalid pickups," both mercenary and not: this homosexuality was the existential guarantee of Pasolini's commitment, as an intellectual, to the analysis of social and cultural change. Homosexuality then, doesn't offer itself merely as an "autobiographical" fact, but as a lucid "autobiographistic" foundation that must be shown, more or less covertly, as a guarantee of his own personal commitment as an intellectual [my translation]. One particularly important element in Pasolini's work is the *gaze*. Pasolini's "homosexual" gaze appears to coincide with the *faith* in the gaze itself in its communicative capacity. A function which . . . most homosexual men are familiar with in optimizing the search for a partner. The *battuage*, which represents one type of behavior which ends in the consummation of casual relations, requires accelerated time and types of encounters and, in this, one of the privileged channels of communication is precisely the gaze, understood as both evaluating the erotic capacity of the other and as a means of expressing interest [my translation].

[L'omosessualità fu vissuta da Pasolini come incontro notturno con ragazzi sempre diversi, provenienti dalle classi sociali del sottoproletariato, in situazioni che il "buon senso" non esita a bollare come "squallidi approcci" mercenari e non: questa omosessualità fu la garanzia esistenziale per l'impegno di Pasolini come intellettuale in grado di analizzare i mutamenti sociali e culturali. L'omosessualità, allora, non si presenta come mero dato "autobiografico" ma come lucido fondamento autobiografistico da esibire, più o meno velatamente, una garanzia del proprio impegno di intelletuale.]

[Un elemento particolarmente importante nell'opera pasoliniana è lo *sguardo*. Lo sguardo di "omosessuale" di Pasolini . . . sembra coincidere con la *fiducia* nello sguardo stesso, nella sua capacità comunicativa. Una funzione che, del resto, una buona parte di omosessuali conosce attraverso l'esperienza di ottimizzazione delle pratiche per l'incontro del partner. Il *battuage,* che rappresenta un tipo di comportamento generalmente finalizzato alla consumazione di un rapporto occasionale, obbliga ad una accelerazione dei modi e dei tempi di incontro, in cui uno dei canali di comunicazione privilegiati è proprio lo sguardo inteso sia come valutazione delle potenzialità erotiche dell'altro, sia come mezzo per esprimere interesse.]

On pages 115 and following, De Santi comments on the representation of males by Pasolini:

Pasolini's cinema, due to the dominant morality of the `70's, but also by his own choice, usually represents heterosexual encounters . . . , yet he still shifts the attractive charge onto the masculine body. It is the male body which is invested with mystery (*Teorema*) and sacrality (*Accattone* and *The Gospel According to Matthew*) and through those intermediaries epiphanized . . . The man's body is not always revealed and presented naked. But even enveloped in clothes and obscured by shadows it is from him that the miracle of eros emanates. So, the sensorial apprehension directed by the camera frames the male and obscures the feminine image. In looking at the man and his sexual game (manifest or implicit), director and spectator (a spectator obviously tuned into the rhythm of the film) slide imperceptibly in the space occupied by the woman. More than a discourse of love, it's a syntax of desire that is exalted by the gazes tossed at the camera by the characters, gazes that are also desiring in the sense of possession and control of bodies . . . But in Pasolini the impossibility of a full liberation on the homosexual plane leads to the sensorial weight of the details: pants, the zipper, the swollen crotch [my translation].

[Il fatto che nel cinema di Pasolini, per ragioni di morale dominante negli anni Sessanta ma anche per opzione del regista, venga piuttosto rappresentato il rapporto eterosessuale . . . sposta in fatto, la pulsione sul corpo maschile. E questo ad essere investito di mistero (*Teorema*) e di sacralità (*Accattone, il Vangelo secondo Matteo*) e per tale tramite epifanizzato . . . Non sempre il corpo dell'uomo viene scoperto e fatto apparire nella sua nudità. Ma pure racchiuso in abiti e fasciato da coltri di buio, e da lui che promana il miracolo dell'eros. Così l'apprensione sensoriale orientata dalla camera requadra il maschio e obnubila l'immagine femminile. Nel guardare l'uomo e il suo gioco sessuale, manifesto o implicito, regista e spettatore (uno spettatore ev-

identamente sintonizzato con le pulsioni del film) scivolano impercettibilmente nello spazio occupato dalla donna. Più che un discorso d'amore, è una sintassi del desiderio che si esalta con gli sguardi gettati in macchina dai personaggi, sguardi anch'essi desideranti nel senso del possesso e del governo dei corpi . . . Ma in Pasolini l'impossibilità di una piena liberazione sul piano omosessuale lascia aperta la grevita sensoriale dei dettagli: i calzoni, la patta, i gonfiamenti sul basso ventre.]

56. *La Stampa*, 7 Nov. 1970: "É un giudizio universale alla napoletana . . . e a Napoli – si sa – si invoca sempre la Madonna, non Dio."

The following are some notes regarding the association between Pasolini's homosexuality and his representation of the Madonna:

Comments by Ricketts:

The fact that the Virgin Judge in the tableau is played by Silvana Mangano adds another layer to this complex pastiche. Silvana Mangano is the actress who played Jocasta in *Edipo Re* (Oedipus Rex) (in both the modern day Bologna and the ancient Thebes versions), where she is deliberately modeled after Susanna Pasolini, Pier Paolo's mother. The sequence of shots framing Mangano in the Last Judgment tableau rhymes with the sequence of shots framing the actress in meadow scenes of Jocasta in *Edipo Re*. This visual homonymity sets up an association among the Virgin, Jocasta, Silvana Mangano, and Susanna Pasolini that bears on our reading of Pasolini's Last Judgment. To further emphasize this point, in Pasolini's *Vangelo secondo Matteo*, Pasolini cast his mother, Susanna, to play the aged Virgin Mary.

In *Pier Paolo Pasolini* (p. 152), Greene elaborates on the autobiographical bent of Pasolini's *Edipo Re*, on the identification of Jocasta with Mary, and Susanna:

Briefly, masterfully, the silent prologue, full of autobiographical allusions, suggests the intensity of love and rivalry at the heart of the Oedipus complex. One shot of the prologue, in particular, will resonate throughout the film, evoking, as it does, the primordial and fateful bond between mother and son. Seated in a verdant meadow with her suckling infant at her breast, the mother looks directly into the camera for an unbearably long time . . . A circling pan tilts upward to encompass the trees enclosing the meadow before the camera returns to mother and child as if they, seated in the meadow, were at the center of the universe. And, of course, each is the center of the world for the other.

Although definite autobiographical motifs run throughout Pasolini's cinema, never before, as in *Edipo Re*, had he so explicitly alluded to events, people, and places in his life. Even visual details were drawn from a reservoir of personal memories: the lush green meadow of the prologue and epilogue, he said, "corresponds exactly to the meadow where my mother took me to walk when I was a child. I had the clothes (the mother's dress and yellow hat) reproduced from old photographs."

And quoting Pasolini directly regarding the film:

"In *Edipo Re* I recount the story of my own Oedipus complex. The little boy of the prologue is myself, his father is my father . . . the mother . . . is my own mother."

The central close-up of the mother in the prologue – a close-up embodying all the force of forbidden and fatal desire – is matched by a similar close-up of Jocasta. The resemblance between these two close-ups, a resemblance that points to the fundamental identification of Jocasta with the mother, further compels our attention because both women are placed by the same actress, Silvana Mangano . . . "With Jocasta," said Pasolini, "I represented my own mother projected into myth."

Silvana Mangano also plays the role of Lucia, the bourgeois housewife in *Teorema*, as well. In this role she has a sexual encounter with The Stranger, whereupon she abandons her traditional behavior and takes to cruising the streets, picking up young men for sexual intercourse. More than one critic has commented upon the similarity between Lucia's cruising behavior and Pasolini's private sexual life.

57. Cowie, "Fantasia"; Constance Penley, ed., *The Future of an Illusion*; Parveen Adams, "Per (Os)cillation"; Silverman, "White Skin, Brown Masks."

58 James H. Stubblebine, *Giotto*, p. 90.

59. Miles, *Image as Insight*, p. 89.

60. Silverman, "White Skin, Brown Masks," p. 24.

61. Sedgwick, *Epistemology*, p. 249.

62. An indication that the mother might be the focal point of his gay anxieties is supported by Pasolini's belief that his mother was "genetically" the cause of his homosexuality. Pasolini's cousin, Nico Naldini, in *Casi, Desiderio di Pasolini* explains:

Pasolini didn't accept his homosexuality as a purely personal fact. He didn't really accept it as a fact at all. But, obligated to submit to it, he considered it a specifically non-individual fact. In fact, for a long time . . . he thought that there was a psycho-physiological reason for his homosexuality, a hereditary trait . . .

Like a wood worm he opened up a path in his history coming up with the initial cause in our grandmother. From our grandmother homosexuality was supposed to have derived . . . Pasolini excluded the possibility that homosexuality had ever existed in the paternal branch of the Pasolinis. He excluded it also from the paternal branch of the Colussi . . . In his search for the origin, he finally ended up finding it in our poor grandmother . . .

In his attempt to explain his own homosexuality, and after having isolated it in the maternal part, to be more precise, the maternal part of the maternal part, he finds homosexuality present in other components of this maternal family. As a result, he considers it an objective demonstration of genetic transmission, and an historical, familial destiny [my translation].

[Pasolini non accettava la sua omosessualità come un fatto indivduale. Non l'accettava, intanto, come fatto. Ma dovendolo subire, la considerava un fatto non individuale. Infatti per molto tempo . . . ha pensato che c'era una ragione psico-fisiologica della sua omosessualità, una discendenza ereditaria . . .

Come un tarlo si era aperto una via nella sua storia anteriore arrivando a trovare questa causa iniziale in nostra nonna . . . Pasolini escludeva che l'omosessualità fosse mai esistita nel ramo paterno dei Pasolini. La escludeva anche dal ramo paterno

dei Colussi . . . Andando alla ricerca di questa origine, alla fine la trovò nella nostra povera nonna . . .

Pasolini nel tentativo di spiegare la propria omosessualità e dopo averla individuata nella parte materna, anzi, nella parte materna della parte materna, scopre la presenza dell'omosessualità in altri componenti di questa famiglia materna. E quindi la considera una prova oggettiva della trasmissione genetica, e di una fatalità storica familiare.]

63. Sedgwick, *Epistemology*, p. 19.
64. Ibid., pp. 248 ff.
65. Ibid., p. 247.
66. In his article "Pasolini and Homosexuality," in Paul Willemen, ed., *Pier Paolo Pasolini* (p. 62), Richard Dyer argues that "gay men are brought up to despise themselves, and one form that self oppression takes is to despise, as a consequence, all other gay men too."
67. Mieke Bal and Norman Bryson, "Semiotics and Art History."

SELECT BIBLIOGRAPHY

PRIMARY SOURCES

A list of the manuscripts and incunables of the *Decameron* according to their collocations at the national libraries in Florence and Paris: Biblioteca Nazionale a Firenze (BNF) and Biblioteque Nationale, Paris (BNP):

BNF, Nencini 1.3.4.10 (1527)
BNF, Palat. 2.3.5.15 (1545)
BNF, Palat. 2.8.1.39 (1546)
BNF, Nencini II.8.1.42 (1549)
BNF, Nencini F.6.5.28 (1550)
BNF, Palat. 2.8.1.43 (1552)
BNF, Palat. 2.8.1.41 (1552)
BNF, Magl. 3.8.95 (1552)
BNF, Magl. 3.1.28 (1554)
BNF, Magl. 5.4.88 (1555)
BNF, Nencini F.9.7.65–73 (1555)
BNF, Palat. C(11).10.6.19 (1557)
BNF, Cod. Magl. II. II. 8

BNP, Cod. Fr. 129 (6798) Premierfait
BNP, Cod. Fr. 239 (6887) Premierfait
BNP, Cod. Fr. 240 (d6887) Premierfait
BNP, Cod. 2203 (7999)
BNP, Cod. It. 63
BNP, Cod. It. 482
BNP, Cod. It. 487
BNP, Cod. Lat. 8521

SECONDARY SOURCES

Abruzzese, Alberto. "Boccaccio come il Vangelo." *Paese Sera*, 22 Sept. 1970.
Adams, Parveen. "Per(Os)cillation." *Camera Obscura*, 17 May 1988, pp. 7–30.
Alberti, Leon Battista. *Della famiglia*. Trans. Renee Watkins. Columbia: University of South Carolina Press, 1969.

On Painting. Trans. John R. Spencer. 1956. New Haven: Yale University Press, 1966.

Alexander, Jonathan J. G. "Facsimilies, Copies, and Variations: The Relationship to the Model in Medieval and Renaissance European Illuminated Manuscripts." *Studies in the History of Art* 20 (1989):61–72.

"*Labeur* and *Paresse:* Ideological Representations of Medieval Peasant Labor." *Art Bulletin* (1990):436–52.

Alighieri, Dante. *The Divine Comedy.* Ed. and trans. Charles S. Singleton. 3 vols. 1970. Princeton: Princeton University Press, 1980.

Allen, Beverly, ed. *The Poetics of Heresy.* Saratoga, CA: Anma Libri, 1982.

Almansi, Guido. *The Writer as a Liar: Narrative Technique in the Decameron.* London: Routledge & Kegan Paul, 1975.

Alpers, Svetlana. *The Art of Describing: Dutch Art in the Seventeenth Century.* Chicago: University of Chicago Press, 1983.

"Art History and Its Exclusions." *Feminism and Art History,* ed. Norma Broude and Mary D. Garrard. New York: Harper & Row, 1982.

"Bruegel's Festive Peasants." *Simiolus* 6 (1972–3):163–76.

Aquinas, St. Thomas. *Summa Theologica.* Trans. Fathers of the English Dominican Province. New York: Benziger, 1947.

Arpino, Giovanni. "*Decameron* tutto nudo." *La Stampa,* 8 Oct. 1971.

Ascoli, Albert Russell. "Mirror and Veil: *Così è (se vi pare)* and the Drama of Interpretation." *Stanford Italian Review* 7 (1987):29–46.

Augustine of Hippo. *The Confessions of St. Augustine.* Trans. John K. Ryan. New York: Doubleday & Company, Inc. [Image Books], 1960.

Austin, J. L. *How to Do Things with Words.* Cambridge, MA.: Harvard University Press, 1975.

Baccheschi, Edi. *The Complete Paintings of Giotto.* London: Weidenfeld & Nicholson, 1969.

Bachmann, Gideon. "Pasolini Today."

Bad Object Choices, eds. *How Do I Look?* Seattle: Bay Press, 1991.

Bakhtin, Mikhail. *Rabelais and His World.* Trans. Hélène Iswolsky. Bloomington: Indiana University Press, 1984.

Bal, Mieke. *Death and Dissymmetry: The Politics of Coherence in the Book of Judges.* Chicago: University of Chicago Press, 1988.

Femmes imaginaires. Utrecht: HES, 1986.

Introduction to "Delimiting Psychopoetics." *Style* 18 (1984):239–60.

Lethal Love: Feminist Literary Readings of Biblical Love Stories. Bloomington: Indiana University Press, 1987.

"Myth *à la lettre:* Freud, Mann, Genesis and Rembrandt, and The Story of The Son." *Discourse in Psychoanalysis and Literature,* ed. Shlomith Rimmon-Kenan. London: Methuen, 1987, pp. 57–89.

Narratology. Trans. C. van Boheemen. Toronto: University of Toronto Press, 1985.

"Perpetual Contest." Susan B. Anthony Working Papers, no. 11. Rochester, NY: University of Rochester, 1987.

Bal, Mieke, and Norman Bryson. "Semiotics and Art History." Art Bulletin 73 (1991):174–208.

Baratto, Mario. Realtà e stile nel "Decameron". Vicenza: Pozza, 1970.

Barberi Squarotti, Giorgio. "La vergine Alatiel." Metamorfosi della novella. Ed. Squarotti. Foggia: Bastogi, 1985.

Barolini, Teodolinda. "The Wheel of the Decameron." Romance Philology 36 (1983):521–39.

Barriault, A. "Paintings for spalliere in Florence: Narrative Cycles for Domestic Interiors, 1470–1520." Ph.D. diss., University of Virginia, 1985.

Barthouil, George. "Boccace et Catherine de Sienne: La Dixieme Journee du Decameron: Noblesse ou subversion?" Italianistica: Rivista di Letterature Italiana 11 (1982):249–76.

Baskins, Cristelle L. "Griselda, or the Renaissance Bride Stripped Bare by Her Bachelor in Tuscan Cassone Painting." Stanford Italian Review 10 (1991):153–75.

"Lunga Pittura: Transforming Narrative and Gender in Quattrocento Cassone Painting." Address presented at University of Rochester, Rochester, NY, 15 March 1990.

Batschman, Oskar. "Text and Image: Some General Problems of Art." Word and Image 4 (1988):11–24.

Baxandall, Michael. Giotto and the Orators: Humanist Observers of Painting in Italy and the Discovery of Pictoral Composition, 1350–1450. Oxford: Clarendon Press, 1971.

"Painters and Clients in Fifteenth-Century Italy." Readings in Art History. 3rd ed. Vol. 2. Ed. Harold Spence. New York: Scribners, 1983.

Painting and Experience in Fifteenth-Century Italy: A Primer in the Social History of Pictoral Style. New York: Oxford University Press, 1972.

Beaver, Harold. "Homosexual Signs (In Memory of Roland Barthes)." Critical Inquiry 8 (1981):99–119.

Bellezza, Dario. "Io e Boccaccio." L'Espresso, 22 Nov. 1970.

Bellosi, Luciano. Giotto: The Complete Works. Florence: Sogema Marzari Schio, 1989.

Benvenuto, Bice, and Roger Kennedy. "The Mirror Stage." Jacques Lacan: An Introduction. New York: St. Martin's, 1986.

Bernardo, Aldo S. "The Plague as Key to Meaning in Boccaccio's Decameron." The Black Death: The Impact of the Fourteenth-Century Plague. Ed. Daniel Williman. Binghamton, NY: Center for Medieval and Early Renaissance Studies.

Bertini, A. "Pasolini, la metafora della sceneggiatura." Filmcritica 29 (1978):323–9.

Betti, Laura, ed. Pasolini: Cronaca giudiziaria, persecuzione, morte. Milan: Garzanti, 1977.

Bettinzoli, Attilio. "Per una definizione delle presenze dantesche nel Decameron, I:I registri ideologici, lirici, drammatici." Studi sul Boccaccio 13 (1981–2):267–326.

Blackbourn, Barbara L. "The Eighth Story of the Tenth Day of Boccaccio's Decameron: An Example of Rhetoric or a Rhetorical Example?" Italian Quarterly 27 (1986): 5–13.

Boari, Vittorio, Pietro Bonfigliolo, and Giorgio Cremonini, eds. *Da accattone a "Salò."* Bologna: 1982.

Boccaccio, Giovanni. *Decameron,* Ed. Cesare Segre. Florence: Sadea/Sansoni Editori, 1980.

Decameron. Ed. Vittore Branca. 2 vols. Milan: Oscar Mondadori, 1985.

Decameron. Ed. Vittore Branca. 3 vols. Florence: Sadea/Sansoni Editori, 1966.

Decameron. Trans. Mark Musa and Peter Bondanella. New York: Norton, 1982.

Bonadeo, Alfredo. "Marriage and Adultery in the *Decameron." Philological Quarterly* 50 (1981):287–303.

Bondanella, Peter. *Italian Cinema: From Neorealism to the Present.* New York: Unger, 1984.

Bonnefoy, Yves. "Time and the Timeless in Quattrocento Painting." *Calligram.* Ed. Norman Bryson. Cambridge: Cambridge University Press, 1988.

Boucher, Holly Wallace. "The Romance of the Name: The Ambiguity of Religious and Sexual Language in the *Decameron* and the *Canterbury Tales." Dissertation Abstracts International* 48(4) (1987):921A. Brown University, 1987.

Boynton, Andrew. "For the Love of the Chase." *Art and Antiques,* Sept. 1986, 80–85.

Bragantini, Renzo. "Dall'allegoria all'immagine: Durata e metamorfosi di un tema: Per la novella VIII.7 del *Decameron." Studi sul Boccaccio* 13 (1981–2):199–216.

Branca, Vittore. *Boccaccio: The Man and His Works.* Trans. R. Monges. New York: New York University Press, 1976.

Boccaccio medioevale. Sansoni Editore, 1970.

"Boccaccio visualizzato." *Studi sul Boccaccio* 15 (1985–6):85–119.

"Copista per passione: Tradizione caratterizzante, tradizione in memoria." *Studi e problemi di critica testuale.* Bologna (1961):69–84.

"Interpretazioni visuali del *Decameron." Studi sul Boccaccio* 15 (1985–6):87–119.

"La prima diffusione del *Decameron." Studi di filologia* 8 (1950):110–15.

"Un primo elenco di codici illustrati di opere del Boccaccio." *Studi sul Boccaccio* 15 (1985–6):121–48.

"Un secondo elenco di manoscritti illustrati." *Studi sul Boccaccio* 16 (1987):249–54.

Branca, Vittore, and Franca Ageno Brambilla. "Studi sulla tradizione del testo del *Decameron." Studi sul Boccaccio* 1 (1981–2):21–160.

Britton, A. "Sexuality and Power, or the Two Others." *Framework* 6 (1977):7–11.

Brooks, Peter. "Storied Bodies, or Nana Unveil'd." *Critical Inquiry* 16 (1989):1–32.

Broude, Norma, and Mary D. Garrard, eds. *Feminism and Art History.* New York: Harper & Row, 1982.

Brunetta, Gian Piero. "Temi della visione di Pier Paolo Pasolini." *Italian Quarterly* 21–2 (1980–1):151–7.

Bryson, Norman. *Tradition and Desire.* Cambridge: Cambridge University Press, 1984.

Vision and Painting: The Logic of the Gaze. New Haven: Yale University Press, 1983.

Word and Image. New Haven: Yale University Press, 1981.

Bullough, Vern L. "Medieval Medical and Scientific Views of Women." *Viator: Medieval and Renaissance Studies* 4 (1973):487–93.

Burke, Peter. *The Italian Renaissance: Culture and Society.* Rev. ed. Princeton: Princeton University Press, 1987.

Butler, Judith. *Gender Trouble: Feminism and the Subversion of Identity.* New York: Routledge, 1990.

Bynum, Caroline Walker. "The Body of Christ in the Later Middle Ages: A Reply to Leo Steinberg." *Renaissance Quarterly* 39 (1986):399–439.

 Fragmentation and Redemption: Essays on Gender and the Human Body in Medieval Religion. New York: Zone Books, 1992.

Cadden, Joan. "Medieval Scientific and Medical Views of Sexuality: Questions of Propriety." *Mediaevalia et Humanistica* 14 (1986):157–255.

Callmann, Ellen. "The Growing Threat to Marital Bliss as Seen in Fifteenth-Century Florentine Painting." *Studies in Iconography* 5 (1979):73–92.

Camille, Michael. "The Book of Signs: Writing and Visual Difference in Gothic Manuscript Illumination." *Word and Image* 1 (1985):133–48.

 The Gothic Idol: Ideology and Image Making in Medieval Art. Cambridge: Cambridge University Press, 1989.

Capellanus, Andreas. *The Art of Courtly Love.* Trans. John J. Parry. New York: Norton, 1969.

Carroll, Margaret D. "Peasant Festivity and Political Identity in the Sixteenth Century." *Art History* 10 (1987):289–314.

Casamassima, Emanuele. "Dentro lo scrittoio del Boccaccio: I codici della tradizione." *Il Decameron: Pratiche testuali e interpretative.* Ed. Aldo Rossi. Bologna: Cappelli, 1982.

Casarino, Cesare. "Oedipus Exploded: Pasolini and the Myth of Modernization." *October* 59 (1992):27–48.

Casi, Stefano, ed. *Desiderio di Pasolini: Omosessualità, arte e impegno intellettuale.* Turin: Edizioni Sonda, 1990.

Cechi, Emilio. *Giotto.* Milan: Editoriale D'arte, 1959.

Celli Olivagnoli, Franca. "'Spazialità' nel *Decameron*." *Stanford Italian Review* 3 (1983):91–106.

Chastel, André. *Botticelli.* New York: New York Graphic Society, 1958.

Clark, Kenneth. "Botticelli's Illustrations to Dante." *The Art of Humanism.* New York: Harper & Row, 1983.

 The Drawings by Sandro Botticelli for Dante's "Divine Comedy." London: Harper & Row, 1976.

Clark, T. J. *The Painting of Modern Life.* Princeton: Princeton University Press, 1984.

Clayton, Jay. "Narrative and Theories of Desire." *Critical Inquiry* 16 (1989):33–53.

Coetzee, J. M. *White Writing: On the Culture of Letters in South Africa.* New Haven: Yale University Press, 1988.

Cohan, Steven. "Masquerading as the American Male in the Fifties: *Picnic*, William Holden and the Spectacle of Masculinity in the Hollywood Film." *Camera Obscura* 25–6 (1991):43–74.

Colasanti, Arduino. "Due novelle nuziale del Boccaccio nella pittura del Quattro-cento." *Emporium* 19 (1904):200–15.

Colomina, Beatriz, ed. *Sexuality and Space: Princeton Papers on Architecture*. New York: Princeton Architectural Press, 1992.

Cottino-Jones, Marga. "Fabula vs Figura: Another Interpretation of the Griselda Sto-ry." *The Decameron, A New Translation*, ed. Mark Musa and Peter Bondanella. New York: 1977.

"Magic and Superstition in Boccaccio's *Decameron.*" *Italian Quarterly* 18 (1975):5–32.

Cowie, Elizabeth. "Fantasia." *m/f* 9 (1984):71–105.

"Woman as Sign." *m/f* 1 (1978):49–63.

Culler, Jonathan. *On Deconstruction*. Ithaca, NY: Cornell University Press, 1982.

Darling, Robert M. "A Long Day in the Sun: *Decameron* 8.7." *Shakespeare's "Rough Mag-ic": Renaissance Essays in Honor of C. L. Barber*, ed. Peter Erikson and Coppelia Kahn. Newark: University of Delaware Press, 1985.

de Lauretis, Teresa. *Alice Doesn't*. Bloomington: Indiana University Press, 1984.

"Re-Reading Pasolini's Essays on Cinema." *Italian Quarterly* 21–2 (Fall 1980, Win-ter 1981):159–66.

de Michelis, Cesare. *Contraddizioni nel "Decameron."* Milan: Guanda, 1983.

de Santi, Pier Marco. "Pasolini fra cinema e pittura." *Bianco e Nero* 46 (1985):6–24.

Depaoli, E. "Da Marx a Freud attraverso l'umorismo tragico." *Cinema Nuovo* 24 (1975):202–5.

Derrida, Jacques. "Différance." *Margins of Philosophy*. Trans. Alan Bass. Chicago: Uni-versity of Chicago Press, 1982.

"The Ends of Man." *Margins of Philosophy*. Trans. Alan Bass. Chicago: University of Chicago Press, 1982.

di Giammatteo, Fernaldo. "Pasolini la quotidiana eresia." *Bianco e Nero* 37 (1976):3–32.

di Piero, Thomas. "The Patriarch Is Not Just a Man." *Camera Obscura* 25–6 (1991):125–44.

di Tommaso, Andrea. "Nature and the Aesthetic Social Theory of Leon Battista Al-berti." *Mediaevalia et Humanistica* 3 (1972):31–50.

Donald, Adrienne. "Coming Out of the Canon: Sadomasochism, Male Homoeroti-cism, and Romanticism." *Yale Journal of Criticism* 3 (1989):239–52.

Durling, Robert M. "Boccaccio on Interpretation: Guido's Escape (*Decameron* VI.9)." *Dante, Petrarch, Boccaccio: Studies in the Italian Trecento in Honor of Charles S. Singleton*, ed. Aldo S. Bernardo and Anthony L. Pellegrini. Binghamton, NY: Medieval and Renaissance Texts and Studies, 1983.

Edelman, Lee. "Homographesis." *Yale Journal of Criticism* 3 (1989):187–207.

Escobar, Roberto. "Pasolini e la dialettica dell'irrealizzabile." *Bianco e Nero* 44 (1983):148–62.

Ettlinger, L. D., and Helen S. Ettlinger. *Botticelli*. London: Thames & Hudson, 1976.

Faithfull, R. G. "Basic Symbolism in Boccaccio." *Lingua e Stile* 20 (1985):247–57.

Felman, Shoshana. *The Literary Speech Act: Don Juan with J. L. Austin, or the Seduction in Two Languages*. 1980. Trans. from the French by Catherine Porter. Ithaca, NY: Cornell University Press, 1983.

Ferguson, Margaret W. *Trials of Desire*. New Haven: Yale University Press, 1983.

Fido, Franco. "Silenzi e cavalli nell'eros del *Decameron*." *Belfagor: Rassegna di Via Umanita* 38 (1983):79–84.

Foote, Timothy, and the Editors of Time-Life Books. *The World of Bruegel, c. 1525–1569*. New York: Time-Life Books. 1968.

Freixe, Guy. "Approche du *Decameron* de Pier Paolo Pasolini." *Les Cahiers de la Cinemathique* 42–3 (1985):143–51.

Freud, Sigmund. *Dora: An Analysis of a Case History of Hysteria*. New York: Macmillan [Collier Books], 1963.

 "Femininity." *The Standard Edition of The Complete Psychological Works*. Vol. 22. Trans. James Strachey. London: Hogarth, 1964.

 General Psychological Theory. Trans. and intro. Phillip Rieff. New York: Macmillan [Collier Books], 1963.

 The Interpretation of Dreams. Ed. and trans. James Strachey. New York: Avon Books, 1965.

 Sexuality and the Psychology of Love. Trans. and intro. Phillip Rieff. New York: Macmillan [Collier Books], 1963.

 Three Case Studies: Wolf Man, Rat Man and the Psychotic Dr. Schreber. Trans. James Strachey. New York: Basic Books, 1975.

 "The Uncanny." *Collected Papers*, ed. Phillip Rieff. Vol. 10. Macmillan [Collier Books], 1963.

 Three Essays on the Theory of Sexuality. Trans. James Strachey. New York: Basic Books, 1962.

Fried, Michael. *Realism, Writing, Disfiguration*. Chicago: University of Chicago Press, 1987.

Friedreich, Pia. *Pier Paolo Pasolini*. Boston: Twayne, 1982.

Fryns, Marcel. *Pierre Brueghel l'Ancien*. Brussels: Editions Meddens, 1964.

Fuss, Diana. *Inside/Out*. New York: Routledge, 1991.

Gallop, Jane. *The Daughter's Seduction*. Ithaca, NY: Cornell University Press, 1982.

 Reading Lacan. Ithaca, NY: Cornell University Press, 1986.

Gambetti, Giacomo. "Pasolini da Boccaccio a Chaucer, per una 'trilogia popolare, libera, erotica.'" *Cineforum ns* 121 (March 1973):221–9.

Ganim, John M. "Chaucer, Boccaccio and the Anxiety of Popularity." *Assays: Critical Approaches to Medieval and Renaissance Texts* 4 (1987):51–67.

Giannotto, Nella. "Parody in the *Decameron*: A 'Contented Captive' and Dioneo." *Italianist* 1 (1981):7–23.

Gibson, Walter S. *Bruegel*. New York: Oxford University Press, 1977.

Gnudi, Cesare. *Giotto*. Milan: Aldo Martello Editore, 1958.

Goldberg, Harriet. "Sexual Humor in Misogynist Medieval Exempla." *Women in His-panic Literature: Loons and Fallen Idols,* ed. Beth Miller. Berkeley and Los Angeles: University of California Press, 1983.

Gombrich, E. H. "Botticelli's Mythologies: A Study in the Neoplatonic Symbolism of His Circle." *Journal of the Warburg and Courtauld Institutes* 8 (1945):7–60.

Grazzini, Giovanni. *"Decamerone." Corriera della Sera,* 29 June 1971.

Greene, Naomi. *Pier Paolo Pasolini: Cinema as Heresy.* Princeton: Princeton University Press, 1990.

Grieco, David, "Il Boccaccio di Pasolini senza messaggi." *L'Unità,* 23 Sept. 1970.

Grossmann, F. *Pieter Bruegel: Complete Edition of the Paintings.* London: Phaidon Press, 1955.

Haines, Charles. "Patient Griselda and Matta Bestialitade." *Quaderni d'Italianistica* 6 (1985):233–40.

Hartt, Frederick. *History of Italian Renaissance Art.* 2nd ed. Englewood Cliffs, NJ: Pren-tice-Hall.

Havely, Nicholas. "Chaucer, Boccaccio and the Friars." *Chaucer and the Italian Trecen-to,* ed. Piero Boitani. Cambridge: Cambridge University Press, 1983.

Hedrick, Donald Keith. "The Ideology of Ornament: Alberti and the Erotics of Re-naissance Urban Design." *Word and Image* 3 (1987):111–37.

Herlihy, David. "Did Women Have a Renaissance?: A Reconsideration." *Mediaevalia et Humanistica* 13 (1985):1–22.

Higonnet, Margaret. "Speaking Silences: Women's Suicide." *The Female Body in West-ern Culture,* ed. Susan Rubin Suleiman. Cambridge, MA: Harvard University Press, 1985.

Hindman, Sandra. "The Illustrated Book: An Addendum to the State of Research in Northern European Art." *Art Bulletin* 68 (1986):536–42.

Hodgdon, Barbara. "The Making of Virgins and Mothers: Sexual Signs, Substitute Scenes and Doubled Presences in *All's Well That Ends Well." Philological Quarterly* 66 (1987):47–71.

Holberton, Paul. "Of Antique and Other Figures: Metaphor in Early Renaissance Art." *Word and Image* 1 (1985):31–58.

Holland, Eugene W. "Boccaccio and Freud: A Figural Narrative Model for the *Decameron." Assays: Critical Approaches to Medieval and Renaissance Texts* 3 (1985): 85–97.

Hollander, Robert. "Boccaccio's Dante: Imitative Distance (*Dec.* I.1 and VI.10)." *Stu-di sul Boccaccio* (1981–2):169–98.

"Imitative Distance: Boccaccio and Dante." *Mimesis: From Mirror to Method, Augustine to Descartes,* ed. John Lyons and Stephen G. Nichols. Hanover, NH: University Press of New England for Dartmouth College, 1982.

Holly, Michael Ann. "Past Looking." *Critical Inquiry* 16 (1990):371–96.

Hope, Charles. "Aspects of Criticism in Art and Literature in Sixteenth-Century Italy." *Word and Image* 4 (1988):1–10.

Horne, Herbert P. *Botticelli: Painter of Florence*. Princeton: Princeton University Press, 1980.

Howard-Hill, T. H. "Boccaccio, Ghismonda, and Its Foul Papers, Glausamond." *Renaissance Papers* (1980):19–28.

Janssens, Marcel. "The Internal Reception of the Stories within the *Decameron*." *Boccaccio in Europe: Proceedings of the Boccaccio Conference, Louvain, December 1975*, ed. Gilbert Tournoy. Louvain: Louvain University Press, 1977.

Janus, and Dino Pedriali. *Pier Paolo Pasolini*. Bologna: Editrice Magma, 1975.

Jardine, Alice, and Paul Smith, eds. *Men in Feminism*. New York: Methuen, 1987.

Jattorelli, Emidio. "Pornografia a disperse con il *Decameron*." *Il Tempo*, 30 June 1971.

Jed, Stephanie H. *Chaste Thinking: The Rape of Lucretia and the Birth of Humanism*. Bloomington: Indiana University Press, 1989.

Johnson, Barbara. Translator's introduction to Jacques Derrida, *Dissemination*. Chicago: Chicago University Press, 1981.

Jones, Alexander, ed. *The Jerusalem Bible*. Garden City, NY: Doubleday, 1966.

Jordan, Constance. "Boccaccio's In-Famous Women: Gender and Civic Virtue in the *De mulierbus claris*." *Ambiguous Realities: Women in the Middle Ages and Renaissance*. Detroit: Wayne State University Press, 1987.

Jordan, Tracey. " 'We Are All One Flesh': Structural Symmetry in Boccaccio's Tale of the Prince and Princess of Salerno." *Studies in Short Fiction* 24 (1987):103–10.

Kelly, Joan. "Did Women Have a Renaissance?" *Becoming Visible: Women in European History*, ed. Renate Bridenthal and Claudia Koonz. Boston: Houghton Mifflin, 1987.

Kirkham, Victoria. "An Allegorically Tempered *Decameron*." *Italica* 62 (1985):1–23.
"The Last Tale in the *Decameron*." *Mediaevalia* 12 (1989):205–23.
"Painters at Play on the Judgment Day (*Dec.* viii, 9)." *Studi sul Boccaccio* 14 (1983–4):256–77.

"A Preliminary List of Boccaccio Portraits from the Fourteenth to the Mid-Sixteenth Centuries." *Studi sul Boccaccio* 15 (1985–6):167–88.

Kirkpatrick, Robin. "The Griselda Story in Boccaccio, Petrarch and Chaucer." *Chaucer and the Italian Trecento: A Bibliography*, ed. Piero Boitani. Cambridge: Cambridge University Press, 1983.

Klapische-Zuber, Christiane. *Women, Family and Ritual in Renaissance Italy*. Trans. Lydia Cocharan. Chicago: University of Chicago Press, 1985.

Kleinhans, Chuck. "Forms, Politics, Makers and Contexts: Basic Issues for a Theory of Radical Political Documentary." *Show Us Life, Toward a History and Aesthetics of the Committed Documentary*, ed. Thomas Waugh. Metuchen, NJ: Scarecrow, 1984.

Kristeva, Julia. "Giotto's Joy." *Desire in Language: A Semiotic Approach to Literature and Art*. New York: Columbia University Press, 1980.

Lacan, Jacques. *Écrits: A Selection*. Trans. Alan Sheridan. New York: Norton, 1977.
Feminine Sexuality. Ed. Juliet Mitchell and Jacqueline Rose, trans. Jacqueline Rose. New York: Norton [Pantheon Books], 1982.

The Four Fundamental Concepts of Psycho-Analysis. 1978. Ed. J. A. Miller, trans. Alan Sheridan. New York: Norton, 1981.

Lanza, Maria Teresa. "Della povera Griselda o di un corto teatrino delle crudeltà." *Problemi: Periodico Quadirimestrale di Cultura* 66 (1983):22–47.

Laplanche, Jean. *Life and Death in Psychoanalysis.* Trans. and intro. Jeffrey Mehlman. Baltimore: Johns Hopkins University Press, 1985.

Lawton, Ben."The Evolving Rejection of Homosexuality, the Sub-Proletariat, and the Third World in the Films of Pier Paolo Pasolini." *Italian Quarterly* 21–2 (1980–81): 167–73.

"The Storyteller's Art: Pasolini's *Decameron,* 1971." *Modern European Filmmakers and the Art of Adaptation.* Ed. Andrew Hornton and Joan Magretta. New York: Ungar, 1981.

"Theory and Praxis in Pasolini's Trilogy of Life: *Decameron."* *Quarterly Review of Film Studies* 2 (1977):395–415.

Layman, B. J. "Boccaccio's Paradigm of the Artist and His Art." *Italian Quarterly* 13 (1970):19–36.

Leparulo, William E. "Figurative and Narrative Fantasy in Pasolini's and Boccaccio's *Decameron."* *Sex and Love in Motion Pictures,* ed. Douglass Radcliff-Umstead. Romance Language Department Kent State University, 1984.

Lightbown, Ronald. *Sandro Botticelli.* 2 vols. Berkeley and Los Angeles: University of California Press, 1978.

Sandro Botticelli: Life and Work. New York: Abbeville, 1989.

Luborsky, Ruth Samson. "Connections and Disconnections between Images and Texts: The Case of Secular Tudor Book Illustration." *Word and Image* 3 (1987):74–85.

MacBean, James Roy. "Between Kitsch and Fascism: Notes on Fassbinder, Pasolini, (Homo)sexual Politics, the Exotic, the Erotic, and Other Consuming Passions." *Cineaste* 13 (1984):12–19.

Macchiocchi, Maria Antonietta. *Pasolini.* Seminar directed by M. A. Macchiocchi. Paris: Bernard Grasset, 1980.

Magrelli, Enrico. *Con Pier Paolo Pasolini.* Ed. Enrico Magrelli. Rome: Bulzoni, 1977.

Mahaini, Nabil Reda. *"Decameron." Cinema* 60, Jan. 1972.

Maraini, Dacia. "Ma la donna è una slot machine?" *L'Espresso,* 22 Oct. 1972.

"Pier Paolo Pasolini." *Vogue Italia,* May 1971.

Marcon, Susy. "I codici a Vernoa." *Studi sul Boccaccio* 17 (1987):101–2.

"Descrizione dei codici nelle Biblioteche veneziane." *Studi sul Boccaccio* 16 (1987):255–71.

Marcus, Millicent J. *An Allegory of Form: Literary Self-Consciousness in the "Decameron."* Saratoga, CA: Anma Libri, 1979.

"The *Decameron:* Pasolini as a Reader of Boccaccio." *Italian Quarterly* 21–2 (1980):175–80.

"Misogyny as Misreading: A Gloss on *Decameron* VIII, 7." *Stanford Italian Review* 4 (1984):23–40.

Martellini, Luigi. *Pier Paolo Pasolini.* Florence: Le Monnier, 1983.

Mazzotta, Giuseppe. *The World at Play in Boccaccio's "Decameron."* Princeton: Princeton University Press, 1986.

Meiss, Millard. "The First Fully Illustrated *Decameron.*" *Essays in the History of Art, Presented to Rudolf Wittkower.* London: Phaidon, 1967.

　　Painting in Florence and Siena after the Black Death. Princeton: Princeton University Press, 1951.

　　Preface. *Les très riches Heurs du Duc de Berry.* Reproduced from illuminated manuscript belonging to Musée Condé, Chantilly, France. London: Thames & Hudson, 1969.

Metz, Christian. *The Imaginary Signifier.* Bloomington: Indiana University Press, 1977.

Miles, Margaret. *Image as Insight: Visual Understanding in Western Christianity and Secular Culture.* Boston: Beacon, 1985.

　　"The Virgin's One Bare Breast: Female Nudity and Religious Meaning in Tuscan Early Renaissance Culture." *The Female Body in Western Culture: Contemporary Perspectives.* Cambridge, MA: Harvard University Press, 1986.

Monson, Don A. "Andreas Capellanus and the Problem of Irony." *Speculum* 63 (1988):539–72.

Moravia, Alberto. "Boccaccio." *L'uomo come fine e altri saggi.* Milan: Bompiani, 1964.

Moravia, Albert, and Alain Elkann. *Vita di Moravia.* Milan: Bompiano, 1990.

Moxey, Keith P. F. "A New Look at Netherlandish Landscape and Still Life Painting." *Arts in Virginia* 26 (1988):46–57.

Mulvey, Laura. "Visual Pleasure in Narrative Cinema." *Screen* 16 (Autumn 1975): 6–18.

Murrin, Michael. *The Allegorical Epic.* Chicago: University of Chicago Press, 1980.

Newton, Stella Mary. *Renaissance Theatre Costume.* New York: Theatre Art Books, 1975.

Nichols, Stephen G., Jr. *Romanesque Signs: Early Medieval Narrative and Iconography.* New Haven: Yale University Press, 1983.

Orlandi, Stefano. *Historical-Artistic Guide of Santa Maria Novella and Her Monumental Cloisters.* Florence: S. Becocci.

Orto, N. "Il rapporto mito realità nell'itinerario di Pasolini." *Cinema Nuovo* 26 (1977):424–31.

Ovid. *Metamorphoses.* Trans. Rolfe Humphries. Bloomington: Indiana University Press, 1955.

Pächt, Otto. *Book Illumination in the Middle Ages.* Trans. Kay Davenport. Oxford: Oxford University Press [Harvey Miller], 1986.

Panofsky, Erwin. *Studies in Iconology: Humanistic Themes in the Art of the Renaissance.* 2nd ed. New York: Harper & Row, 1962.

Pasolini, Pier Paolo. "Le ambigue forme della ritualità narrativa." *Cinema Nuovo* 23 (1974):342–7.

"L'ambiguità." *Filmcritica* 25 (1974):308–10.

Le ceneri di Gramsci. Milan: Garzanti, 1976.

Cinema d'aujourd'hui. Editions Seghers, 1973.

"The Cinema of Poetry." *Cahiers du cinema in English* 6 (1966):34–43.

"Cinematic and Literary Stylistic Figures." *Film Culture:* 42–3.

"Convegno su 'cinema, industria e cultura.' " *Bianco e Nero* 35 (1974):157–60.

"Conversazione con Pier Paolo Pasolini." Ed. Allesandro Gennari. *Filmcritica* 25 (1974):280–2.

"Conversazioni con Pier Paolo Pasolini." Ed. Gideon Bachmannn e Donata Gallo. *Filmcritica* 26 (1975):235–9.

Empirismo eretico. Milan: Garzanti Editori, 1981.

Lettere luterane. Turin: Einaudi, 1976.

La nuova gioventù. Turin: Einaudi, 1975.

"Observations on the Long Take." Trans. Norman MacAfee and Craig Owens. *October* 13 (1980):3–6.

"Oedipus Rex," a Film by Pier Paolo Pasolini. Trans. John Matthews. New York: Simon & Schuster, 1976.

"Pasolini come Giotto." *Epoca,* 18 Oct. 1970.

"Pasolini on Semiotics." *Framework* 3 (1976):16–21.

"La pazzesca razionalità della geometria religiosa." *Cinema Nuovo* 23 (1974):184–7.

Pier Paolo Pasolini, I disegni: 1941–1975. Ed. Giuseppe Zigaina. Milan: Edizioni di Vanni Scheiwiller, 1978.

Poems. Trans. Norman MacAfee. New York: Random House [Vintage Books], 1982.

Ragazzi di vita. Milan: Garzanti, 1955.

"The Scenario as a Structure Designed to Become Another Structure." Trans. M. S. de Crux-Saenz. *Wide Angle* 2 (1977):40–52.

"Sceneggiatura del *Decameron*" (copia segretaria di edizione, Nov. 8).

Scritti corsari. Milan: Garzanti, 1990.

"Lo sguardo di R. R." *Filmcritica* 28 (1977):131.

Il sogno di una cosa. Milan: Garzanti, 1987.

"Strutture dell'ipocrisia e tecniche del linguaggio." *Cinema Nuovo* 25 (1976):27–33.

"Treatment for il Decameron." Typescript by Pasolini, Archives, Fondo Pier Paolo Pasolini, Rome.

Trilogia della vita. Ed. Giorgio Gattei. Bologna: Capelli Editori, 1975.

Trilogia della vita. Ed. Giorgio Gattei. Bologna: Capelli Editore, 1977.

Trilogia della vita. Ed. Giorgio Gattei. Oscar narrativa, 1990.

Una vita violenta. Turin: Einaudi, 1979.

"What Is Neo-Zhdanovism and What Is Not." Trans. Norman MacAfee and Craig Owens. *October* 13 (1980):7–10.

Patillo, N. Allen. "Botticelli as a Colorist." *Art Bulletin* 26 (1954):218–20.

Penley, Constance, ed. *Feminism and Film Theory.* New York: Routledge, 1988.

The Future of An Illusion. Minneapolis: University of Minnesota Press, 1989.

"Reply to Mieke Bal's 'Perpetual Contest.'" Susan B. Anthony Working Papers no. 11. Rochester, NY: University of Rochester, 1987.

Petrarca, Francesco. "On Boccaccio's *Decameron* and the Story of Griselda." Trans. James Harvey Robinson and Henry Winchester Rolfe in their *Petrarch: The First Modern Scholar and Man of Letters.* New York: Greenwood, 1968.

Piguet, Nicola. "Variations autour d'un mythe ovidien dans l'oeuvre de Boccace." *Revue des Etudes Italiennes* 31 (1985):25–35.

Pope-Hennessy, J., and K. Christiansen. *Secular Painting in Fifteenth-Century Tuscany: Birth Trays,* Cassone *Panels and Portraits.* New York: 1980.

Potter, Joy H. *Five Frames for the "Decameron."* Princeton: Princeton University Press, 1982.

Previtale, Giovanni. *Giotto, La capella degli Scrovegni.* Milan: Fratelli Fabbri Editori, 1967. *Giotto e la sua bottega.* Milan: Fratelli Fabbri Editori, 1967.

Pugliese, Guido. "*Decameron* II.3: Un caso di contingenza causale." *Esperienze Letterarie: Rivista Trimestrale di Critica e Cultura.* 5 (1980):29–41.

"'Nastagio degli Onesti' ovverosìa della lotta dei sessi." *Ipotesi Rivista Quadrimestrale di Cultura* 8–9 (1983):3–13.

Reynolds, Catherine. "Illustrated Boccaccio Manuscripts in the British Library (London)." *Studi sul Boccaccio* 17 (1988):113–69.

Rimmon-Kenan, Shlomith, ed. *Discourse in Psychoanalysis and Literature.* London: Methuen, 1987.

Rodowick, D. N. "Reading the Figural." *Camera Obscura* 24 (1990):11–46.

Rose, Jacqueline. *Sexuality in the Field of Vision.* London: Verso, 1986.

Rossi, Aldo. "Decameronian Combinations: Andreuccio." *Russian Literature* 12 (1982):131–44.

Russo, Luigi. *Letture critiche del Decameron.* Bari: Laterza, 1977.

Salvini, Roberto. *All the Paintings of Botticelli.* 29 vols. Trans. John Gillenzini. Vols. 26, 28. New York: Hawthorn, 1965.

Sanguineti, Federico. "La novelletta delle papere nel *Decameron.*" *Belfagor* 37 (1982):137–46.

Santi, Bruno. *Botticelli.* Florence: Becocei Editore, 1976.

Saslow, James M. "'A Veil of Ice between My Heart and the Fire': Michelangelo's Sexual Identity and Early Modern Constructs of Homosexuality." *Genders* 2 (1988):77–90.

Scaglione, Aldo. "Inganni del sesso e beffe della morte nel *Decamerone* inglese di Pasolini." *Paese Sera,* 3 July 1972. *Nature and Love in the Late Middle Ages.* Berkeley and Los Angeles: University of California Press, 1963.

Scarry, Elaine. *The Body in Pain.* New York: Oxford University Press, 1985.

Schor, Naomi. *Breaking the Chain: Women, Theory and French Realist Fiction.* New York: Columbia University Press, 1985.

Schubring, Paul. *Cassoni: Truhen und Truhebilder der Italienischen Frührenaissance: Ein Beitrag zur Profamalerei im Quattrocento.* Karl W. Hiersemann. Leipzig: Hiersemann, 1915.

Scott, Joan W. "Gender: A Useful Category of Historical Analysis?" *American Historical Review* 91 (1986):1053–75.

Sedgwick, Eve Kosofsky. *Between Men: English Literature and Male Homosocial Desire.* New York: Columbia University Press, 1985.

　Epistemology of the Closet. Berkeley and Los Angeles: University of California Press, 1990.

　Tendencies. Durham: Duke University Press, 1993.

　"Tide and Trust." *Critical Inquiry* 15 (1989):745–57.

servizio dedazionale. "Pasolini ha copiato Giotto per il *Giudizio universale.*" *La Stampa,* 7 Nov. 1970.

Sherman, Claire Richter. "Taking a Second Look: Observations of the Iconography of a French Queen," Jeanne de Bourbon (1338–1378). *Feminism and Art History,* ed. Norma Bronde and Mary D. Garrard. New York: Harper & Row, 1982.

Showalter, Elaine. *Sexual Anarchy: Gender and Culture at the Fin de Siècle.* New York: Viking Penguin, 1990.

Siciliano, Enzo. *Pasolini, A Biography.* Trans. John Shepley. New York: Random House, 1982.

　Vita di Pasolini. Milan: Rizzoli Editore, 1981.

Silverman, Kaja. *The Acoustic Mirror.* Bloomington: Indiana University Press, 1988.

　'Fassbinder and Lacan: A Reconsideration of Gaze, Look and Image." *Camera Obscura* 19 (1989):4–23.

　"Histoire D'O: The Story of a Disciplined and Punished Body." *Enclitic* 7 (1983):63–81.

　Male Subjectivity at the Margins. New York: Routledge, 1992.

　"Masochism and Male Subjectivity." *Camera Obscura* 17 (1988):31–68.

　The Subject of Semiotics. New York: Oxford University Press, 1983.

　"White Skin, Brown Masks: The Double Mimesis, or With Lawrence in Arabia." *Différences* 1 (1989):3–54.

Simons, Pat. "Women in Frames: The Gaze, the Eye, the Profile in Renaissance Portraiture." *History Workshop* 25 (1988):4–30.

Singleton, Charles. "On Meaning in the *Decameron.*" *Italica* 21 (1944):117–24.

Smarr, Janet Levarie. "Ovid and Boccaccio: A Note on Self-Defense." *Mediaevalia* 13 (1987):247–55.

　"Rewriting One's Precursors: Notes on the *Decameron.*" *Mediaevalia* 5 (1979):205–16.

Spivak, Gayatri C. "French Feminism in an International Frame." *In Other Worlds: Essays in Cultural Politics.* New York: Routledge, 1988.

　"French Feminism Revisited: Ethics and Politics." Address presented at University of Rochester, Rochester, NY, 15 Feb. 1990.

　"A Literary Representation of the Subaltern: A Woman's Text from the Third World." *In Other Worlds: Essays in Cultural Politics.* New York: Routledge, 1988.

Translator's Preface to *Of Grammatology* by Jacques Derrida. Baltimore: Johns Hopkins University Press, 1976.

Stack, Oswald. *Pasolini on Pasolini: Interviews with Oswald Stack.* Bloomington: Indiana University Press, c. 1969.

Stechow, Wolfgang. *Pieter Bruegel the Elder.* New York: Abrams, 1940.

Steinberg, Leo. "Picasso's Sleepwatchers." *Other Criteria: Confrontations with Twentieth-Century Art.* New York: Oxford University Press, 1972.

 The Sexuality of Christ in Renaissance Art and in Modern Oblivion. New York: Pantheon: 1983.

Steiner, Wendy. *Pictures of Romance: Form against Context in Painting and Literature.* Chicago: University of Chicago Press, 1988.

Steven, Peter, ed. *Jump/Cut: Hollywood, Politics and Counter Cinema.* New York: Praeger, 1985.

Stewart, Pamela D. "Giotto e la rinascita della pittura: *Decameron* VI.5." *Yearbook of Italian Studies* 5 (1983):22–34.

Stillinger, Thomas C. "The Language of Gardens: Boccaccio's *Valle delle Donne.*" *Traditio* 39 (1984):301–22.

Storey, Harry Wayne. "Parodic Structure in 'Alibech and Rustico': Antecedents and Traditions." *Canadian Journal of Italian Studies* 5 (1982):163–76.

Stubblebine, James H. *Giotto: The Arena Chapel Frescoes.* London: Thames & Hudson, 1969.

Suleiman, Susan. *The Female Body in Western Culture: Contemporary Perspectives.* Cambridge, Mass.: Harvard University Press, 1986.

Todini, Umberto. "Pasolini and the Afro-Greeks." *Stanford Italian Review* 5 (1985):219–22.

Tordi, Rosita, ed. *Pier Paolo Pasolini. Galleria,* Jan.–Aug., 1985.

Usher, Jonathan. "Boccaccio's Experimentation with Verbal Portraits from the *Filocolo* to the *Decameron.*" *Modern Language Review* 77 (1982):585–96.

 "Narrative and Descriptive Sequences in the Novella of Lisabetta and the Pot of Basil (*Dec.* IV.5)." *Italian Studies* 38 (1983):56–69.

Van Leer, David. "The Beast of the Closet: Homosociality and the Pathology of Manhood." *Critical Inquiry* 15 (1989):587–605.

 "Trust and Trade." *Critical Inquiry* 15 (1989):758–63.

van Miegroet, Hans F. "*The Twelve Months* Reconsidered: How a Drawing by Pieter Stevens Clarifies a Bruegel Enigma." *Simiolus* 16 (1986):29–35.

Viano, Maurizio. *A Certain Realism: Making Use of Pasolini's Film Theory and Practice.* Berkeley and Los Angeles: University of California Press, 1993.

Vigorelli, Giancarlo, and Edi Baccheschi. *L'opera completa di Giotto.* Milan: Rizzoli Editore, 1977.

Wack, Mary F. "Imagination, Medicine, and Rhetoric in Andreas Capellanus' *De amore.*" *Magister Regis: Studies in Honor of Robert Earl Kaske,* ed. Arthur Groos with Emerson Brown, Jr., Giuseppe Mazzotta, Thomas D. Hill, and Joseph S. Wittig. New York: Fordham University Press, 1986.

Wailes, Stephen L. "Why Did Jesus Use Parables? The Medieval Discussion." *Mediaevalia et Humanistica* 13 (1985):43–64.

Waller, Gary F. "Deconstruction and Renaissance Literature." *Assays: Critical Approaches to Medieval and Renaissance Texts* 2 (1983):69–93.

Watson, Paul F. "The Cement of Fiction: Giovanni Boccaccio and the Painters of Florence." *MLN* 99 (1984):43–64.

"Gathering of Artists: The Illustrators of a *Decameron* of 1427." *TEXT: Transactions of the Society for Textual Scholarship* 1 (1981):147–56.

"More Subjects from Boccaccio." *Studi sul Boccaccio* 16 (1987):273–74.

"A Preliminary List of Subjects." *Studi sul Boccaccio* 15 (1985–6):149–66.

"*Virtu* and *Voluptas* in *cassoni* Painting," Ph.D. diss., Yale University, 1970.

Weiss, Andrea. "From the Margins: New Images of Gays in the Cinema." *Cineaste* 15 (1986):4–8.

Wetherbee, Winthrop. *Platonism and Poetry in the Twelfth Century.* Princeton: Princeton University Press, 1972.

Willemen, Paul, ed. *Pier Paolo Pasolini.* London: British Film Institute, 1977.

Willis, Sharon. "Disputed Territories: Masculinity and Social Space." *Camera Obscura* 19 (1989):4–23.

"Special Effects: Sexual and Social Differences in *Wild at Heart*." *Camera Obscura* 25–6 (1991):275–96.

Witthoft, Brucia. "Marriage Rituals and Marriage Chests in Quattrocento Florence." *artibus et historiae* 5 (1982):43–60.

Yashiro, Yukio. "The Sensuous Botticelli." *Readings in Art History.* Vol. 2. Ed. Harold Spencer. New York: Scribners, 1969.

Zeitlin, Froma. "The Dynamics of Misogyny: *Myth and Myth-making* in the *Oresteia*." *Arethusa* 11 (1978):149–84.

Zigaina, Giuseppe. *Pasolini tra enigma e profezìa.* Venice: Marsilio, 1989.

"Total Contamination in Pasolini." *Stanford Italian Review* 4 (1984):267–85.

FILMOGRAPHY: FILMS DIRECTED BY PIER PAOLO PASOLINI

1961	*Accattone*
1962	*Mamma Roma*
1963	*La ricotta* (Third episode of *Rogopag* or *Laviamoci il cervello;* other episodes by Roberto Rossellini, Jean-Luc Godard, Ugo Gregoretti)
1964	*Comizi d'amore*
	Sopraluoghi in Palestina
	Il vangelo secondo Matteo
1966	*Uccellacci e Uccellini*

1967 *La terra vista dalla luna* (Third episode of *Le streghe;* other episodes by Luchino Visconti, Mauro Bolognini, Franco Rossi, Vittorio De Sica)
Edipo Re

1968 *Che cosa sono le nuvole* (Third episode of *Capriccio all'italiana;* other episodes by Steno, Mauro Bolognini, Pino Zac, and Mario Monicelli
Teorema
Appunti per un film sull'India (Short film, made for Italian television, concerning a proposed film on hunger in India)

1969 *La sequenza del fiore di carta* (Third episode of *Amore e rabbia;* other episodes by Carlo Lizzani, Bernardo Bertolucci, Jean-Luc Godard, Marco Bellocchio)
Porcile
Medea

1970 *Appunti per una Orestiade africana*

1971 *Il Decamerone*

1972 *12 decembre*
I Racconti di Canterbury

1974 *Il fiore delle mille e una notte*
Le mura di Sana'

1975 *Salò o Le 120 giornate di Sodoma*

INDEX